D1444213

The Artist and the City

European Perspectives
A Series of the Columbia University Press

The Artist
and
the City

EUGENIO TRÍAS

Translated by Kenneth Krabbenhoft

New York
Columbia University Press
1982

Library of Congress Cataloging in Publication Data

Trías, Eugenio, 1942–
The artist and the city

(European perspectives)
Translation of: El artista y la ciudad.
Includes bibliographical references and
index.
I. Title. II. Series.
AC75.T6513 086'.1 81-21730
ISBN 0-231-05286-3 AACR2

Columbia University Press
New York Guildford, Surrey

Clothbound editions of Columbia University Press books are
Smyth-sewn and printed on permanent and durable acid-free paper.

On December 10, 1975, a jury consisting of Salvador
Clotas, Hans Magnus Enzensberger, Luis Goytisolo,
Xavier Rubert de Ventós, Mario Vargas Llosa, and
the editor Jorge Herralde, without vote, awarded
the IV Premio Anagrama, by a majority decision, to
Eugenio Trías's *El artista y la ciudad*, of which this
book is a translation.

To My Mother

Contents

Foreword

Although the so-called "May Revolution" of 1968 seems safely tucked into oblivion, that student revolt in Paris has had a lasting effect in Spain. The Catalan philosopher and essayist Eugenio Trías (b. 1942) was jostled into intellectual awareness by the tremors originating beyond the Pyrenees and spreading to the other side of the Atlantic. By the late 1960s, it is true, an aging Franco had relinquished some of his ideological hold over the Spanish university. But Thomistic Scholasticism, tacitly supported by the fascist regime, still reigned in philosophy departments throughout Spain. Nevertheless, students there began imitating their counterparts in France and the United States in looking leftward toward Marcuse and Marxism. The new thinking held out the promise of a renewed social order. Yet what first seemed to offer only liberation had a disturbing underside: it was dogmatism of the Left, asserted with as much intransigeance as the oft-repeated doctrines of the Right. Hence it found a subtle adversary in Trías, an enemy of all ideologies. Every Western philosophy, he asserted, has a structure of doctrines to be included and another structure to be excluded. Whatever the changes in structure from one philosopher to the next, the total set of problems posed by all philosophy remains constant. Trías found it a contradiction in terms to speak of a "revolutionary"

philosophy. True "revolution," as the student radicals advocated, would only end up devouring philosophy.[1]

A public demonstration of Trías' concern for philosophy took place in 1976. Amidst a political crisis at the state-run University of Barcelona, he and three other philosophy professors founded their own Col·legi de Filosofia. The purpose of this experiment was to offer the public of Barcelona philosophy courses free of the taint of politics and of institutional prerequisites. Intent on opening their minds to all sectors of Barcelonese society, the founders moved their Col·legi from place to place throughout the city and continually renewed their methods and projects. The variety of themes taken up by the Col·legi reflected a will to mental self-renewal: "Theory of Philosophical Discourse" (1977), "Theory of Passions" (1978), "Hegel as a Living Force" (1979), "Knowledge, Memory, and Creativity" (1981). In 1977 Trías offered a course at the Col·legi on "Philosophy and Power"; in 1978 he taught "The *Raison du coeur*"; in 1979, "Stuggle and Reconciliation in Hegel's *Phenomenology of Mind*"; and in 1981, "On the Esthetics of the Sinister."

If certain themes of Trías' works can be used to describe his philosophical attitude, they are doubtlessly antidogmatism, freedom from ideologies, and concern with the essence of philosophy and the bases of Western culture. His first five published books all focus upon the question, "What is philosophy?" while his later works reflect on the foundations of European culture.[2] From 1972

1. *La filosofía y su sombra* (Barcelona, 1969), pp. 56–57. On philosophy in Franco Spain of the 1960s, I heavily rely on a letter to me from Eugenio Trías dated August 20, 1981.

2. To date, Trías has published the following books: *Philosophy and Its Shadow* (*La filosofía y su sombra*), *Philosophy and Carnival* (*Filosofía y carnaval,* Barcelona, 1970), *Theory of Ideologies* (*Teoría de las ideologías,* Barcelona, 1970), *Methodology of Magical Thinking* (*Metodología del pensamiento mágico,* Barcelona, 1970), *Dispersion* (*La dispersión,* Madrid, 1971), *Drama and Identity* (*Drama e identidad,* Barcelona, 1974), *The Artist and the City* (*El artista y la ciudad,* Barcelona, 1976), *Meditation on Power* (*Meditación sobre el poder,* Barcelona, 1977), *Thomas Mann and His Works* (*Thomas Mann y su obra,* Barcelona, 1978), *The Lost Memory of Things* (*La memoria perdida de las cosas,* Madrid, 1978), *Goethe and His Works*

on, these cultural reflections, though present in the earlier writings, dominate Trías' work. *The Artist and the City*, first published in 1976, alludes in its title to Europe as the "city" of Western values. Like Nietzsche, Trías finds himself alienated from that city, aspires to delve to its bases, and hopes to suggest ways for strengthening and renovating it. In fact, Trías endeavors to rescue what is best in modern thought by a return to the classics. "Let us return to our classics, the classics of European philosophy and literature. Let us become imbued with their spirit. Only in that way, through the exercise of active remembering, will it be possible to make attitudes in philosophy and life fruitful which otherwise run the risk of being incidental, merely fashionable."[3] Clearly a return to the classics requires selection, inclusion of some authors, exclusion of others. Those chosen by Trías have formulated ideas sturdy enough to furnish a foundation for Western culture.

(*Goethe y su obra,* Barcelona, 1980), *Treatise on Passion* (*Tratado de la pasión,* Madrid, 1979), *The Language of Forgiveness: An Essay on Hegel* (*El lenguaje del perdón, un ensayo sobre Hegel,* Barcelona, 1981). For this bibliography I have consulted Trías' dossier published in *Anthropos* (August 1981), p. 5; on the Col·legi de Filosofia, pp. 9–10. Trías distinguishes two periods in his works (1969–1971, 1974–1981). During the first period, he addresses ideological issues of the 1960s while employing the structuralist methods and lexicon of Lévi-Strauss and Foucault; during the second, he begins his radical reflection on the underpinnings of European culture. This information appears in his August 20 letter.

3. I have translated Trías' words from the August 20 letter: "Volvamos a nuestros clásicos, los clásicos de la filosofía y de la literatura europea, impregnémonos de su espíritu; sólo así, mediante ese ejercicio de memoria activa, será posible fecundar posiciones vitales o filosóficas que, de otro modo, corren el riesgo de ser coyunturales, mero efecto de la moda." This is not the first time that a twentieth-century Catalan philosopher has called for a return to classicism. Eugenio d'Ors advocated a "classical sense of life," conceived as attention to harmony, order, precise detail, proportion, limits. But d'Ors's classicism responds to the need of the Catalan ethos to assert its identity vis-à-vis Castilian mysticism and unlimited aspirations, according to José Luis L. Aranguren, *La filosofía de Eugenio D'Ors* (Madrid, 1981), p. 121. Trías' classicism stems from a greater sense of urgency: he wishes to return to European roots for the salvation of Western culture. In a letter to me dated October 8, 1981, he has remarked that his cultural concern is identical to Nietzsche's; see the chapter, "Nietzsche: Mind Divorced from the City."

From the dialogues of Plato, Trías has garnered the ideal of the synthesis of subject and object, of soul and city, of the principles of *Eros* and *Poiesis*. In the Neo-Platonic thought of Pico della Mirandola, Trías discerns an attempt to harmonize the ever-changing artist with the city in which he creates. It is tempting to see in Trías' idealization of Renaissance Florence a fantasy of what his own Barcelona could be, enriched with the ever-shifting philosophical concerns of his Col·legi. In Goethe, by contrast, Trías finds a solitary artist for whom the syntheses of artist and city, love and creativity, exist as problems capable of solution. The ideal begins to falter with Hegel, Trías says, who held that such harmonies can materialize only in the mind. Following on Hegel, Wagner witnesses the split between the soul and the city, while Thomas Mann narrates the disintegration of the three syntheses in the twentieth century (pp. 49–50).

Trías is not satisfied to provide a serene spectacle of the breakdown between the artist and his society. He enters heatedly into the debate between "radical thinkers in France, Germany, and America" on the themes of desire and creative effort, eroticism and public production (p. 9). Among these "radicals" are the German-American Marcuse with his work *Eros and Civilization: A Philosophical Inquiry into Freud* (Boston, 1953); Gilles Deleuze and Felix Guattari, authors of *Anti-Oedipus: Capitalism and Schizophrenia* (New York, 1977); and J. Lacan, who has written *Le Mythe individuel du névrosé ou "Poesie et vérité" dans le névrosé* (Paris, 1953).[4] Trías' contribution to the debate unfolds in a quasi-narrative form which attempts to reconstruct the psychological situations in which great Western thinkers create. The re-creation of the past becomes Trías' creative task. The process of reconstruction enables him to accept or reject *a posteriori*, as it were, the theories of others.

Precisely how much does he agree or disagree with Marcuse, Deleuze and Guattari, and Lacan? In *Eros and Civilization*, we recall, Marcuse takes for his point of departure Freud's idea that civili-

4. Trías names these authors and their works in a letter to me dated September 19, 1981.

zation, in order to progress, requires a severe repression of man's biological instincts. But Marcuse maintains that civilization has become so advanced that it depends for its survival on the removal of all constraints on human drives. The creative powers of *Eros* must be unleashed and allowed to play themselves out. Through a rereading of Plato's *Symposium* 210–11, Marcuse comes to redefine Freudian *Eros* as an impulse toward cultural creativity. Freud conceives *Eros* as the life instinct, as the drive to "form living substance into ever greater unities, so that life may be prolonged and brought to higher development." Marcuse points out, however, that for Plato, *Eros* generates spiritual as well as bodily creatures, and lends order not only to interpersonal relationships, but also to entire cities. Sexual impulse becomes sublimated into cultural effort. *Eros*, aspiring to perpetuate pleasure, requires "continual refinement" of the individual. This requirement gives rise to new life-promoting, pleasure-producing projects, among them, "the abolition of toil, the amelioration of the environment, the conquest of disease and decay, the creation of luxury." Such operations comprise *work* which organizes individuals into larger units. Work relationships, far from repressing human potential, can help it to endure and expand.[5]

Trías concurs with Marcuse's interpretation of *Eros* in Plato. Yet he diverges from Marcuse in considering the aims of *Eros*. The erotic impulse does not tend toward the "abolition of toil" to promote life and pleasure, as Marcuse would have it, but toward self-perpetuation. According to *The Artist and the City* (p. 17*n*13), Marcuse glimpses no middle term between toil and pleasure; but for Trías creativity can form the bridge. Returning to the *Symposium* 206c, Trías notes that *Eros* does not reach its essence through repose, but through its "permanent and stable tendency to create. By virtue of its fertility it endlessly reproduces itself" (p. 18). The dynamic conception of *Eros* pervades the whole of *The Artist and the City*. It becomes most patent in the chapter on Pico della Mir-

5. Herbert Marcuse, *Eros and Civilization* (Boston, 1971), pp. 211–12; Marcuse quotes Freud's definition of *Eros* as it appears in *Collected Papers* (London, 1950), 5:135.

andola or the Renaissance man, an endless self-creation. "We may dream about the Greeks," Trías concedes, "but we must nevertheless be able to see ourselves in the Venetian merchants and the Italian condottieri" (p. 48). In other words, we as heirs of Western civilization must measure ourselves, insofar as we are creative beings, against Alberti and da Vinci, the Medicis and Piero della Francesca, synthesizing action and contemplation, poetry and politics.

As a thinker engaged in the creation of ideas, Trías practices a style of cognition related to that of Deleuze and Guattari, while avoiding their clinical trappings. Using "schizoanalysis," Deleuze and Guattari attempt to understand the subconscious, which they conceive neither as a structure, nor as a metaphor, but as an active process of desiring and producing, whereby production and product become one. Production through desire strikes Trías as the central theme of *Anti-Oedipus*. He recognizes his proximity to Deleuze and Guattari in focusing his own work on the endeavor to bridge the gap between desire and production. The solutions reached by all three converge upon a self-renewing activity which would reconcile wish-fulfillment with extrapsychic reality. But Trías strives to reconsider the idea of production through desire on a more radical level. For this reason he finds it necessary to return to Plato, whose dialogues are cornerstones of Western culture. A rereading of Plato reveals that the work of Deleuze and Guattari errs on the side of reductionism: they concern themselves with ways to "introduce desire into thought, into discourse, into action";[6] but their writing, Trías thinks, suggests that they are confusing dreams with reality, activity with passiveness, the soul with the city, and creativity with toil (p. 128*n*22). Plato, on the other hand, carefully preserves the distinction between the terms of each binomial. He is well aware of the distance between the world of appearances, of change, and the world of Ideas, of being. Trías, too, prefers to recognize the separation of the two worlds

6. Michel Foucault, "Preface," *Anti-Oedipus: Capitalism and Schizophrenia*, tr. Robert Hurley, Mark Seem, and Helen R. Lane (New York, 1977), p. xii.

when examining the movements of *Eros* and of *Poiesis* in the sub-conscious of Western man.

Marcuse, Deleuze, and Guattari affect Trías' theories on the possible harmony between desire and production. Yet he is in constant dialogue with Jacques Lacan in the parts of his book treating the divorce of the soul from the city. From *Le Mythe individuel du névrosé,* he says that he has derived his diagram of the path that desire follows when the soul lives alienated from its urban surroundings. The soul falls back upon itself, creativity lapses into mindless production. Trías disagrees with Lacan, though, in the way he traces creativity to the individual's inner calling. The Lacanian theory, an amalgam of Heidegger, Freud, and structuralism, holds that vocation is the call to devise a program of life, whereby the individual may defend himself against the tyranny of death. Trías, however, prefers the approach to vocation of the "classic" Nietzsche. Rather than speaking of an impersonal threat which looms over the individual at the end of life, Nietzsche espouses the notion of a more immediate and intimate responsibility to oneself. The individual owes it to himself to realize his personal potential. He even assuages guilt by obeying his inner imperative to achieve his authentic being. Indeed, he cancels his inner debt to himself when he acts to the limit of his capacities, surmounts himself, and achieves new heights of human excellence. It is true that he may, like Trías' Goethe, postpone the effort of self-surmountal until late in life (p. 63). But once he does overcome his inertia, his works represent the synthesis of creativity and emotion (p. 74).

The Artist and the City, therefore, emerges from a dialogue between its author and contemporary philosophers and psychologists. Yet this work transcends the dialogue. Trías, hostile to dogmatism, invites the reader to make his own interpretation. A polysemic work is being offered to those willing to engage in their own experiment in hermeneutics. Trías the essayist keeps in mind every idea he has suggested as he sets down new ones. They recur in varying orders like Wagnerian leitmotifs. Hence he asks the reader to move his mind over the text both in a horizontal direction, as he is accustomed, and in a vertical one, so as to perceive at the same

time links between several levels of philosophical concern—in this case, the esthetic, the epistemological, and the ontological.

Perhaps no single theme can better illustrate Trías' demands on his reader than the Proteus leitmotif. At the base of Trías' allusions to the mythical master of metamorphoses lies a doctrine of ontology which generates a principle of epistemology and esthetics. Trías' "principle of variation" may be expressed as follows: an individual being tests its own universality by undergoing changes, by repeating and re-creating itself in different events. To know that individual is to contemplate it in a work of art, where universals and particulars are conjugated without the mediation of concepts.[7]

Trías employs that principle as a yardstick to measure the value for European culture of the classics he examines. He admittedly is giving a diachronic twist to Aristotle's doctrine "anima est quodammodo omnia" (p. 83n1). Hence Plato, according to Trías, banishes the representational artist from the city because of his Protean ability to be and make all things. But Plato's reasoning acquires value for Western civilization when Pico della Mirandola uses the same rationale to justify integrating the artist into the city. For Pico, man's essential mutability injects energy into an otherwise static universe (p. 47). Like Pico, Goethe, as viewed by Trías, aspires to embody "the *uomo singulare,* the soul that is to some degree all things" (p. 77). In the light of this aspiration it is best to read Trías' complex appraisal of Goethe's "Protean biography as well as his dramatis personae" (p. 63). The same Faustian impulse of the soul to be all things pervades Hegel's *Phenomenology of Mind.* Here Trías lauds Hegel for holding the soul responsible for externalizing for itself the totality of all things deposited within it (p. 84). With Richard Wagner, however, Trías plays a somewhat different variation on his Proteus leitmotif. The composer's "Protean nature" causes him to espouse many beliefs in succession (p. 92).

7. For the definition of the "principle of variation," I rely on Trías' dossier in *Anthropos,* p. 4.

With his vocation for theater, according to Trías, Wagner fulfills the humanistic or Faustian ideal as an actor would. "He never became all things, he simply acted them out and in the process testified to the bankruptcy of humanism." In the dialectical flux of history, Wagner finds a complement in Nietzsche, who, in Trías' words, "fulfilled the same ideal," except "in the realm of hallucination" (p. 103). Viewed as a concrete individual, Nietzsche "becomes all things" in his imagination, identifies himself with all historical figures, until he eventually finds himself; while Nietzsche, conceived as a cultural innovator, discovers his identity by reading others and writing (p. 111). Finally, in Thomas Mann, the age-old ideal of the soul to be all things has decayed into the tendency to daydream. If, as Trías suggests, Mann embodies the character of contemporary Europe, to what hope of self-affirmation can Europeans now cling? With a Nietzschean *amor fati,* Trías discovers in the decline of the West yet another lesson for life: inertia and reverie provide the individual with endurance tests as he faces the irrational forces of existence, so that he may emerge mature and fully human (p. 140).

A value-judgment underlies *The Artist and the City*: the greatness of a man is directly proportional to his versatility, his ability to assume new forms and to assert his identity in the process. The more varied the transmutations with which he affirms his uniqueness, the more universal he is. A *Deus occasionatus,* as Nicholas of Cusa called him, man becomes a creature of his own making, recreating himself in time. By constantly reconstituting himself, moreover, he immerses himself in the chain of universal being, lives in harmony with the universe. Trías conceives all being as the endless re-creation which all creation undergoes. He has derived this idea of ontology from his perception of the arts. With Nietzsche, he regards art as the most patent phenomenon of being. Accordingly, he has applied esthetic principles to being itself. Trías supposes that the principle of variation governs all art as well as all being. "The theme keeps taking on shape and richness, acquiring new determinations and concrete contours, unfolding wealth, 'es-

sence,' in the measure that it varies.'"[8] Every variation of a theme is unique. It is a re-creation of something created previously, yet it has acquired being in its own right. What does it matter if the composer of the variation lives long after the composer of the theme? Brahms's "Variations on a Theme by Paganini" have a being independent of Paganini's original melody. The same holds true for Trías' variations on themes of Plato, Pico, and Nietzsche. Re-creation throughout history obviates the danger of lifeless repetition. Errors of the past do not recur, while continuity engenders innovation in an unbroken series.

NELSON R. ORRINGER

University of Connecticut
March 1982

8. I have translated Trías' words from his unpublished manuscript of *Filosofía de futuro*, p. 115; "el Tema se va formando y enriqueciendo, cobrando nuevas determinaciones y concreciones, desplegando riqueza, 'esencia', en la medida misma en que se varía." On Nietzsche's idea of art see *Filosofía*, p. 114.

The Artist and the City

European Perspectives
A Series of the Columbia University Press

Prologue

I

Nothing appears to offend the modern sensibility more than centralism. In all of its forms, open or disguised, it brings with it a host of corruptions, tearing apart natural units, enforcing conformity, giving power to bureaucracy, increasing the red tape. The offense is most common in the political arena, but it is not easily appeased: it tends to spill over into other areas, where it always provokes the same charge, that local rights are being violated.

One area recently ravaged by the vigorous ideals of dispersion and decentralization is the book, that is, the Book as Unit or cultural artifact which, in response to external pressures generated by the self-interest of publishing houses, gives an artificial unity to that spontaneous, organic object called the Text. Whenever the dialectic is left to run its course, this provincialism goes on to question the secondary units as well, units like the chapter, the paragraph, the sentence, and the syllable. This absurd procedure has of course given rise to senseless babble, to the transcription of pure sounds, to the indiscriminate coupling of composition and scribbling, and to the completely blank page.

This book follows a criterion that mediates between the two extremes. It does not consider itself a Unit in the traditional sense, nor does it treat each chapter as a Unit. It cannot be said systematically to develop a central Thesis beneath which other, secondary

theses are ranked in hierarchical order. Neither can it be called an ad hoc or an a posteriori collection of separate essays that came into being in different places and at different times: it was thought out as a unified whole extending from the first page to the last, although the material within it is organized in a different, nontraditional manner. It rigidly upholds the ideal of unity while protecting the inflexible ideal of autonomy against nineteenth-century liberalism. The combination of these two ideals has created a book of interrelated essays in which several themes recur like leitmotifs. Like the evolution of the essays in the book considered as a whole, these themes unfold organically. They are born, grow, mature, and die. They develop, split apart, and come together again. I used this typically Wagnerian method in my book *Drama e identidad*. In that case it remained a secret, as Caution—a virtue one does well to heed now and then—had whispered in my ear that I could conveniently experiment under wraps. Consequently I thought up the mammoth theme of the differences between Drama and Tragedy, a theme with all the characteristics of a Central Thesis, in order to disguise my method, to which I referred only vaguely in the introduction. This book, in contrast, has no Central Thesis. There are only the individual leitmotifs which nevertheless work together, coordinating, counterpointing, and suggesting elusive readings, etc.

The reader can therefore begin with whatever interests him and read the essays in the order he prefers. He should know, however, that in my opinion they will leave him dissatisfied if read in this fashion, because I have tried to leave them dangling, tried to end each one as if it were an unresolved chord. Experience leads me nevertheless to assume that some readers will disregard my advice. For this reason I have written footnotes as if they were blazes indicating the path to follow. This reverses the footnote policy I followed in *Drama e identidad*, where I simply eliminated them. I am now following this infamously gratuitous, pedantic, academic usage in order to give my footnotes a different kind of meaning, to create a tighter, drier, more philosophical countertext that relates to the (more narrative) text "above" as the bass line relates to the melody.

If the reader wants to penetrate this book's every nook and cranny, therefore, he must read it not only from beginning to end but from "top" to "bottom," that is, he must read it horizontally and vertically. I know that the disruption of the linear flow of the text by systematic footnotes will displease many of you, and you may wonder whether to keep on reading or to abandon the text. Far be it from me to tell you what to do. It is good to question those practices which give us pleasure, because pleasure is often a euphemism for habit.

II

What is this book about? What does it set out to prove? What is its central idea, its unifying thread? Obviously these questions must remain unanswered, because they imply a preconceived notion about the Book as Unit, a notion that this text transcends. In any event I would do well in this introduction to give the reader a few tips on how to negotiate the maze in such a way that his sense of adventure is aroused. One way to do this would be to state a few of the hypotheses that turn up most frequently, providing a key to the narrative. There are quite a few of them, though, as mentioned above, and they are all interwoven in such a way that they themselves are the figure in the carpet, the very text itself. To give a list of leitmotifs would be unbearably pedantic, and as for presenting a brief summary of the story, the evolution of the thing, this would infringe on the reader's inalienable and always invoked right to be given a plot. I will therefore repress the urge to explain, canceling once and for all the meaning and purpose of these introductory remarks, which would seem to exist for the sole purpose of justifying their intrinsic pointlessness.

But at the very least the reader deserves an explanatory word about the title I have given the book, because, upstanding book that it is, it does have a title. I will simply say that from my imaginary inventory of leitmotifs I chose the title that ties together the greatest number of narrative threads. My decision was based on statistics: of all the titles I could think of, this one sounded the

best. It is also the title of one of the first essays, and these essays that make up the first part of the book are fundamental in that they lay the foundation for what in the second part amounts to "variations on a theme." I am also fond of the titles of the other two beginning essays: "Creativity and Desire" and "Man in Proteus's Likeness." I decided on the title of the second essay, however, with an eye to the work as a whole. Taken together, in fact, these three titles obviate any introductory remarks about narrative threads.

Methodology

A few remarks are in order regarding the methodology I have followed, that is, the scope and perspective of the following investigation. It is not a conspicuous, visible methodology, as this would go against the narrative requirements of the work. But it is more or less identifiably critical, in the permanent sense that Criticism has been understood since Kant. It is also historical in the permanent sense that History has had since Hegel.

The method traces a given phenomenon, such as the modern phenomenon of "Desire" or "Creativity," to the origin or logos that gave birth to it. This source is simultaneously the condition that makes possible the phenomenon's existence and the principle that determines its historical reality. The goal is to identify that original, previously existing space within which immediate, everyday phenomena become meaningful. The original space is the origin and progenitor of these phenomena. It is of course conceptual and as such necessarily integrated or capable of being integrated into a broader, more comprehensive meta-space. This meta-space is actually the objective being that exists outside the mind and underlies the objectivity of both Subject and Object. Within it thinking inflects and reflects itself, opening itself to the being outside itself. In so doing, thinking becomes systematized, developing a map of categories by which it takes its bearings in the world. Just as thinking is usually not synonymous with consciousness, this map need not be consciously recognized. On the contrary, it sets a course for

and directs the progress of consciousness and the correlative creation of ideas. Because the ideas that evolve from this topography are necessarily ideological, the method attempts to reach that critical or, if you prefer, "scientific" stage where the underlying reasons for the rise of ideologies become clear, and where ideologies can also be stripped of their claim to represent "the truth." In the eyes of the higher court, ideology is simply a mask, a paper tiger. It covers up the truth of its birth and development, hiding the circumstances that have made it what it is. Once it has obviated the critical-historical stage of its growth, ideology presumes to speak the truth for all eternity. It tries to legislate. As a consequence ideology rests on an ontology which is neither critical nor historical. It must elaborate a belief or faith. It is the eternal antidote and alibi of reason, the eternal lifeguard or rescuer of truth. It undermines both life and thought.

The only alternative to ideology is the order-giving Idea that points the way for life, thought, and action beyond the boundaries of itself, toward the future. It works of necessity with hypotheses, in the realm of the "what if," of the working utopia and the rational dream. The order-giving Idea is also the only alternative to nihilism, the inevitable outgrowth of all movements of critical unmasking. When faith and hope are lost the naive first movers of all actions lose their foothold. Life and action are not condemned by this, however. On the contrary, doing, being, and existing do not become meaningful until this change has taken place. No other approach can avoid cynicism, the other necessary consequence of critical reflection. Cynicism reveals the truth but walks away from it, refusing to obey the inner calling to change the world. It accommodates itself to the flow of things, leaving the world as it found it. It acts, in other words, along the lines of what already is. It is the necessary countermovement to Ideology's unacknowledged hypocrisy, but it is no more than that. Cynicism fails to present an alternative to belief. Like Nihilism, it often uses pessimism—the undervaluing of life and action—as an alibi.

More perhaps than at any period in recent history, the intelligentsia of today, as well as the political, business, labor, and gov-

ernmental castes, lean toward nihilism and cynicism. But this does
not mean that these are the only relevant stances that can be ra-
tionally maintained. On the contrary, we must revise our thinking
about rationality and action. We must view them as a broader and
more comprehensive phenomenon within which rationality plays
a necessarily skeptical role, thereby opening up a field of action
that is not obstructed by ideology, idols, or illusions, where our
actions are based on Enlightenment, Self-awareness and Reason.
In this way we can avoid the idealistic corollary of the nihilistic or
cynical notion that contemplation is our sole alternative, illusion
necessarily action's spur. The ideological belief that the world is
ruled exclusively by credos, commandments, and laws manipulated
by some malign spirit, perhaps even the Lord of Hosts, who sits
in his baleful supralunar heaven and acts through a hierarchy of
subordinates, makes us shake our heads in resignation before the
spectacle of the world. All beliefs are ideological: although ideology
seeks to distance itself from gods and theologies, it is itself a new
version of affirmative theology. Metaphysics is at work in the
equation God equals State equals System equals Money, which
expresses all of the ideology's fundamental concerns in their basic
configuration.[1]

One of this book's most important intentions, although not the
primary one, is to search for that a priori space which allows us
to identify the historical manifestations of the modern intellectual
state usually labeled Awareness, which is antithetical to both life
and action. With respect to the phenomena analyzed in my previous
book, *Drama e identidad,* especially the last two chapter-essays, what
follows is an attempt to achieve critical distance.

1. Fernando Savater examines this problem from a different angle in his excellent
Ensayo sobre Cioran (Madrid, 1975), one of the liveliest contributions to contem-
porary Spanish thought. This book is recommended to the reader who wants more
information on the subject.

PART ONE

From Plato to Pico della Mirandola

Creativity and desire: the heading may suggest to some readers a number of issues amply debated in recent years by radical philosophers in France, Germany, and America. This book obviously takes part in that debate. In order to provide an answer, however, it attempts to distance itself from the ideological and epistemological arena in which these questions are usually discussed, searching instead for the historical or even prehistorical roots of the debate. The approach should be understood for what it is, lest it seem surprising or even shocking: the problem posed by the much-sought synthesis of desire and creativity is here examined from a genuinely archaic perspective, in the strict sense of the word archaic. My interpretation of various Platonic texts, in particular the *Symposium* and the *Phaedo*, detonates a problem that involves something more than present-day philosophy and ideology. Because the realm of desire is separated, sundered, and alienated from the realm of creativity, and the subjective, mental world of eroticism is cut off from the public, objective world of labor, and because we experience this schism in our everyday lives, the issue bears on the very heart of our identity and our existence.

What happens when the synthesis of *Eros* and *Poiesis* implicit to classical Platonic philosophy breaks down?[1] What happens when Soul and City stop being interconnected, dialectical orders, instead

1. Unfortunately the semantic range of the Greek terms Eros and Poiesis is too broad and rich in nuance to be translated adequately as desire or creativity.

becoming separate, autonomous realms? When does the artist, the individual who is simultaneously erotic and poietic, cease relating to society and the city, that is, to his natural space and habitat? When does the City, an object that results from the artist's erotic creativity, establish itself as an order apart from Beauty and Art, subject to the naked principle of productivity unmediated by any eroticism at all? These questions indicate the kind of issues that turn up consciously and deliberately in the course of this work, but not systematically. They set the search moving toward the undefined relationship between the Artist and the City.

Unlike Plato's artisan, the artist does not restrict his work to a limited and clearly defined area. Rather than submit to the ideal city's unbending rules of the division of labor and strict specialization, the artist resembles Proteus in that he constantly varies what he does, at times changing his very being, to such an extent that he can be defined as someone who sets out to be and do all things. For this very reason the philosopher (Socrates) suggests that the artist be expelled from the city: in a metropolis where each individual is subordinate to a single activity and a single social role and no one can in any way alter his fate or reduce his sentence, the artist is always a focal point of subversion. Protected by a Praetorian Guard (the watchdogs), the philosopher-king safeguards this principle against all attempts to subvert it. The political and philosophical spheres thus appear to subjugate the productive social base, which consequently operates according to the principle of naked productivity, unmediated by any eroticism or poiesis.

Expelled from the city, the artist becomes convincing proof of the theory (the synthesis of *Eros* and *Poiesis*) that Plato invented without being able to give it concrete form (in the city). The synthesis remained theoretical, a thought or notion that could never take root in reality, precisely because of the artist's expulsion. Such a synthesis was only conceivable as a reality in the real world of Renaissance Florence, far removed from Plato's ideal republic. In Florence the artist became synonymous with humanity itself. Like Proteus, he is represented in the philosophy of that time as the being who lacks a clearly defined essence and identity. He can for

this very reason construct, create, make himself over into any identity. Pico della Mirandola's philosophy implicitly reunites the Artist with the City, and the synthesis that Plato could bring about in theoretical terms alone is here realized in the practical sense. The triple synthesis of *Eros* and *Poiesis*, Soul and City, Art and Society suggests a social order in which all men are artists, that is, individuals who are simultaneously erotic and creative. This does not imply, however, that the social hierarchy be crowned by a political and philosophical superstructure cut off from the erotic-productive base. When the triple synthesis breaks down, the psychic realm loses contact with the social realm: *Eros* no longer extends itself to any kind of creativity, and *Poiesis* bases and inspires itself in neither *Eros* nor Beauty. At this moment Desire steps in, Desire as a modern notion built on the previous schism of subject and object. Without the mediation of Creativity, Desire also loses touch with the object—the Good, the Beautiful—toward which it strives. If this happens the object that naturally corresponds to Desire seems eternally absent and independent. Desire can only be reunited with its object through the disintegration of the desiring individual in Death or Madness. Creativity, the modern notion that becomes the objective manifestation of Desire, then appears as a correlative development. But when this Creativity or Work loses contact with its origin, whether this be called the Good or the Beautiful, it suffers a fate analogous to that of Desire: it becomes a separate, autonomous realm, cut off from the psychic world of the desiring individual. Consequently it becomes a realm based on its own pointlessness, creativity striving simply to reproduce itself without rhyme or reason, production for production's sake. In this respect the end-point of its search, like Desire's, is Death, the frontier of waste and destruction that Creativity leads to when it turns in on itself.

1

Plato: Creativity and Desire

Where the idea of beauty reigns, there the law of life forfeits
its precedence. The principle of beauty and form does not
spring from the sphere of life itself; its relation to life is that
of a stern critic and corrector. It is indeed proudly
melancholic, and it is closely and deeply allied with the
idea of sterility and death.

Thomas Mann, "Marriage in Transition"[1]

I

Only a superficial reading of Plato's *Symposium* would narrow
it to the passage where Diotima, priestess of love, solemnly and
ceremoniously describes the ascending path of *Eros* that leads from
beautiful bodies to beautiful souls, from beautiful virtues to beau-
tiful laws, from beautiful laws to beautiful knowledge and ulti-
mately to the highest science of them all, knowledge of the Beau-
tiful. A hurried reading would tend to suppose that the object of
the ascent is "a wondrous vision, beautiful in its nature, . . . the
final object of all those previous toils."[2] The purpose of *Eros*, the

1. Thomas Mann, "Marriage in Transition," in Count Hermann Keyserling, *The
Book of Marriage* (New York: Blue Ribbon Books, 1931), trans. W. H. Hilton-Brown,
p. 250.

2. Plato *Symposium* 210e. Trans. W. R. M. Lamb (Cambridge, Mass., and Lon-
don: The Loeb Classical Library, 1975), p. 205. The initiation is gradual, but the
revelation is sudden and unforeseen.

goal of its pursuit and the reason for its caring, is that the soul possess the Beautiful in an act that has the nature of a vision. Now, in some of the stages of Eros's ascent to the Beautiful one can already see, reading the text carefully, that the goal is not as simple as what I have just described. Likewise, the act of possession is less limited than what it described above as vision, contemplation, *theoria*.[3]

He who would proceed rightly in this business must not merely begin from his youth to encounter beautiful bodies. In the first place, indeed, if his conductor guides him aright, he must be in love with one particular body, and *engender beautiful converse therein*; but next he must remark how the beauty attached to this or that body is cognate to that which is attached to any other, and that if he means to ensue beauty in form, it is gross folly not to regard as one and the same beauty belonging to all; and so, having grasped this truth, he must make himself a lover of all beautiful bodies, and slacken the stress of his feeling for one by contemning it and counting it a trifle. But his next advance will be to set a higher value on the beauty of souls than on that of the body, so that however little the grace that may bloom in any likely soul it shall suffice him for loving and caring, and *for bringing forth and soliciting such converse as will tend to the betterment of the young*; and that finally he may be constrained to contemplate the beautiful as appearing in our observances and our laws, and to behold it all bound together in kinship and so estimate the body's beauty as a slight affair. From observances he should be led on to the branches of knowledge, that there also he may behold a province of beauty, and by looking thus at beauty in the mass may escape from the mean, meticulous slavery of a single instance, where he must centre all his care, like a lackey, upon the beauty of a particular child or man or single observance; and turning rather towards the main ocean of the beautiful may *by contemplation of this bring forth in all their splendour many fair fruits of discourse and meditation in a plenteous crop of philosophy*. . . .[4]

The italicized sections clearly indicate that *Eros* is not soothed or appeased by either contemplation of bodies or souls fertilized by

3. The author uses the Spanish word *teoría* to indicate both theory in the modern sense and the Platonic notion of contemplation, or *theoria*. When the latter is clearly intended I have used the word *theoria* to avoid confusion—tr.

4. Plato *Symposium* 210a (p. 203).

beauty, or by the contemplation of beauty in all of its ideal purity. At best contemplation or *theoria* is a prerequisite or, better yet, a necessary ingredient requiring the presence of something else to become complete, something that somehow transcends or exceeds the theoretical instance. One could even say that *Eros* requires the possession of beauty through contemplation as a necessary condition or key ingredient for achieving its true goal, which is neither simple satiety nor something like theoretical possession. Rather, this possession or satiety points beyond itself toward the action or process referred to as fertilization, the process that makes procreation and birth possible in the above passage.

Like beautiful speeches and thoughts, beautiful rules and laws and beautiful children, beautiful cities and fields of knowledge are also engendered and born. *Eros*'s goal is not therefore to possess beauty through contemplation but rather "to beget and give birth in beauty." Through Diotima, Plato says quite clearly in an earlier section of the *Symposium*: "You are wrong, Socrates, in supposing that love is of the beautiful. . . . It is of engendering and begetting upon the beautiful."[5] One might object that this is a provisional goal, that in the final stage it will be modified and surpassed.[6] In the final stage pure *visual* contemplation would overwhelm creative activity. A reference to sight, for example the use of a visual metaphor, would validate this interpretation, showing that the entire process of begetting and creating would at the height of its ascent suspend itself in order to give way to the pure act by which the idea of the beautiful itself would be seen in an immaculate vision. If, as the *Phaedo* would have it, the soul is congenial to the ideas, and ideas are uncreated entities, immortal and in no way subject to movement, then the act of seeing, the most characteristic and essential property of the soul, is likewise an instance of eternal rest

5. *Symposium* 206e (p. 193). *Eros*'s characteristic activity is earlier defined as "begetting on a beautiful thing by means of both the body and the soul," 206b (p. 191).

6. This is the traditional interpretation. A detailed discussion of it can be found in Léon Robin, *La théorie platonicienne de l'amour* (Paris, 1964).

and repose and cannot conceivably give rise to any creative action whatsoever.

This static concept of the soul, and consequently of the ideas, is apparently modified in later dialogues, notably the *Phaedrus*.[7] In both the *Symposium* and the *Republic* the original doctrine of stasis appears alongside the second, dynamic doctrine. In the *Symposium* the use of visual metaphors seems to account for the leaning toward *theoria* and contemplation. In a passage of the *Republic* the entire ascent described in the *Symposium* is not only summarized but also modified in such a way that the sexual metaphors of touch, copulation, and marriage appear most appropriately to describe the instant when the soul takes possession of the object of its desire:

But might we not fairly plead in defence our account of the true lover of knowledge as one born to strive towards reality, who cannot linger among the multiplicity of things which men believe to be real, but holds on his way with a passion that will not faint or fail until he has laid hold upon the essential nature of each thing with that part of his soul which can apprehend reality because of its affinity therewith; and when he has by that means approached real being and entered into union (*migeis*) with it, *the offspring of this marriage is intelligence and truth; so that at last, having found knowledge and true life and nourishment, he is at rest from his travail?* (my italics)[8]

Touch, union, and copulation are the topics here, not sight, and they entail conception, labor pains, and birth. At issue is the individual's (the soul's) creation of a separate being out of itself, an otherness in which it transcends itself as an individual, as a self. Although the word *migeis* appears in the *Symposium*, its use as a

7. In particular *Phaedrus* 245c. "Every soul is immortal. For that which is ever moving is immortal; but that which moves something else or is moved by something else, when it ceases to move, ceases to live. Only that which moves itself, since it does not leave itself, never ceases to move, and this is also the source and beginning of motion for all other things which have motion." Trans. H. N. Fowler (Cambridge, Mass., and London: The Loeb Classical Library, 1977), p. 469.

8. Plato *Republic* 490a. Trans. Francis MacDonald Cornford (New York: Oxford University Press, 1964), p. 197.

sexual metaphor emphasizes the subterranean thinking that could eventually obstruct the strictly visual metaphor (whose metaphorical nature has occasionally been forgotten in the history of this tradition). We can now see to what extent the object of the soul's pursuit is not *exclusively* the contemplation of the Beautiful and how by the same token this kind of contemplation broadens and extends itself into a more inclusive and intimate act, which in turn gives rise to an act of creation or genesis—or, speaking Platonically, an act of *poiesis*.[9]

The early dialogue *Phaedo*, like the visual metaphor—whether or not it is appropriate—endorses the view that Plato's thinking is theoretical or logical. I would propose a reading of the same dialogue, however, which on the basis of the sexual metaphor would join *theoria* to a fuller, more fertile act. In this interpretation contemplation or vision becomes united with a process whose ultimate goal or objective is creation—the creation of beautiful speeches, beautiful laws, beautiful virtues, children, and sciences. Plato's all-encompassing notion of *Eros* allows us to extrapolate this metaphor to all areas of spiritual life and existence.[10] "Sexuality" consequently would appear to cover much more ground than simply carnal love. Plato understood *Eros* to be the origin of life, a kind of psychic engine, a notion that Freud attempted to recoup in his later works.[11] But far from defining *Eros* as simple *desire*—that is, the need and pursuit of beauty as an object simul-

9. See *Symposium* 205c for the double meaning of *poiesis* (creation or productivity and "poetry"), defined as the agent that brings *what does not exist* into *being*. The definition appears again in the *Sophist* 265b.

10. *Symposium* 205b-c. Before expanding his concept of *Eros* from the narrow domain of sex and love to designate other activities and ideas, Plato speaks of *poiesis*, which in the language of the time meant not only poetry but "doing," because of the nuances of the term.

11. Sigmund Freud, *Beyond the Pleasure Principle*, trans. James Strachey (New York: Bantam Books, 1967). *Eros* is that force which gives unity and cohesion to all things. Because it binds all things together it is the counterforce to the primary, preexisting power that Freud called "freely mobile energy." His thinking about the latter led him to hypothesize the death instinct (*thanatos*), to which *Eros* in the final analysis is subservient.

taneously present in and absent from the soul—Plato attempts to go beyond the concept.[12] *Eros* is not desire, that is, not *only* desire, because it is not satisfied by the possession or presence of what it lacks, be that the Beautiful or the Good. In other words, contemplation alone is not enough to guarantee satisfaction, not even if it brings about the self-satisfied, restful "pacification" of the urge (in this sense the Platonic notion differs from all forms of hedonism).[13] Fertilization is the goal of *Eros* and what essentially defines it. By extension *Eros* itself is the act of fertilizing, of creation. To summarize: Plato achieved a unified, synthetic concept of *Eros* and Creativity (*Eros* and *Poiesis*). Modern society has split them apart. The passage from Thomas Mann that introduces this section clearly

12. The notion is implicit in Lacan: *Eros* understood as *desire*, *desire* defined as the lack or absence of the primary, original object (the so-called "a-object"). By virtue of this lack the individual becomes "the one who lacks" and consequently initiates a frenzied search for the absent object, for which always changing substitutions can be made only precariously by means of *signs*. The pristine presence of Absence alone reveals Truth, but this presence is Death itself. Hence the close tie of Subject to Desire to Truth to Death. Lacan's thinking only makes sense when it takes the total divorce of subjectivity from objectivity as its working theoretical point of departure. Lacan's concept of desire is a lucid meditation on the historical and empirical situation that followed upon this divorce. Unfortunately it is never more than a meditation: because it does not make experience itself an object of critical analysis it becomes a mere reflection of experience and of course ends up hardening into an ideology. The opposite approach would be to develop a (scientific) *critique* of the *empirical* concept of Desire as the basis, for instance, of the Platonic notion of *Eros* as presented in the following pages. My essay on Goethe [chapter 4 of this book] examines Lacan's approach at greater length.

 The criticism I am here suggesting can be summarized as follows: the Individual is *not only* "subjected" to Lacan's Other: even before this it experiences the reality of otherness in the objective realm of society and work. I am suggesting a synthetic union of subject and object (soul and society) from which a double sphere can be analytically abstracted. Only when the abstraction becomes real does the Other appear as object of the subject. Correlatively, Capital appears as subject of the object.

13. This interpretation is implicit in Marcuse, for whom "pacification" and "rest" are the goals of *Eros*. He ignores the existence of any term that mediates between alienated work and "pleasure" (the principle of reality and pleasure), that is, artistic creativity, which he equates with hedonism.

demonstrates to what extent this rupture or fragmentation is now sanctioned.[14]

How do we explain the fertile, creative, "poietic" nature of *Eros*? The text says that *Eros* seeks the permanent and stable possession of all that is beautiful and good. Because it is fundamentally "imperfect" it is neither immortal like the gods nor mortal like men. It is a genie or demon, by nature an arbitrating being, and to this extent comparable to the demigods and the immortal heroes. To take permanent, stable possession of its nature, then, it relies not on beatific visions or eternal repose at the side of the idea of beauty but the permanent and stable tendency to create. By virtue of its fertility it endlessly reproduces itself, thus occupying a position midway between the haphazard process of birth and corruption that characterizes the physical world and the stasis of pure beatific vision that characterizes the immortals. As a subject of eroticism the soul thus becomes an eternal, unchanging, undying principle. It is like the ideas except that it acquires its attributes through perpetual motion. Plato presents the doctrine of the soul in this form in the *Phaedrus* and the *Laws*, Book 10. The doctrine of ideas also undergoes a statutory change from *Parmenides*, the *Sophist*, and the *Phaedrus* on, when movement, difference and nonbeing are added to the inventory. The passage from the *Symposium* under discussion here is perhaps the first tentative contribution to the notion of stasis developed in the *Phaedo*, where this important modification of the doctrines of the soul and the ideas takes place. In a word, the notion of *creative Eros* prefigures the doctrines of the soul's eternal mobility and the dialectical relationship of the ideas.

14. See my essay on Thomas Mann [in chapter 8 of this book]. Mann, a disciple of Schopenhauer, has the merit of having searched for something to mediate between the realms of Life and Death and found it in artistic creation. He merely corrected Schopenhauer's conclusions, however, without criticizing their theoretical basis. Schopenhauer's notion is in fact that Beauty and Death are conjoined and that Beauty has been divorced from the realm of "civil society" (the world of business and labor). At any rate, Mann the novelist in a certain sense goes beyond these premises while providing the critical tools necessary for understanding their historical origins.

What does the synthetic union of *Eros* and creativity achieve? Nothing less than immortality, that which mediates between the eternal youth of the gods and the harsh cycle of aging and rebirth in creatures in the state of becoming.[15] Thanks to its fertility, *Eros*, son of *Poros* (Abundance, Generosity, Resource) and *Peinia* (Want, Destitution, Need) gains access to the kingdom of the immortals.[16] *Eros*'s fertility assures the propagation of the species, nurturing the ideal of permanence in the heart of pure becoming. It makes possible the incarnation of idea and genus in the physical world. *Eros* makes the ideas something more than transcendent entities: they become the source of immanence, genera in the broadest sense of origin and parents of numerous progeny.

This book began by questioning the assumption that the ascent of *Eros* ends in an utterly transcendent contemplative state. I argued that contemplation, abetted by visual metaphors, was rather than a standard or a result simply a condition of the ascent and therefore a kind of creative process as well. The path of *Eros* does not lead to an *illuminatio*, or at least not to this alone: a careful reading of the text reveals that even the final enlightenment touches off a productive or creative process. It is true that the initiate "suddenly will have revealed to him, as he draws to the close of his dealings in love, a wondrous vision, beautiful in its nature."[17] But of course what is revealed in the vision is *idea*. In fact idea suggests vision: both words share the same root, *vid*, in Latin *videre*, as does the Greek word *theoria*.[18] Further proof: is not the process of knowing the ideas compared to the process of seeing? In the *Republic*, the knowing individual has the attributes of an eye (the eye of the soul) which perceives visible objects (ideas) as a function of light. Light is the "third thing" that links the sense of sight and the power of

15. *Symposium* 206c.
16. *Symposium* 202e.
17. *Symposium* 210e (p. 205).
18. In *Platos Lehre von der Wahrheit* (Berne, 1954), Martin Heidegger is concerned solely with the actuality of idea. Gerhard Krüger's brilliant remarks on the *Symposium* in his *Einsicht und Leidenschaft* (Frankfurt am Main, 1939) are much closer to my hypothesis.

being seen. It is dispensed by the Sun, the solar deity that "is responsible for making our eyes see perfectly and making objects perfectly visible."[19]

This passage of the *Republic* lays bare the entire ensemble of metaphors tailored to the notion of sight, which in turn sustains the many allusions to the process of knowing that appear in Plato's dialogues. One might say that this visual repertory is "Apollonian." But we have also come across another stock of metaphors supplying a different kind of repertory, an orgiastic, Dionysian repertory in which Nietzsche's *Zwang zum Orgasmus* beats with unusual insistence.[20] This second stock of metaphors is also present in the whole of Plato's canon. On this level the dialogues are a consummate synthesis of the Greek passion for representation or the figurative mode that finds expression, epistemologically, in the very notion of idea (the most faithful translation of the term would be Figure or Form) and the rich outpouring of energy that characterizes the pansexual fervor of the underground gods, especially Dionysus. These deities secure immortality and the propagation of the species,

19. *Republic* 507a (pp. 218–19).

20. In a passage of "The Will to Power as Art," included in his would-be opus *The Will to Power*, Nietzsche reinterprets the notions of "Apollonian" and "Dionysian" originally developed in his early work, *The Birth of Tragedy*. The characteristic drunkenness of the Dionysian state is an "orgasmic compulsion," and its goal is to beget, create, fertilize, give birth. The notion is basically Platonic. Far from proving once again Nietzsche's supposed "positivism," the physiological metaphors in fact are a reworking of commonplaces from Plato and other Greek thinkers. To use Heideggerian jargon, this is another aspect of Nietzsche's "origin-ality." Heidegger, for his part, has vacillated on this point, as he has on so many others. See his *Nietzsche*, vol. 1 (Pfullingen, 1961). Nietzsche understands artistic phenomena in physiological terms: born of the fertilizing orgasmic compulsion, art is a sign of "ascending" vitality. Ascent and descent differ from each other as fertility differs from sterility. Decadent art is defined as orgiastic activity *without issue*. In the interpretation he usually gives of the Dionysian spirit, Thomas Mann apparently forgets this aspect of the question. Nothing could be further from Nietzsche's thinking than the "Dionysian-orgiastic" aesthetic of his self-styled followers, one of whom, especially in his early "pessimistic" stage, was by his own admission Thomas Mann.

if only now and then, epidemically, by canceling the *principium individuationis*.[21]

The synthesis of vision and copulation, of contemplation and climax, of idea and fertility, can be seen in the following passage, where both linguistic paradigms come together freely, smoothly, and unobtrusively:

In that state of life . . . a man finds it truly worthwhile to live, as he *contemplates* essential beauty. . . . Do but consider . . . that there only will it befall him, as he sees the beautiful *through that which makes it visible*, to *breed* not illusions but true examples of virtue, since *his contact is not with illusion but with truth*. So when he has *begotten* a true virtue and has reared it up he is destined to win the friendship of Heaven; he, above all men, is immortal.[22]

In terms of sight, the goal here is sheer understanding, but it is also the creation or begetting of true virtues. This form of creativity implies not only virtue but also contact, copulation, matrimony with the Beautiful. By this synthetic joining of *theoria* and copulation a man becomes immortal, if only for that fleeting moment in which the meaning of his entire life is revealed to him (a phenomenon fully explored, in Renaissance philosophy, by Marsilio Ficino).[23] This momentary vision is not in itself sufficient, however, to reveal this truth: the process that renders the newly accrued capital productive is also important. It is a meta-visual process, in a strict sense erotic, which opens the soul to self-transcendence. In the *Phaedo*, Plato's so-called theorizing affirms that "the philoso-

21. If one takes into account the ideological corrections of Nietzsche's mature work, this interpretation of Plato can be seen to be at the root of his thinking in *The Birth of Tragedy*.

22. *Symposium* 211d (pp. 207–9).

23. In his *Pagan Mysteries of the Renaissance* (New Haven: Yale University Press, 1958), Edgar Wind presents one of the loveliest, most suggestive and accurate interpretations of the Florentine Academy's philosophy, especially Ficino's. Wind brings out the glorious synthesis of mysticism and hedonism that characterizes the Academy.

pher must die" in order to achieve immortality through the utterly transcendent contemplation of the ideas. In the *Symposium,* as Plato's approach becomes more subtle, sensible, humane, and truthful, *Eros* is said to reach the same goal of immortality through creative, "poietic" activity, that is, through glory, fame, and renown, by begetting children and speeches, through making new laws and the practice of public and private virtue, through the cultivation of the arts and the advancement of science, through education and, above all, politics.[24]

The confusion that has supported the claim that Plato's thinking is primarily theoretical is visible in most of the traditional commentators, including some of the "moderate" critics like Léon Robin. Such critics are too cautious in their attempts to disavow this point of view. To the extent that they underemphasize the importance of *Eros*'s creative role they grant only secondary importance to the pertinent texts and thereby limit the meaning of *Eros* to the modern notion of Desire. *Eros* is consequently understood primarily as a lacking or loss, and its instability must then be carried over into Pure Idea. The Platonic notion of *Eros* nevertheless stands midway between Desire and Idea. It is not appeased by work or action, visions or contemplation. The true entelechy of the process is not reached in direct contemplation of Idea but in creative activity. It is no accident that before defining *Eros,* in the *Symposium,* Plato relies on the term *Poiesis,* which he generically defines as the movement from nonbeing to being.[25] Entelechy is reached, then, by the synthetic union of the notions expressed by these two words, *Eros-Poiesis.* This means that the erotic impulse can only come to fruition in the act of creation or production that generates *works.*

Both *Eros* and *Poiesis* are points on the line that extends from nonbeing (the material world) to being (the world of the ideas). The erotic urge leads the soul from matter to Idea, while the poietic urge requires the soul to descend from the state of contemplation

24. *Symposium* 208b.
25. *Symposium* 205b.

into the "kingdom of shadows," so that it can infuse the material world with the paradigms it has observed in contemplation. The erotic-poietic process therefore culminates in the work of art or "technique," the product of this demiurgic act or *techne*.[26] The work of art derives from the soul's passage through Beauty: without the erotic urge and the infusion of Beauty into the world, made possible by *Eros*'s creative nature, it would be impossible. The *artist* executes the erotic-poietic plan. The *city* is his work.

II

In the *Phaedrus,* in the third discourse on the enamored soul, Socrates speaks of "the fourth kind of madness." One arrives at it by remembering the Beautiful, stimulated by any material object capable of evoking the memory. Rapt in contemplation, the soul experiences

a recollection of those things which [it] once beheld, when it journeyed with God and, lifting its vision above the things which we now say exist, rose up into real being. And therefore it is just that the mind of the philosopher only has wings, for he is always, so far as he is able, in communion through memory with those things the communion with which causes God to be divine. Now a man who employs such memories rightly is always being initiated into perfect mysteries and he alone becomes truly perfect: but since he separates himself from human interests and turns his attention toward the divine, he is rebuked by the vulgar, who consider him mad and do not know that he is inspired.[27]

26. *Techne* brings to light the powers of virtues (*dynamis*) hidden within nature (*physis*). In this respect the artist excercises a "maieutic" function with regard to the city, allowing nature to "come to life" in the city. It is nevertheless true that Plato's notion of *techne* is already divorced from *physis*. This is especially clear in the *Laws*, Book 10, where Soul and Nature are shown to be divorced, Nature transformed into Body (inert objects) that can only be brought to life by the extrinsic intervention of Soul. The split is not limited to this: it finds a corollary in the transformation of the city into a technical object once its original connection to Nature is severed.

27. *Phaedrus* 249c (p. 481).

This new version of *Eros* that appears in the *Phaedrus* complements the *Eros* of the *Symposium*. The desire for beauty, the urge to possess beautiful things, is here a kind of divine madness. In the grips of it the individual loses self-control and acts as if he were insane. It is not clinical insanity, however, but an ex-centricity caused by the god that has taken him over, carried him off and possessed him. This god is none other than the idea of the beautiful.

Eros is madness, then, the sublime madness that Plato calls *Theia mania*. Love links itself intimately with this kind of derangement in which the individual loses his unique identity. At the same time the individual cannot attain the object he desires, that is, the Beautiful, without going mad. The danger of the Beautiful, then, is that it leads the seeker to the very brink of insanity and death. The soul cannot stand in direct contemplation of it, as in this state he "gives himself up to pleasure and like a beast proceeds to lust and begetting."[28] Rather, he must first undergo lengthy rites of passage and apprenticeship.[29] An idea that was to flourish in Romantic and Postromantic poetry appears for the first time in the *Phaedrus*: the notion of beauty as a terrible state of possession, as an "intimation of awesome power that man is able to bear" (Rilke), a goddess who everywhere sows prosperity and disaster (Baudelaire) or a being inexorably associated with death (Von Platen, Thomas Mann):

> He who sees beauty with his eyes
> Is already bespoken to death.[30]

As early as Plato, then, the Beautiful forms an awesome circle with its sisters madness and death. This is why the philosopher must die (*Phaedo*) or go mad (*Phaedrus*) in order to experience it. We ask: what is different or unique about Plato's thinking on this score? What, rather, does modern thought, especially since Romanticism, present as new or different?

In Plato the soul's experience of self-loss, derangement, and death

28. *Phaedrus* 251a (p. 487).
29. Ibid.
30. In Thomas Mann, "Marriage in Transition," p. 250.

is simply a phase, a stage of life. It is very much like a rite of passage that fulfills a necessary function in the learning process. But it is in no way an end: it is a means. One can only embrace the Beautiful by obeying the erotic urge, which implies derangement and death. And yet it is necessary to go beyond that stage, to die the very same death and suffer the same derangement as part of the resurrection in which the soul is truly reborn by descending from contemplation to action.

The soul in effect prolongs the phase of the divine madness by fertilizing other souls and other beings with the seeds of its own erotic experience. The erotic process described in the *Phaedrus* ends with such an act of fertilization, by means of words:

when one employs the dialectic method and plants and sows in a fitting soul intelligent words which are able to help themselves and him who planted them, which are not fruitless, but yield seed from which there spring up in other minds other words capable of continuing the process forever, and which make their possessor happy, to the farthest possible limit of human happiness.[31]

Only this process by which *Eros* fertilizes others, through education, assures the immortality of the soul. Madness and death are not so much events that make the absolute purity or spiritualization of the soul possible, as the *Phaedo* suggests, as means that qualify the productive process in such a way that the finished work is good and beautiful, that is, somehow *artistic*. The philosopher must go mad or die not in order to lose himself in pure, idle contemplation of Idea but with a view to returning to the life of men, in the city, once he has achieved his ascent.

Eros can therefore be said to experience a *double transcendence*:

1. The transcendence that leads the soul through madness and death to the Beautiful.

2. The transcendence that leads the soul from the peak of its ascent to the world of men, to the city.

31. *Phaedrus* 277a. See Léon Robin's brilliant observation, in the work cited above, that the ultimate educational purpose of the *Phaedrus* is revealed in the closing discussion of the creative power of words.

Eros also knows a *double ecstasy*:

1. The ecstasy of ascent, which we may call the *mystical way*.
2. The ecstasy of descent, which we may call the *civic way*.

The task of *Poiesis*, be it artistic, demiurgic, or technical in the Platonic sense of *techne*, implies this necessary double activity. In giving his work shape as a citizen, the artist must also walk this double path.[32]

In the modern age, that is, since Romanticism—the necessary corollary of "bourgeois industrial civilization"—this double activity has been smashed apart, and the two separate halves have turned their backs on each other. As a consequence,

1. Madness and death are no longer means to attain an awesome but alluring end. *Todeslust*, the "lure of the abyss," becomes the

32. My thinking about the notion of art, the nucleus of a future Aesthetic, rests on the two-part synthesis suggested by Platonic philosophy:

 1) The synthesis of Soul and City.
 2) The synthesis of *Eros* and *Poiesis*.

At bottom the two syntheses are obviously connected, acquiring concrete form whenever each and every one of the constitutive elements expressly refers to the transcendent source, the Good, which is synonymous with Truth and the Beautiful. The diagram below shows the structure and dynamics of these relationships, which are the structure and dynamics of art itself:

	Subjective Realm	Objective Realm
Set of Transcendent Phenomena	The Truth, the Good, the Beautiful	
Set of Immanent Phenomena	Soul	City

The arrow connecting Soul to transcendence marks the course of *Eros* (ascent), while the arrow that goes from the Good to the City traces the course of *Poiesis*. We should not forget that *Poiesis*, in the form of poetry, "comes from on high" through inspiration and rapture. As soon as this "inspiration" takes root in the objective realm as word or shape, however, it becomes an instance of *poiesis* in the broad sense of the act that brings "non-being" into the "light" of being. "Non-being" is, on the one hand, the shadowy, cavelike world in which the artist works. On the other hand, because it is "beyond essence" it is synonymous with the Good itself.

The second arrow, connecting the City to Soul, indicates the dialectical nature of the process.

ultimate frontier of experience and death the final end of all love. The notion of "romantic love" comes about as a consequence, and art and aesthetics become disconnected from the sources of vitality and creativity, disconnected, too, from the everyday realities of social and urban life.

2. Correlatively, creativity loses its fertile link to erotic passion and the Beautiful, degenerating into alienated work that produces works devoid of quality.

It is therefore accurate to state that the modern notions of *Desire* and *Creativity* come into being after this schism has taken place and as a result of it.[33] They are the ideological manifestations of that act by which the Platonic synthesis of *Eros* and *Poiesis* is destroyed

33. The diagram below gives an approximate idea of the dynamics of this schism:

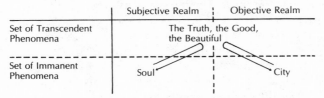

As can be seen, there is no real access to transcendence here. Instead of attaining Truth, the Good, or the Beautiful, Desire is limited to knowing Madness and Death (that is to say, the presence of Truth as Absence). The object it seeks therefore does not and cannot make itself known. This "failed" access can be called "empty transcendence." The soul does not find what it is looking for and the city, lacking a basis upon which to build, grows and reproduces itself without the guidance of either Truth or Beauty, that is, without any standards of quality.

It is interesting that the diagram of Desire's trajectory virtually duplicates Lacan's. In fact neither subject nor object achieves transcendence: they are shut off from it and withdrawn into immanence. The clear awareness that the other realm exists, however, gives rise to the attempt to transcend: this is the inevitably frustrated trajectory of empty transcendence. We might also say that the creative realm, like Freud's *Eros*, falls under the sway of *Thanatos*. It is no surprise that creativity, spurred on by the ideal of constantly surpassing itself in quantity of production (creativity's goal in this case is always to "make more"), seems to have a "growth limit": once it reaches its limit it simply falls back on itself. The superfluous products that result from this activity must then be absorbed by the powers of destruction, either directly, in the war machine, or indirectly, in the "planned obsolescence" of consumer products.

and broken down into the separate realms of the private love and public creativity, the "spiritual" realm of art and the "material" realm of social activity (economic and industrial activity), the subjective domain of desire and the objective domain of productivity. The most penetrating and responsible thinkers and writers of the modern age have tried to restore the synthesis. Because they must begin by experiencing the schism, however, they are faced with the necessity of presenting the synthesis as a future task. As in Marx and Nietzsche, it becomes an ideal state of affairs, a *working utopia*, a *rational dream*.[34]

In Plato both avenues are not only necessary, they are inextricably entwined. Without Desire, Creativity degenerates into simple production, lacking both Beauty and Quality. The beginnings of the schism are already to be seen in Plato's social model, which reflects a fundamental empirical distinction between *banausia* (the work of artisans and slaves) and *poiesis*. Similarly, without Creativity, *Eros* is reduced to love or passion that lacks any objective social dimension. The true goal of this kind of individualistic or "romantic" love is madness and death. This is why, since Romanticism, the total identification of *Eros* and death has supplanted the relationship described by Plato. This dangerous association is evident as early as Goethe's *Young Man Werther*, whose protagonist is also estranged from the objective world.[35] In this concrete form Death somehow bridges the gap or chasm created by the separation of the subjective realm of desire from the objective realm of creativity. Although *Eros* thereby becomes the source of life, it is ultimately subject to *Thanatos*. This relationship is apparent from Schopenhauer to Freud and Thomas Mann: death is the portal of transcendence that ushers

34. For Nietzsche the Superman embodies the synthesis of Love and Creativity. In *Thus Spoke Zarathustra* Love is defined as superabundance rather than lack. It is the basis of all creativity. It is also the will to power, insofar as the will to power is also for Nietzsche the will to create.

35. In my essay on Goethe [see chapter 4], I illustrate the extravagant behavior of the soul adrift in the monad of subjectivity, that is, *Desire*. Referring to Goethe's career I also show that salvation, if it is to be found at all, is found in *Poiesis*. Only through creativity and social action can the Individual pull himself out of the emotional rut that Desire inevitably leads to.

the individual into the beyond. Existentialism is merely a reworking of this commonplace born of Romanticism and bourgeois industrial society.[36] The modern urge to experience beauty arises, then, in a context in which uncontrolled creativity is blindly given over to frenzied production in ever greater quantities. Madness and death are its entelechy, its goal. This urge is of course Desire: the urge to attain an ultimately defective object. It can only be satisfied by death, its sole master. Our personal, social, and historical experience all point to this schism between Desire and Creativity: the modern individual experiences the "foundation of his existence" as an "alien power" because he cannot use it to consummate his erotic needs. Quite the contrary, the foundation of his existence presents itself as an obstacle to his erotic fulfillment with which he must constantly negotiate and compromise.[37] Lacking contact with the subjective world of eroticism and aesthetics, the objective world is governed by the absurd principle of raw production.[38]

Plato arrived at a conceptual synthesis of this duality, but he did not succeed in carrying it over into concrete reality. The following essay attempts to explain why he could not possibly have succeeded.

36. In this sense Heidegger is an ideological reflection of a schismatic culture. For Heidegger the individual can constitute himself as Subject and thereby commit himself to *being* only by plunging into the anxious presence of Absence (Death).

37. For this very reason Freud's dialectical notion of mediation is based on the necessarily nondialectical notion of *transacting*. This in turn dictates the necessarily per-verse nature of Desire.

38. Both this essay and the book as a whole assume the synthetic unity of art and society or the city, despite the fact that in modern times this unity disintegrates into "art for art's sake," on the one hand, and society ruled by nonaesthetic principles on the other. My position on this is similar to that of Xavier Rubert de Ventós in two outstanding works, *El arte ensimismado* and *Teoría de la sensibilitat*.

2

Plato: The Artist and the City

I

"My notion is, said I, that a state comes into existence because no individual is self-sufficing; we all have many needs."[1]

From this initial premise Plato goes on, in the *Republic*, to populate his city with people divided into groups according to the specific needs of the whole: clothing, food, and shelter. Farmers, artisans, and merchants pass before the readers' eyes. They are the foundation of the city, upon which in a later section of the dialogue Plato builds the superstructure of a government protected by "watchdogs" (the Praetorian Guard of the philosophical monarchy), with the philosopher-king or philosopher-tyrant at top.

The city is unified by principles and statutes that equally govern each and every sector. Plato makes constant and at times obsessive reference to them: "ours is the only state in which we shall find a shoemaker who cannot also take command of a ship, a farmer who does not leave his farm to serve on juries, a soldier who is not a tradesman into the bargain."[2] This rigid specialization of labor into sectors and occupations is based on the philosophical premise that "there are innate differences which fit [different people] for different occupations," that "no two people are born alike."[3] Consequently, "everyone ought to perform the one function in the

1. Plato *Republic* 369b (p. 55).
2. *Republic* 397e (p. 56).
3. *Republic* 370a-b (p. 56).

community for which his nature best suits him."[4] In the basic occupations of this society, therefore, every individual "is what he is," and his identity is essentially determined by his job, trade, or craft. He "is what he is" (cobbler, farmer, sailor, artisan) once and for all. He "is what he is" by nature and ability, and the attributes which define him and set him apart never abandon him, apparently, in the entire course of his life.

Justice, one of the principal themes of the dialogue, appears in this light to be the virtue that assures each thing and each individual of being itself and nothing else, making certain that everyone settles in where he belongs and conforms to the limit established by custom, occupation, and individual character.[5] Every man has his assigned place in the Platonic society. It is a specific and unique place. The occupation of cobbler, physician, or merchant belongs inherently, specifically, and decisively to the individual, and there is nothing else that belongs to him. Nothing is more offensive to the Platonic vision of the city than the Protean figure of the man engaged in diverse activities and occupations. As will be seen in the following essay, the antithesis of Plato's vision of urban man as presented in the *Republic* paradoxically appears in the period of Platonism's most spectacular success, that is, in the heart of the Italian Renaissance, especially in Florence. There is nothing more opposed to Plato's rigid social ideal than the "uomo singulare" and "universale" as represented by Alberti, Leonardo, Lorenzo de' Medici, Federico de Montefeltro, et al.

II

A city with these characteristics should by rights entrust itself to a deity associated with the principles of identity and rigid spe-

4. *Republic* 433a (p. 27). Also 370.

5. "You remember how, when we first began to establish our commonwealth, and several times since, we have laid down as a universal principle that everyone ought to perform the one function in the community for which his nature best suited him. Well, I believe that that principle, or some form of it, is justice." *Republic* 433a (p. 127).

cialization of labor. Nothing could be further from this than to imagine that "the gods, though they do not really change, trick us by some magic into believing that they appear in many different forms."[6] The proper deity could never conform to Proteus and Thetis as the poets describe them, for instance, "wandering to and fro among the cities of men, disguised as strangers of all sorts from far countries."[7] On the contrary, the deity must be "a being of entire simplicity and truthfulness in word and in deed. In himself he does not change, nor does he delude others, either in dreams or in waking moments, by apparitions or oracles or signs."[8] It embodies, in other words, the attributes of Idea as presented in the *Phaedo* and the *Symposium*, as well as the *Republic*: simplicity, immutability, self-consistency, eternity, stability, and self-sufficiency.[9]

Plato's society, founded on a rigid specialization of labor that locks each individual into a single occupation and social stratum and thereby assigns him a fixed identity, finds its epistemological and theological support and justification in the theory of the immaculate ideas and the doctrine of an utterly pure and immutable deity.[10] Plato conceives of his society, like the ideas and the Deity, according to the categories of Sameness, Rest, and Being, although

6. *Republic* 380d (p. 73).

7. "If so, my friend, the poets must not tell us that 'the gods go to and fro among the cities of men, disguised as strangers of all sorts from far countries; nor must they tell any of those false tales of Proteus and Thetis transforming themselves, or bring Hera on the stage in the guise of a priestess collecting alms for 'the life-giving children of Inachus, the river of Argos.' Mothers, again, are not to follow these suggestions and scare young children with mischievous stories of spirits that go about by night in all sorts of outlandish shapes. They would only be blaspheming the gods and at the same time making cowards of their children." *Republic* 380d (p. 73).

8. *Republic* 382c (p. 75).

9. In the "precritical" dialogues (those written before the doctrines of the ideas and the soul were revised in *Parmenides* and *Phaedrus,* respectively) these attributes are also applied to soul, at least in its highest manifestation, as intelligence, because the soul is made of the same stuff as the ideas.

10. In *The Open Society and its Enemies* (Princeton: Princeton University Press, 1963; 4th ed., rev.) Karl R. Popper points out the "ideological" nature of the theory of ideas in a quite convincing, if tendentious, way.

in the *Sophist*, a late dialogue, the same categories exist side by side with their opposites: Otherness, Motion, and Nonbeing.[11] Because they subvert these established principles, Proteus and Thetis as they are presented by the poets are by contrast spurious representatives of godliness. They conform to the *eidola* rather than to Idea: they do not participate in Being, Rest, and Sameness but in Nonbeing, Motion, and Otherness. They must be expelled from the pantheon because they contravene any social order based on the specialization of labor and the identity of work and occupation. Instead, they endorse quite a different principle, backing the representational artist as opposed to the artisan favored by Plato.[12]

A complex, two-faced deity challenges the simple god that is the object of the philosopher's contemplation and the justification of Plato's society, founded on the identity of each individual with his work and occupation. This Protean, chameleonlike deity, worshipped by the representational artist, is also the basis of a society diametrically opposed to Plato's, a society in which each individual is always someone other than himself and each soul is both itself and its "other." In this society all men and all things considered individually or as a whole are simultaneously each and everyone or everything else. In this context mimesis becomes the method by which we can clarify man's propensity to be something other

11. Francis M. Cornford's *Plato's Theory of Knowledge* (London, 1952) contains a magnificent commentary on the theory of the genera as elaborated in the *Sophist*.

12. Regarding the difference between *eikon* (copy, the artisan's work that represents the ideas in the physical world by the proper practice of *mimesis*) and *eidola* (image or simulacrum, the dramatic artist's work which achieves mimesis through simulation) see Deleuze's outstanding chapter on Plato in the appendix to his *Logique du sens* (Paris: Éditions de Minuit, 1969). In the present essay I am attempting to demonstrate that there is a no-man's-land between the "good artisan" and the "dramatic artist" that can be occupied by the *creative artist* (a figure quite absent from Plato's inventory). The creative artist renders useless any reference to the idea-model: insofar as he produces objects, his standards are *material*. He differs from the dramatic artist in the same sense, in that he creates things, not mere evocations. My reflections on the theory of imagery (simulacra) and evocation are therefore guardedly critical. In the final analysis, all evocations and simulacra exist "for-the-sake-of-someone," regardless of how "decentered" that someone may be. Deleuze's approach therefore presupposes an underlying subjectivism.

than himself, a propensity nourished by false images from mythology and theology: the problem is that through imitation "one becomes oneself like someone else in speech and appearance."[13] Homer, for example, alters his identity as narrator when he lets other "characters" who appear in the narrative (Achilles, Ulysses, Hector) speak "for" him. If Homer continued to speak "as himself and not as if he were Chryses," he would not be "telling his story by way of dramatic representation" but rather setting it forth "in simple narrative."[14] Epic poetry is an ideal complement to this type of *mimesis*, but tragedy and comedy are even more appropriate, as in these genres the "author" himself (that is, the Self) hides himself in otherness, thus clearing the way for the "masks" to circulate.[15] Insofar as they undermine the social order based on the principle of identity and the specialization of labor, the artist's or poet's work is inspired by principles quite antagonistic to the philosopher's or the ruler's. This is why Plato wonders if there is any place for the artist in the city or if, on the contrary, he should be expelled from it. He concludes, "Perhaps the answer follows from our earlier principle that a man can only do one thing well." This relates

13. *Republic* 393c.

14. *Republic* 393d (p. 81).

15. Readers acquainted with my *Filosofía y carnaval* (Barcelona, 1970) will here recognize a leitmotif common to that book and the present essay: the notion of the carnival and the mask. What in the earlier work was but a preliminary sketch I am here attempting to develop from a different point of view. In *Filosofía y carnaval* I studied the problem of subjectivity from the vantage point of *madness* (otherness, fragmentation). This in turn led to the question of *masks*. The direction of my investigation was basically the same as Heidegger's, although Heidegger, more "Protestant" in this respect than baroque or Latin, speaks of *Death* instead of *Folie*. The investigation reveals that an "evil" or empty transcendence results whenever the necessary mediation of subjectivity in the realm of immanence is lacking beforehand. This mediation refers to the objective realm of society and production. Thanks to Lacan's *intersubjective* approach the subjective realm does not remain covered up. Intersubjectivity speaks of objectivity from a point *within* the Individual. "Free objectivity" (the realm of society and production) becomes what is truly "free otherness," however, in respect to the *Différence* to which the Individual finds himself "subjected."

directly to the problem of representation, since "no man can successfully represent many different characters in the field of art or pursue a corresponding variety of occupations in real life."[16] Plato eventually adds many qualifications to this harsh assertion, but they do not significantly alter his original notion.

III

The following diagram is based on these Platonic notions. The correspondences between the various social, epistemological, and theological categories can clearly be seen. At the same time, the philosophical option that Plato chose is distinguished from the option he rejected.[17] It is of course an approximation.

(+)	(−)
Simple Deity	Proteus, Thetis
Immutable Idea	Eidola
Being–Rest–Sameness	Nonbeing–Motion–Otherness
Philosopher king	Representative artist (sophist)
Social realm (in the	?
Republic and the *Laws*)	

In the *Phaedrus,* the *Parmenides,* and the *Sophist* the above analysis is questioned. The *Sophist,* for example, attempts to discover a term that mediates between the "Friends of the Forms," represented by the (+) column, and the "Friends of Matter," represented by the (−) column. Being, Rest, and Sameness consequently join Nonbeing, Motion, and Otherness to form the total set of ultimate genera. At the same time, however, the *eidola* is granted a certain ontological status, just as Nonbeing is found in some way to "be." The difference between philosopher and sophist, or philosopher

16. *Republic* 394e and 395a (p. 82).
17. I am here making the same methodological assumptions that I made in my *La filosofía y su sombra* (Barcelona, 1969), especially in the second essay.

and representational artist (both the sophist and the representational artist seek constant solace in the *eidola*) consequently disappears.[18]

It is also true, however, that as early as the *Phaedrus* the Soul is defined as "self-motion," that is, as the being whose constant, necessary motion becomes the proof of its immortality. In the *Timaeus* the Soul is presented as a combination of Sameness and Otherness,[19] and in the *Parmenides* the ideas seem to undergo the same change of status, that is, they are presented as combinations of unity without substance and plurality lacking a material basis.[20] How then can this dialectical conception of the ideas and the dynamic vision of the soul be reconciled with the social, political, and also individual or psychic doctrine devised by Plato in the *Republic* and taken up again in his last work, the *Laws*?[21] There is reason

18. The scope of Plato's spiritual itinerary is staggering. Having made the immense theoretical commitments implied by the doctrines of the ideas and the soul in the *Phaedo, Symposium,* and *Republic,* Plato proceeds to demolish them with criticism that is far more radical and abrasive than that made by his student Aristotle. He may well represent the most extreme and exemplary instance of intellectual integrity in the history of philosophy.

19. Sameness in that the soul contains the source and mechanism of its motion *within itself*; Otherness because in *moving* it goes from Self to Otherness, while containing the Otherness inside itself.

20. See Víctor Gómez Pin's *De usía a manía* (Barcelona, 1972), where the difficulties of *Parmenides* are discussed in all their implications.

21. Regarding this problem, see Víctor Gómez Pin's *El drama de la ciudad ideal* (Madrid, 1973). The present work adopts a polemical attitude toward this excellent study, assuming in effect that "dialectical philosophy," rudimentary in Plato and later perfected by Hegel, provides the dénouement of the "drama of the ideal city." The drama of the *real* city, on the other hand, can only be brought to a close by Logos (philosophy) on condition that the social base and the superstructure of power are kept fundamentally separate. This superstructure is perfected in the synthesis of the philosophical and political realms, without which there can be no successful undermining of the social-productive realm. This sabotage can only be justified, however, if its *actions* reveal a dialectical intention of disappearing once its goal has been achieved. When this does not in fact occur, or when it takes place in theory alone (after being given concrete form as dogma), *pure* philosophical and political power is attained (in the sense of a form that is its own content as well, provided the content is not "external" or "economic"). In a sense this formalism is the full realization of the ideal Platonic city. The will to power rids itself of *class* content without, of course, thereby ceasing to be what it really is.

to speculate that in his second phase (his thinking about the soul, the ideas, the deity, philosophy, and the city as a whole) Plato was attracted by the notion of the *dialectical philosopher* as someone who could bridge the otherwise impassable gap that separated the philosopher-king from the representational artist (or sophist). He also seems to have found in the dialectical doctrine of the ideas a way of arbitrating between the categories of Identity, Being, and Rest and their opposites, Otherness, Nonbeing, and Motion. Finally, he appears to have found in the doctrine of the soul, and perhaps in the notion of the demiurge, a more solid and consistent theological justification than in the strict notion of the absolutely pure and simple deity (which he appears to question even in the *Republic* when he proposes the enigmatic notion that the Good is "beyond being").[22] And yet the second phase of Plato's thought still lacks both a social and political doctrine and a conception of art and the artist to go along with these important revisions.

In summary: Plato left unanswered the problems raised by the repercussion of his revisions upon the protagonists of his philosophical drama. These protagonists are the Artist and the City.

IV

In an apparently unimportant passage of the *Sophist* Plato considers the problem of the representational artist. In reality, this passage is the necessary complement to his thinking in the *Republic*, as it includes representational art clearly in the genre of *Poietic Art*. This also includes agriculture, "and all kinds of care of any living beings, and that which has to do with things which are put together or moulded (utensils we call them)." These arts are called collectively the productive art (*poietiken*).[23]

As artist, the representational artist is also a producer. Therefore he inhabits the most *basic* stratum of the Platonic social body. As

22. *Republic* 509b (p. 220).
23. *Sophist* 219b. Trans. H. N. Fowler (Cambridge, Mass. and London: The Loeb Classical Library, 1977), pp. 273–75.

presented in this passage, *Poiesis* means "anything whatever that passes from not being into being [because of] composing or poetry (*poiein*),"[24] as in the analogous passage of the *Symposium*. The first section of the diagram counterposes the mimetic artist to the "dogmatic" philosopher, as we have seen: the same artist makes a new appearance in the *Sophist*, but both *mimesis* and its medium, the *eidola*, here enjoy a new status. Rather than imitator, the artist now appears in the guise of the creator.

The dialectical philosopher holds the middle ground between the sundered protagonists of the dialogue. The corresponding figure is missing, however, in the realm of art. This lack reveals a flaw in Plato's approach, possibly the same flaw that leads to the abortive revision of the dialogues from his transitional phase and maturity (*Phaedrus, Parmenides, Sophist*).[25] The flaw becomes obvious when we ask: strictly speaking, can the philosopher, whether dogmatic or dialectical, be said to belong to the "productive" branch of society? Is the philosopher, in other words, a member of the most basic stratum of the social body or is he a member of the ruling superstructure, be he orthodox or heterodox, producer of dogma or dialectics (including the "Hegelian" heirs to the latter)? If the philosopher belongs to the ruling superstructure he is necessarily estranged from the creative process and to this extent also from the artist and the poet, the doctor and the artisan. In effect the philosopher *thinks* society, mentally unifying all of its estates and activities. The social body comes together as a whole in his mind. Because of his conscious mental control the philosopher is able to govern the city.[26]

24. *Symposium* 205b (p. 186).

25. Neither the cosmic demiurge nor the philosopher himself playing the role of demiurge in relation to the *polis* is the right candidate for the vacated office: their relationship to the ideal model (to the ideas) makes them accomplices of the superstructure.

26. It is not a question of the philospher being *in addition* a king or tyrant, or of the king being *in addition* philosopher. Although he never actually states it, Plato occasionally gives his readers cause for suspecting that he believes the practice of philosophy to be at the heart of tyranny, provided that we understand tyranny to be the will to absolute power and philosophy to be "total knowledge." Reflection on

Meanwhile, the artist creates. Embodied in his works, he creates in so many areas that he sometimes seems to be "all things." Another passage of the *Sophist* discusses this proclivity:

> *Stranger* If anyone should say that by virtue of a single art he knew how, not to assert or dispute, but to do and make all things—
>
> *Theaetetus* What do you mean by all things?
>
> *Str* You fail to grasp the very beginning of what I said; for apparently you do not understand the word "all."
>
> *Theaet* No, I do not.
>
> *Str* I mean you and me among the "all," and the other animals besides, and the trees.
>
> *Theaet* What do you mean?
>
> *Str* If one should say that he would make you and me and all other created beings.
>
> *Theaet* What would he mean by "making"? Evidently you will not say that he means a husbandman; for you said he was a maker of animals also.
>
> *Str* Yes, and of sea and earth and heaven and gods and everything else besides . . .[27]

At first glance this supreme maker seems quite similar to the divine demiurge of the *Timaeus,* who arranges the preexisting *chora* to match ideal models. This maker is in fact the sophist or representational artist, specialist in the production of simulacra.

On the other hand, leading the city, there is the dialectical philosopher. He thinks the unity of different parts, but he also thinks the differences within identical things. He is subtler and more polished than the dogmatic philosopher who did not waste time think-

the intrinsic link between *knowledge* and *power* might well lead to a political theory that is also in the same sense an epistemology.

The modern totalitarian state fulfills the Platonic ideal: the "watchdogs of the city" (the Praetorian Guard) safeguard political power by possessing total knowledge (the police keep records on "all things"). For a more detailed discussion of this point see the final section of "Nietzsche: Spirit Divorced from the City," below.

27. *Sophist* 233d-e (p. 327).

ing about Difference and Nonbeing. At bottom, however, his status remains unchanged, as he restricts himself to nonproductive thinking, by virtue of which he is able to rule and exercise control.[28] On the other hand, allied with the farmers, doctors, and instrument makers is the artist-producer integrated into the basic stratum of society. He differs from the others only in that he creates simulacra of things rather than real objects. Instead of remaking the earth, the fields, the heavens and the sea he fashions images of things *that already exist.*[29] What is missing is a third type of individual who can incorporate the artist's productive capacity, his polymorphous work mode, and his ambition to make and produce all things while deposing the philosopher who, disconnected from the productive process, rules the masses from the top of the social pyramid.[30] This individual will be called the *creative artist.* His product will be nature or the city rather than their representation. He will think in terms of concrete objects, not ideals. Instead of presenting concepts or ideas he will play the role of demiurge or technician.

Unlike the artist-producer, who epitomizes the synthesis of *Eros* and *Poiesis* described in the previous essay, the philosopher, whether dogmatic or dialectical, does not do all things: he merely conceives of them, merely knows them. He does not experience or feel the reality of things, he merely "takes them in" intellectually and mediates on them. He is familiar with all things, but he cannot give birth to them. Because he lacks precisely the experiences that would make his actions creative, that is, conception and giving birth, he

28. "To rule" means, or may mean, "to make others produce." The meaning may include the sense of "to provide work." What would happen in a society in which automation and other factors made it possible for the labor force to take total control of "management" and "regulatory" positions? Would this mean the ultimate collectivization of power and knowledge, or would the problem of authority (the master-slave relationship) crop up in another area, for instance in the relationship between the human and nonhuman (i.e., *Physis*) sectors of society?

29. Unlike the artist-producer, the dramatic artist does not transform the world: he is restricted to simulating it. Similarly, the philosopher king is limited to contemplating and interpreting the world.

30. This is the working utopia and the *rational dream* that is the premise of the entire text.

is left with the contemplation of all things. He has overview, vision, theory, and control and uses them to exert his power over the productive masses.

The strict specialization of labor proposed in the *Republic* and the *Laws* and endorsed by the doctrine of the pure and indivisible Idea makes possible a more advanced, modern, and dynamic social order. It will still reproduce the distinction between the ruling political stratum and the productive masses: the political estate must consist of philosophers, as they alone can govern society. Only philosophy allows all things, individuals, and other beings belonging to the social body to come together in a unified intellectual whole, while in the productive social base each soul is chained to his unique place, work, and occupation. This rigid structure becomes dynamic and dialectical at the top of the pyramid alone. In this way the chain of authority is perfected.

The solution of Plato's dilemma is to be found, therefore, in dialectical philosophy, but it articulates nothing more than the transition from an orthodox, dogmatic idealism to a subtler and more clever dialectical idealism. Yet neither the primacy of Idea nor the primacy of Philosophy is at any time questioned or debated by Plato or those philosophers who, like Hegel, loudly proclaim their intention of reforming and perfecting their discipline.[31]

31. Renaissance philosophy provides a viable solution. See the following essay, second part.

3

Pico della Mirandola: Man in Proteus's Likeness

*Est autem haec diversitas inter Deum et homines, quod
Deus in se omnia continet uti omnium principium, homo
autem in se omnia continet uti omnium medium.*

Pico della Mirandola, *Heptaplus* 5.6

I

It would seem that Pico della Mirandola derived the inspiration for his *Oration on the Dignity of Man* from the world view bequeathed to him by the Middle Ages, without modifying it in any important way. In the medieval world view all being is divided into levels of the cosmic hierarchy. God, the supreme architect, has embellished the region beyond the heavens with creatures of pure mind. Below it is the region in which the "eternal souls" weightlessly float, like "heavenly spheres." All animal life inhabits the lowest region, the "excrementary and filthy parts of the lower world."[1] There appears to be no place for the questioning individual

1. Giovanni Pico della Mirandola, *Oration on the Dignity of Man,* trans. Elizabeth Livermore Forbes, in *The Renaissance Philosophy of Man,* ed. Ernst Cassirer, Paul Oskar Kristeller, and John Herman Randall, Jr. (Chicago: University of Chicago Press, 1948), p. 224. This is an excellent anthology of texts from Petrarch to Pomponazzi and Vives, with introductory notes. Included are the Pico text in question and an extraordinary work by Marsilio Ficino. For more on the view of man in the Renais-

in this closed, strictly bounded and defined world. Everything has its place and is defined by the place it occupies. Every object and every individual—from God, the angelic minds, and the cosmic soul to the sublunar world and even matter—has its unique territory. A divinus influxus flows from one stratum to the next, of course, nourishing all things with its spiritual energy,[2] and the Deity, fashioned after the Platonic and Neoplatonic model of the One-That-Is-Not, stands somewhat outside the absolutely perfect and closed cosmos. There is not a single hint in this world view, however, of the awesome notions so prevalent in mystical theology and Nicholas of Cusa, such as the idea of Infinity. There is even less of an indication in Pico's harmonious and reasonable text of the now "modern" conception of Universe.[3] And yet a guest arrived who disturbed the appealing harmony of that cosmos, so content with its own perfection. That guest was man.

Until God decided to create man the world was indeed flawless and well-ordered. Until that moment all creation followed a peaceful plan in which each created entity inhabited a specific place, and that place was once and for all its *very own*. Mind, soul and beast all had their own locations and spheres of action. In fact this cosmos was oddly similar to the society proposed by Plato in his *Republic*: in both, all things have their place and rank in the hierarchy, and everything is perfectly arranged and apportioned. But the Creator

sance, especially at the Florentine Academy, see Paul Oskar Kristeller's *Renaissance Concepts of Man* (New York: Harper and Row, 1972). I also recommend Cassirer's *The Problem of Knowledge,* the section on Renaissance philosophy. On Pico de la Mirandola in particular, see Henri de Lubac, *Pic de la Mirandole* (Paris, 1974) and Father Eusebio Colomer's excellent work, *De la Edad Media al Renacimiento* (Ramon Lull, Nicholas of Cusa, Giovanni Pico de la Mirandola) (Barcelona, 1973).

All of the citations in the following section, unless otherwise noted, are from Pico's *Oration* in the Forbes translation.

2. On the notion of the divinus influxus in the general context of Florentine Neoplatonism see the rich and informational overview by Erwin Panofsky in *Studies in Iconology* (New York: Harper and Row, 1972), chapter 5, "The Neoplatonic Movement in Florence and North Italy."

3. On the difference between cosmos and universe, and on the notion of identity, see A. Koyré et al., *La ciencia moderna* (Barcelona, 1972).

discovered that there was no place left in his cosmos for the newest, the latest creature—man. "All was now complete; all things had been assigned to the highest, the middle, and the lowest orders." The newest member of the cast is met with strange injustice! Like Malthus's dispossessed, he arrives after everything has been divided up and finds all the seats taken. Lacking belongings, inheritance, and property, he bursts on the scene with all of the characteristics of the proletariat, the pariah of the world.

"Neither a fixed abode nor a form that is thine alone nor any function peculiar to thyself have we given thee, Adam, said God." This creature has nothing to call his own. Like Stirner's One, man owns nothing whatsoever, with the exception of his strange, ambiguous identity. But can we even say that he has an identity? He is neither god nor beast, neither angelic mind nor cosmic soul. He is not even matter. It would seem that he has no identity, and what he has he holds on to precariously, repeating a litany of denials. The same is true of the One, which is also the case of the Deity itself. Strictly speaking, he does not exist: he owns nothing, not even his own name.

What a strange thing man is! What sophistry, what wild imaginings can help us to understand such an ethereal, changeful nature? Pico della Mirandola answers: man, like a great chameleon, Protean, can be all things precisely because he is nothing.

II

Man belongs nowhere: for this very reason he can make himself at home anywhere, creating for himself "what abode, what form, and what functions" he desires. His wealth grows out of his very indigence.

Man has no identity: by virtue of this defect he can choose whatever identification marks he desires, adapting himself to any role. Freedom is the hallmark of his being. His being is not defined and limited beforehand but takes shape through his acts. Several cen-

turies went by before these revolutionary ideas of Pico della Mirandola became dominant, with the advent of existentialism.[4]

Man is "neither of heaven nor of earth, neither mortal nor immortal" being, but he can be whatever he wants, heavenly and/or earthly, mortal and/or immortal. He is "the maker and molder of himself." Like Plato's *poietic artist*, he has the ability to shape and build everything around him. Consequently he is able to make himself into a work of art, to fashion himself "in whatever shape he prefers." He can "degenerate into the lower forms of life, which are brutish," or he can be "reborn into the higher forms, which are divine." God has made a microcosm of man, "conferred the seeds of all kinds and the germs of every way of life" in him. He is not a microcosm in the traditional sense, however, not even as understood by Pico's teacher Ficino. Man is not a microcosm in the sense of constituting the center of the cosmos, for the simple reason that man does not really belong to the cosmos. He is alien to it, he is ex-centric in respect to all things. Far from being the center of the cosmos man typifies being away from the center: he is the creature in whom the natural order of creation seems to have gone haywire.[5]

Man develops according to the seeds he sows:

If they be vegetative, he will be like a plant. If sensitive, he will become brutish. If rational, he will grow into a heavenly being. If intellectual, he will be an angel and the son of God. And if, happy in the lot of no created thing, he withdraws into the center of his own unity, his spirit, made one with God, in the solitary darkness of God, who is set above all things, shall surpass them all.

Man can be all things, make himself into anything. His work, his *poiesis*, is therefore undefined. No single idea automatically dictates

4. Pico fully developed the notion that man has no nature or being of his own, freedom being the foundation of his existence.
5. In regard to the advance made by Pico in his view of man over Ficino, see the first section of Kristeller's book cited above.

his propensity for this or that activity, for this or that way of constructing his identity. He can do all things: he can make himself one with God or diffuse himself in material objects. He can concretely "be" or float indeterminately in "nonbeing." As Pico writes,

Who would not admire this our chameleon? Or who could more greatly admire aught else whatever? It is man who Asclepius of Athens, arguing from his mutability of character and from his self-transforming nature, on just grounds says was symbolized by Proteus in the mysteries.[6]

Man is his own maker: it is no wonder that Proteus comes to symbolize him.

III

If we compare this marvelous text of Pico's youth, inspired by the best of the Platonic tradition, with the passages of the *Republic* analyzed in the preceding essay in which Plato rejects both the Protean version of the Deity and the equally Protean, histrionic dimension of the representational artist (in the *Sophist* Plato states that the representational artist "creates all things" through play-acting), we can see the Copernican revolution that Pico brings about at the very heart of Platonism. Pico wields all of the arguments that support Plato's decree banishing the artist from the city in order to prove that the creature man is marvelous and worthy of admiration. In Pico's view man's dignity is rooted in what for Plato was his wickedness. Plato banished the representational artist because he could transform himself into anything and because he could neither accommodate himself to a single occupation or activity nor measure himself against a set standard of identification: for Pico the same reasons justify incorporating the artist into the city. They are, moreover, the characteristics that make man the

6. Regarding the mystery religions, see Edgar Wind, *Pagan Mysteries in the Renaissance* (New Haven: Yale University Press, 1958).

supreme being of all creation. It is the universe and not man that resembles Plato's society. But man's arrival introduces an element of restlessness and energy into an otherwise closed and tranquil cosmos. In the world that results from this change a political and philosophical superstructure is necessary, as in Plato's society, to assure that everything remains in its assigned place. The philosopher-king becomes superfluous, and the artist takes his place.

Man, according to Pico, is artistic by nature: as we have seen, he is his own maker, the creator and producer of himself. By extension he designs and shapes the malleable world around him. He makes the city. He is polymorphous, omnifarious, never subjected or subservient to a single activity or occupation. Pico's vision of man is a conceptual version of the human Soul and the City as experienced and so beautifully described by the Italian Renaissance, especially in Florence.[7] The experience of the Italian Renaissance gave rise to the "uomo universale" and "singulare," the soul that is all things, the soul that endeavors to build cities in its own image, where Mankind can at last find something like a permanent home.

IV

The citizens of the *real* cities of the Renaissance—men like Alberti, Leonardo, Cosimo and Lorenzo de' Medici, Piero della Francesca—had this in common with Pico della Mirandola's discourse: they fulfilled the final synthesis of Platonism, which implies the artist's reintegration into the city as the only way to make "dialectical" the static, unbending figure of the philosopher king lost in contemplation of the Idea itself. It is also the only way to break the domination of the Specialization of Labor to which Plato enslaved his ideal city.

In practice, this *uomo singulare* and *universale* who is all things, aspires to all occupations, and sets out to make all of his dreams

7. On the place of Renaissance Italian philosophy in Renaissance culture and civilization in general, see Eugenio Garin's works, especially *Medioevo e Rinascimento; studi e ricerche* (Bari: G. Latorza, 1961).

and wishes come true—the man given his final and melancholy expression in Goethe's version of the Faust myth—is the consummate synthesis of doing and knowing, of action and contemplation, of mystical ecstasy and public, political *poiesis*, of poetic rapture and social commitment. Renaissance philosophy and the Renaissance *polis* are closer to us than the Greek city and its philosophy. If we understand "origin" to mean the bedrock of race and dynasty in the factual, historical as well as the mythical sense, then the Renaissance city is closer to our origins. It was built by merchants and bankers, condottieri and the bourgeoisie, princes and tyrants whose worldly interests and enthusiasms—Glory and Fame, for example—and profound sensitivity, introspection, and ability to act and feel are quite simply the organic criteria by which we must judge our own place in history. The cornerstone of the truly humanistic world view is the notion of man as the being who in some sense is all things. To this extent the notion is the yardstick against which we can determine where we now stand, the proof of how far *we* have strayed from the mark.

If we must find an origin myth for our times we must not confuse what is real and historical from what is merely dreamt. We may dream about the Greeks, but we must nevertheless be able to see ourselves in the Venetian merchants and the Italian condottieri. In this configuration both Arcadia and Utopia are different from the immemorial Past and from dreams of a Future that is disconnected from time. They are still empirical reminiscences—in a word, *history*.

Our despair is a function of our distance from this model and its possibilities. The deeper and more destructive it is, the less it is the product of desire and fantasy.

PART TWO

From Goethe to Thomas Mann

Pico della Mirandola's text endows the Platonic synthesis of Soul and City, *Eros* and Creativity, with a subject and an object. The subject is Man, and the corresponding object is the beautiful Renaissance city, object of his desire and creativity. Just as man acquires concrete historical reality as the *uomo universale*, in the Italian city he finds his appropriate projection in matter. This is really a classical synthesis, as it establishes the norm against which all subsequent history must be measured. The course of history since the Renaissance gradually leads to a breakdown of this synthesis: the dialectic slowly splits apart into realms that are separate, autonomous, and mutually estranged. This book can only hint at the underlying reasons for this historical and social schism through their repercussions in the cultural sphere.

In the world that Goethe knew and wrote about this synthesis still seemed a practical possibility, although on a more modest scale. But the problematic nature of the venture actually compensated for its modesty: since the schism or estrangement or split was for Goethe already a given, it was all the more important that he search for a way to link the divorced realms.

In the Hegelian world the synthesis can take place only in the realm of the intellect as men are convinced that the reign of production and creativity has been fully achieved. All that is left is the gloomy task of thinking. Intelligence then becomes a realm cut off from action, life, and the world. Enlightenment arrives.

The final split between the soul and the city occurs in the world of Wagner and Nietzsche. The individual goes astray in the forest of representation or disappears in the cerebral eclipse of his own delusions. A histrionic Self-consciousness arrives on the scene with no dialectical connection to reason and with it the individual lost in hallucination, totally out of touch with the world. Thomas Mann is the ideal spokesman for this gradual breakdown of Desire and Creativity, Subjectivity and the world of objects, the artist and society. He tells the story in his fiction and reflects on it in his essays.

An extensive, systematic study would be required in order to state this question clearly in all of its particulars. This second part does not pretend to exhaust the subject. It is rather an attempt to describe a set of issues vitally pertinent to our contemporary experience of and thinking about life. By turning to the near past, the romantic century that is the historical premise of our own, we may be able to discern at this remove the nucleus and germ of many experiences and ideas that have gained such currency that they are today part of our daily life and taken quite for granted. This historical perspective should help to make the obvious into something exotic, alien, and even to some extent shocking. This is why I have chosen writers and thinkers belonging to a cultural past that apparently "has nothing to say" to our modern sensibility. This is precisely the kind of crass mistake that fuels our tendency to convert all knowledge into negotiable securities, all cultural artifacts into hard cash. Keeping company with Goethe, Thomas Mann and Wagner must be understood, therefore, as a deliberate anachronism: the very fact that they are not "traded" on the cultural stock market of the avant-garde gives them the special capacity to unveil what lies behind their apparent façade. The background of their personal experience is the starting point and the substance of their place in the realm of culture.

4

Goethe: Vocation and Debt

"Arise, go to Nineveh, that great city, and cry against it, for
their wickedness is come up before me." But Jonah rose up
to flee unto Tarshish from the presence of the Lord, and
went down to Joppa; and he found a ship going to Tarshish;
so he paid the fare thereof, and went down into it, to go
with them unto Tarshish from the presence of the Lord.

Jonah 1:2–3

I

In an article entitled "Goethe y Mr. Eliot," Luis Cernuda spec-
ulates on the reasons for the English critic's reticence on the subject
of the great poet and philosopher:

Goethe did not attack Christianity as Voltaire and Diderot had done and
Nietzsche would do again: he simply goes his own way, or rather leaves
it alone. He is not concerned with original sin, contrition, or redemp-
tion. . . . For the medieval aspects of Faust he draws on "Christian my-
thology," of course, but he has no greater personal belief in this than in
the Persian mythology he used in his "West-östliche Divan."

A little later Cernuda makes this truly penetrating observation:
"Catholicism is more content to fight against nonbelievers than

This essay originally appeared in *Cuadernos de la Gaya Ciencia* 1 (Barcelona, 1975).

against those who hold different beliefs."[1] Cernuda ends the essay with a disclaimer aimed at preventing any misunderstandings. The context is his description of Goethe's troubled relationship with Hölderlin. He writes:

> Although I may have been unjust to Goethe by writing these words it is probably unimportant. Goethe's fame is so great that it is beyond the reach of any injustice. When Claudel calls him a "pompous ass," for instance, instead of injuring Goethe he does harm to his own reputation.[2]

In his essay, "Goethe as Sage," Eliot is of course more cautious, more prudent, and less foolish than Claudel. Underlying his reticence, however, may be the same ideological and moral conviction. Cernuda's questioning is therefore both interesting and credible. How else can we make sense of the shamelessly insolent tone of Eliot's article? Faced with a choice between overt, crass stupidity and blatant dogmatism one might well opt for the more casual alternative of an ironic and, for what the paradox is worth, intelligent stupidity. That Eliot chose the latter is evidenced by twenty-odd pages of unsurpassed vacuity.[3]

In my book *Drama e identidad*, I wrote, "Goethe continues to perplex us. He forces us to reproduce the rich ambiguity that characterized his life and works in our criticism of them." This is nothing more than a brief summary of the commentary of Goethe's amanuensis as transcribed by Mann in his fictional account of the poet's meeting with Lotte in her old age. Is it surprising that the most incisive account of the mystery and overall secret of Goethe's life and works should be a novel (*The Beloved Returns*), when the most discerning critics, in particular Walter Benjamin, have done no better than pace around them in circles?[4]

1. Luis Cernuda, "Goethe y Eliot," in *Poesia y literatura* 1 and 2 (Barcelona, 1971).
2. Luis Cernuda, "Goethe y Hölderlin."
3. T. S. Eliot, "Goethe as Sage" in *On Poetry and Poets* (New York: Farrar, Straus and Cudahy, 1957).
4. Walter Benjamin, *Goethes Wahlverwandtschaften*, in *Gesammelte Schriften* (Frankfurt: Suhrkamp Verlag, 1974), vol. 1.

Cernuda also points out, in a footnote, that while Goethe's work is read and appreciated in England, it is "dead and buried" in Spain, "for age-old reasons which need not be brought up here." These reasons seem to crop up silently, nevertheless, throughout his treatise on Mr. Eliot's mental reservations. Cernuda's own reticence constitutes a vote of confidence for the good critic while removing him to a safe distance. This prompts me to pose a polemical question with the sole intention of sowing a seed of discord in our cultural wasteland: is it not surprising, at this moment of Spain's transformation into a non-Christian state, that a militant anti-Christian like Friedrich Nietzsche should personify Neopaganism instead of the man who was in fact Nietzsche's model? True, Nietzsche is "contemporary," while Goethe is lost in the corridors of time. The current lack of interest in Goethe, at a juncture in cultural history when we should by all rights be turning to him, is nevertheless profoundly revealing.

The "different belief" referred to by Cernuda was probably a lived experience for Goethe, while for Nietzsche it seems to have been more like the object of his desire. This hypothesis, if true, explains Nietzsche's progressive identification with his illustrious predecessor. Nietzsche understands and describes this belief as if it could actually be a doctrine. We might say, then, that the texture of Nietzsche's desire and language conveniently make up for the lacking experience, his language being descriptive when not explicitly judgmental. Nietzsche's progressively polemical and hostile attitude toward Christianity indicates that there is a real danger that the different belief could become an opposing belief. Not surprisingly, the Superman's morality degenerates into immorality, and the morality of good becomes the morality of evil. Thomas Mann alone has had the finesse to notice the subtle dialectic that enables Goethe to mediate between tremendous egotism and love, tolerance and utter contempt, benevolence and spite. This dialectic is neither conceptual nor philosophical. To develop it Goethe made use of two powerful weapons: an essay form whose ironic, conversational tone avoids the overly hypnotic quality of Nietzsche's prose; and the framework of fiction. The latter allows him to hold the bio-

graphical content at bay, filtering it through a select number of contemporaries, while the inner monologue is allowed to flow naturally in the guise of the Counselor's life.

If one need be so cautious when dealing with this character, should we wonder that the great pagan himself strikes us in Spain as thoroughly strange, alien, "dead and buried"? We live in the country where Catholicism, in its most intensely Counter-Reformation and least Roman-Renaissance form, permeates the deepest layers of our biological and psychological being as well as our religious and cultural life. And if to our further dismay we add that the great pagan was also a "grand bourgeois," and consequently as alien as possible to the "pampered" aristocratic ways of the wealthy and the ruling elite in Spain, will we be amazed that one of our greatest thinkers, who is not free of those pampered ways, mistakes Goethe's bourgeois nature for "a substantial dose of Philistinism"? No wonder, then, that Joan Maragall, a nonmainstream intellectual, most vividly sympathizes with Goethe. The law of elective affinities is here at work.

Before Ortega y Gasset popularized the notion of an invertebrate Spain, Hegel has already analyzed our national situation in terms of a conceptual dialogue originating in Italy, that country of feeling where no abstract or formal synthesis can ever be achieved. For Hegel, Spain is an example of national or moral unity forged by total disregard for inner conflict, which it overcomes through brute force—whence the danger of invertebration. Politically, this entails the never-ending risk of meaningless totalitarian centralism. In religion and morality, it threatens to impose standards by force, counting on and reinforcing the power of the secular arm of the law. These fundamental national traits are also at work at the level of individual, even intellectual, life. Too often a controversial writer appears before the inquisitors, and although he quite unintentionally causes negligible harm he becomes dangerously symptomatic as a symbol.

We are still Catholic in our judgmental moral habits. Moral judgment is mistaken for true judgment, truth and values being jumbled together in the strangest way. The net result is the con-

tinued presence of an inquisition that has changed uniforms but remained the same in spirit. Who cares whether the accused, Goethe being our case in point, is processed through the holy tribunal of Vital Reason or through the court of Dialectical Reason? Who cares if the sentencing magistrate cites "desertion," when the prosecution's closing statement mentioned "cynicism"? Spain will continue to be a problem as long as she ignores the uncommon "cunningness" of moral judgment, its irrevocable inversion of values, its quid pro quo, and persists in turning against men who have understood the difference between truth and morality and felt no compunction to publicize their knowledge. Men who have deeply experienced the truth of morality, with pain and irony. An inquisitor can achieve greatness if he is aware of this. But one must have a Russian soul like Dostoyevsky to reach this level of enlightenment. No wonder, then, that the Grand Inquisitor joins the ranks of our literary-mythical figures in a great Argentine writer's work: Jorge Luis Borges, in "Deutsches Requiem," shows that he can meditate profoundly on the ambiguous relationship of executioner and victim.

Face to face with Goethe, a Spaniard finds himself on the most recalcitrant and hostile footing. It is at the same time exciting and seductive, though, perhaps because of the danger: like no other game, it demands that he undertake the necessary learning experience of auto-interrogation. To approach Goethe on the terribly unfavorable terms of the game the Spaniard must undergo extensive training in precisely the kind of judgment that is most profoundly repugnant to our national habit: judgment that is moderate but not entirely weak, even if peremptory. Subtle argumentation that still knows how to simplify. A kind of allusion that does not shrink from overview and clarity, that never misses the chance to be light and delicate, that is never baroque, gongoristic, or abusively witty. A strong point of view, in other words, that falls short of being doctrinaire but does not dispense with ethical considerations, highly nuanced comprehension that does not fall prey to exclusively contemptuous tolerance. Subtlety, point of view, nuance: words that were dear to Friedrich Nietzsche, who tried to visualize things in

their entirety, describing them from the most diverse angles. And yet he could not prevent what he repressed from exerting itself in the form of a doctrinaire message too inarticulate to emerge as anything but a savage battle cry. As mentioned above, Goethe was Nietzsche's model: this alone explains why what was for Goethe the natural possession of background, education, and experience became the object of Nietzsche's desire. Nietzsche, with Napoleon, was a forerunner of the Übermensch, the last great man to live on the very eve of modern decadence and mediocrity. In his day Goethe's cosmopolitan view of the world, with its "ideal of the harmonious man," could only be the object of nostalgia or a dream of future Arcadias or Utopias. Nietzsche went after nuance, fighting desperately to cut a path through the labyrinth of perspectives, only to become overly contradictory in the end. He went so far as to question the peaceful synthesis of subject and object that Goethe achieved in his life, the same synthesis that led Hegel to posit Idea as a kind of alternative cosmetic. In any case, Nietzsche did the great service of revealing, with cool critical detachment, the causes and factors that impeded the living synthesis, identifying Christianity as the real villain. His discoveries make him our liberator, the man who delivered us from our willful blindness: his analysis of *Schuld,* which in German means both guilt and indebtedness and for Nietzsche was the sore spot in the spiritual and cultural life of Europe; the deep underlying connection, described in *The Genealogy of Morals,* between creditor and hangman, debtor and victim, and the brilliant perception that these relationships are directly connected to the questions of pleasure, the sign, writing, and inscription. . . . Nietzsche was a great philosophe and rationalist in the best sense of that great tradition. His work is an invaluable focal point for the concerns and methods of this essay on vocation and guilt.

II

In his famous essay, "Goethe desde dentro," Ortega y Gasset stresses the similarities between his definition of life and Heideg-

ger's in *Being and Time*.[5] I am passing over the vexatious, Byzantine debate about the relative priorities of ideas that were prominent in the period between the wars. At any rate I doubt that anyone in his right mind would mistake Heidegger's style or Protestant *Stimmung*, which transliterates scripture word for word, for the great essayist's modernist *bel canto*. Only the victim of bad philosophical education would overlook the fact that the *airoso* of ideas conveyed by a literary style is far more important than their statement in *recitativo secco*: through the literary style filters what we may call, for lack of a better word, "the tonality of the soul," after Nietzsche. This has nothing to do with the sediment of feeling and emotion left in the reader's heart and mind after reading both philosophers, even though they apparently "say the same thing." After all, the similarity is pure illusion.

In this essay Ortega uses the word "vocation" over and over again without ever defining it. In order to discover its full meaning, therefore, we must look at both the specific context of the essay and the general context of Ortega's philosophy. It is not my intention, however, to discuss Ortega's interpretation of Goethe in detail. For one thing, this discussion is present, implicitly, in the following pages. Nor do I want to discuss his particular ideas about vocation, even though when comparing it to Heidegger's philosophy I am reminded of those sections of *Being and Time* dedicated to the issue of vocation in its relationship to guilt. In its pheno-

5. José Ortega y Gasset, *Pidiendo un Goethe desde dentro* (Madrid, 1973). For an accurate analysis of Ortega's approach, see M. Sacristán, *La veracidad de Goethe* (Barcelona, 1967). Sacristan's harsh judgment of Goethe's moral conscience (he calls Goethe a cynic) can be offset by reading Alfonso Reyes's very different point of view in *Trayectoria de Goethe* (Mexico City, 1954), an outstanding, brief but richly informative biography. Without mentioning him by name, Reyes continually takes Ortega to task, refuting his moral judgment of Goethe as a deserter before the high court of ratiovitalism. On Goethe as an educational writer, see Thomas Mann's excellent essays "Goethe as Representative of the Bourgeois Age" and "Goethe's Career as Man of Letters," in *Essays of Three Decades*, trans. H. T. Lowe-Porter (New York: Alfred A. Knopf, 1947).

G. Lukács's *Goethe und seine Zeit* (Berlin: A. Francke, 1947) is an excellent Marxist study of the historical and social context of Goethe's time and his leadership role in it.

menological and existential interpretation, guilt loses the material, commercial sense of indebtedness, which is rooted in exchange. It does not, consequently, apply to the debtor in the ordinary everyday sense. Likewise, interpreted exclusively as debt, *Schuld* loses its theological and moral meaning. Like the other terminology he investigates, Heidegger forces *Schuld* through the phenomenological sieve and collects the existential pulp. In this way these everyday notions, be they economic or theological and moral, are critically rooted in the conditions that give rise to them: neither the individual as economic being nor God himself is a debtor. "God is dead": Nietzsche's version of the infinite Debtor is drastically reduced in importance. There is no properly credentialed and identifiable One to whom fallen Being, thrown-Being-in-the-world, is indebted.[6] Fallen Being nevertheless hears a certain voice or call within its conscience, even though its conscience, which has strained through the *Abschattung*, does not speak for morality. Dasein owes its being to no one: nothing names it, calls on it, or calls it forth. In the final analysis the ambiguous support of guilty Dasein's vocation is seen to be *Nothingness*. By this token Nothingness is responsible for Dasein's vocation, it is also guilty. The debt or guilt of Being, Being towards nothingness, Being-towards-death. When Dasein decides to throw itself towards the nothingness that is death, when it is liberated from its alienated existence and has fallen into everydayness, it finally grasps its unique and authentic vocation. Guilt and vocation are fully apprehended only in the anxious presence of death.

This is a necessarily brief and sketchy survey of the basic ideas developed at length in *Being and Time*. As an overview of issues recently resuscitated by a major psychoanalytic school, however, it is sufficient for our purposes. I am referring to the Lacanian school of analysis, a provocative hybrid of phenomenological-existential analysis, structuralism, and Freudianism based on the proximity of the existential notion of anxiety and one of Freud's prin-

6. The English equivalents of Heidegger's terminology are taken from John Macquarrie and Edward Robinson's translation of *Being and Time* (New York: Harper and Row, 1962), with slight modifications—tr.

cipal theories in this regard. The Despot, who plays the role of creditor, can become flesh and blood only in the world of myth, which according to Benjamin stands in opposition to truth. The paternal masks that all "real" fathers wear are cast from this proto-father's mold. The infant's ego is therefore indebted to a fleeting metaphor without ever escaping or being able to escape from the world of fiction or myth and the universe of language. The drama of the child's vocation, with its emotional ups and downs of ob-sessive doubt, anguished determination, and so forth, plays itself out around the child's immediate relationship to the realm of myth. In the end, however, the masks come off in the presence of Truth, and the real countenance of the Despot—the one and only Lord, says Hegel, and his name is Death—is revealed. The individual responds to this despot's call (ever since the Book of Jonah, to accept one's vocation is to have a calling) by fashioning a design for his life. This design becomes authentically vocational in the genuine, narrow sense only in the presence of the despot by stand-ing firm against the threat of "castration," to use a convenient term. Lacan sets these notions forth clearly in his *Le Mythe individuel du névrosé ou "Poésie et vérité" dans le névrosé*, where as the title suggests he chooses a passage from Goethe's *Autobiography*.[7]

Ortega's questions about the authenticity of Goethe's approach to his vocation find a corresponding philosophical code and sup-porting theory of vocation in Heidegger, whose subtle psychology, armed with the formidable weapons of phenomenological existen-tialism and psychoanalysis, is clearly superior to Ortega's superficial intuitive psychology. Some doubt remains, nevertheless, about both the relevance of Ortega's objections and the theories that could be perfected if restrained within a more substantial theoretical framework. Was Goethe really a deserter? To what degree do his life and works fit Lacan's psychoanalytical diagnosis? Are Lacan's theoretical premises acceptable as they stand? If so, where do we

7. J. Lacan, *Le Mythe individuel du névrosé ou "Poésie et vérité" dans le névrosé* (Paris: Centre de la Documentation Universitaire, 1953). The analysis of the famous episode of the "two sisters" in Goethe's *Autobiography* follows an interpretation of Freud's monograph on the rat man.

look for more substantial premises? Do we look in the analyst or in the analysand? Who should be lying on the couch, and who should do the listening? Who, after all, should submit to radical analysis?

III

In its desire to go beyond the mythical, theological, moral, and economic approaches to vocation, guilt, and fallenness, phenomenological existentialism focuses on these approaches as possibilities. They are nothing more than this, but they are also nothing less. The fertile ground in which the tree is rooted, grows, and branches out is not the subject for inquiry. There is no search for other subterranean layers that might support other crops, other seedings. The same can be said of Lacanian psychoanalysis, where the passage from myth to Truth relies on the assistance of Heidegger's famous *Kehre*. Once the objective cast of "smaller others" had made an appearance on the stage, it is the Great Other's turn. In either case it is accurate to say that the throne of the dead God and the doubted Father has been left vacant. The truth that lurks in the succession of crown-bearing masks nevertheless comes to the fore, namely, that no one has taken the throne away. This truth inevitably acquires an equivocally mythical nature, however, which substitutes the dangerous new monotheism of the Logos for the polytheism of phenomena. Calling it Absent does not do away with the equivocal nature of the term, as what emerges when the pseudopresences abandon the boards is the presence of this very absence. No wonder, then, that this labor of criticism and reflection adds to the theoretical base a pragmatic element—a new mythology, a new morality, and a new theology. Founded on "the death of God," its battle cry is "live anxiously"! This Godless Protestantism, Dasein alone in the presence of the Deity, wipes out the last remaining sacred signs of its holy might, leaving behind in place of a wake the ineradicable tracks of a morality or *ethos* that existential analysis takes it upon itself to examine. The vocational im-

perative (and the passage from concept to precept inherent in it) become understandable: "you must live steadfastly and anxiously in the face of the Other's calling, whose symbolic messenger acquires the form of a single signifier called Death, who has slipped into your conscious utterances like a parasite, constantly disrupting your every statement."

Characters and typologies take shape before Him, in His presence, at His side. This is especially true for the obsessive neurotic, whose indecision becomes the norm: his constant shifting back and forth from one erotic object to another, from one romantic, professional, or personal involvement to another is the systematic expression of a hopeless, extreme, Hamletlike and quite unmethodical doubt. A lack of authenticity, perhaps, or an eternal cavilation, *ewiges Zwanken,* that can only be overcome by irrational recourse to oracles, to the "voice within" if not to superstition and the throw of the dice. Or is constant flight or desertion from love, relationships, and responsibilities—the prophet's obstinate refusal to hear the voice of Yahweh—all sublimated into frenetic activity as a means of making a choice in time . . . ?

Or is it rather *Stimmung,* which is authentic to the degree that it boldly hangs on to existence in the fullness of anxiety and face to face with the truth called Death, face to face with *aletheia.* In this case the verdict is justified, whether the convicted is Goethe or the man whose "many talents confuse and disorient his vocation," "a terrible proof that man cannot have more than the single authentic life dictated by his vocation." Ortega writes:

He is nothing fully and completely: he is a high civil servant who does not take his post seriously, a *régisseur* who hates the theater and cannot really be a *régisseur,* a naturalist who never quite makes the grade and since by the most special of divine decrees he is a poet, he will force the poet that he is to visit the mines at Ilmenau to recruit soldiers while sitting astride an official horse named "Poetry."

In Lacanian terms: superstition, recourse to "heads or tails" as a means of strengthening "existential" resolve, the creation of alter-

egos for the erotic object (one need only read between the lines of the *Roman Elegies* to discover this), indecision, stiffness and formality, the suspicious case against his father in the *Autobiography*, camouflaged incest with his sister. . . . These factors make up the "clinical profile" which Lacan prudently limits to the famous passage about the "two sisters" in the *Autobiography*.

Now, it would be going too far to grant the prerogative of Truthfulness in regard to vocation and guilt to either the Protestant tradition that is at the root of existentialism and Ortega's ambiguous, imported version of it, or to the Judaeo–Christian tradition out of which psychoanalysis grows. The transcendent tools of theology and morality are not sufficient, even in the hands of suspiciously "neutral" practitioners like phenomenologists and psychoanalysts. The traditional approaches cannot be set aside, questioned, or superseded in this way. Neither can they be "known," if true knowledge or science, if you will, implies a "change of scenery" on the phenomenic or phenomenological level. Science is by definition critical, but not in the sense of imposing another layer of interpretation on the empirical base. Science investigates data and suggests a way to transform them. Science is the theoretical, conceptual phase of practice. The simple approach through transcendent categories relies on Neomythology and Neopathos to convolute its aseptic appearance. And yet it is so terribly difficult to uncover any source of inspiration that has not received the seal of approval of the secular Judaeo–Christian tradition! Nietzsche burned himself out questioning this cultural "empiria": his only reward for his effort was mental derangement and the creation of a deviant discourse. Can we not interpret all of his works in the grand style of Pindar's oracular dictum, "become what you are," because they always pose the same problems that are at issue here? In *The Genealogy of Morals* he outlined a nonmoral approach to the problems of guilt and responsibility, an approach that the existentialists dragged back into the moral arena, dressed-up to look phenomenological-existential. If, while reading Heidegger, the structuralists had not come to their senses in time, they would have brought Nietzsche down completely, steering him down the road of popular

economics (where creativity, a word missing from the structuralist vocabulary, is obscured by complex interrelationships).

Nietzsche's nonmoral campaign reaches its high point in *The Genealogy of Morals* by situating moral phenomena in a theoretical context that thoroughly transcends it. Nietzsche combines the *Homo Natura* who existed before he began his campaign with a program for changing from the moral to the nonmoral state without letting his prescription or the prophetic tone detract from the *concrete possibilities* of his approach. In *The Genealogy of Morals* guilt is not assuaged by anxious commitments or promissory notes but by *inscriptions* carved first in the earth or on the body, then on tablets and papyri, and finally in the depths of the soul where the Logos makes its mighty mark and the soul acts as receptive surface or midwife to the word. Perceptible signs etched into earth and sea, heaven and hell—the signs of man's passage through his home environment—this is the currency that liquidates the debt. In the end, however, the debt is only canceled when man undergoes the final metamorphosis, when he seals his work with a hyperborean leap born of the urge to ascend, the need to take flight. Nietzsche's Übermensch and the butterfly of light so wonderfully praised by Goethe come together in this leap into space, this flight to the Space of Light. The track made by this flight is man's last, definitive sign. Nietzsche brought this final metamorphosis about: given his nature he could not have done otherwise. Goethe let his entire life pass before he experienced this seizure of Being, which he experienced as the Space of Light, simultaneously inscribed surface and source of energy, pure act and entelechy revealed in the final flight that Cleverness has perpetually delayed.

Surely vocation is intimately related to these notions of guilt and sign. I will attempt to summarize various aspects of Goethe's life and works in the hope of strengthening or at least clarifying this premise. Goethe's Protean biography as well as his dramatis personae, the protagonists of his puppet show, constantly return to the problem of vocation. In any event I shall avoid attacking this difficult issue head-on or thematically. The very object of our attention will dictate the changing shape of our discourse. In no event

will it be subjected to an a priori treatment. The reader will be invited once again to read and enjoy the life and works of the most puzzling of the classical writers. For many he is a sphinx, an effigy, Medusa's glance. And there is something of Medusa in the broad, intelligent, and overly sensitive look of this man.

IV

Goethe needed time for everything. His native slowness, his inherently hesitating nature, has, curiously enough, been recognized only in our epoch. His life was based on time—on duration. It was ruled by an instinct to leave himself plenty of time, it even shows traces of indolence and irresolute time-wasting.[8]

So wrote Thomas Mann, in whose fictional universe the leitmotif of Time occupies a special place often represented by the icon of the hourglass. Is not Time the merchandise that Mephistopheles peddles to Dr. Faustus? A brief period for the artist to get ahead by wisely marshaling his energy and his days in order to finish his work? In his famous monologue in *The Beloved Returns*, Goethe despairs when he realizes that he hasn't enough Time to carry through with all the projects and ideas that crowd his mind. Time is all he needs: if only he could live a hundred and fifty years! Time is both enemy and friend: it demands that we make decisions and puts a limit to all-powerful fantasy and desire. It makes pacts so that possibility can become reality, subjective indecision become objective inscription. Goethe's incessant brooding about the subjective and objective synthesis of Time and Eternity within each present instant—always a "time for building"—leads his thinking astray, into private meditations on conquering time from within time itself and solitary musings on eternity.

Goethe lived the myth of the modern musician who wants to compress all conceivable harmonies into a single chord outside of

8. Thomas Mann, *Essays*, p. 111.

time. Diachronicity collapsed into total synchronicity, the single page that sums up all others, the book that contains all books. In its encyclopedic form the temporal, homophonic, discursive unfolding is reduced to a single note, word, color, or line. Another step in this direction and modern art discovers its final Truth in the self-destruction of silence, the blank page, the empty wall, absence, madness, and death. It is a causal—not casual—development that contemporary art and philosophy specialize in the condemned categories of Nonbeing and Difference that appear on Plato's list of supreme genera in the *Sophist*.

Thomas Mann's work introduces and develops this second leitmotif of the disembodied spirit that breaks the bonds of enthusiasm and emotion (the "heat of the stable") and even tries to free itself from temporal existence, a condition of the Pact. The attempt to represent time spatially, with the twelve-tone scale, has meaning in this light. In his *The Story of a Novel*, Mann confesses that he, as writer, held the totality of each novel present in each detail of the narration. Only the dark powers of sensuality seem capable of undoing this act of *superbia vitae*. The hourglass marks time again in the heart of the rarified, decaying landscape of Venice.

In his time Goethe could still forge an admirable working compromise between the dark forces and "spiritual discipline." The ideal of the "harmonious life" was not threatened for a single moment. His lineage antedates the anguished "heroes of our time" so marvelously described by Mann in "Death in Venice." Nevertheless Goethe suffered the torture of the same temptation, especially in his final years—the temptation to fly away like the butterfly that follows the light into the interstellar space where the symbolic archetypes, the *Urpflanze* and its sisters, live in the utter unity of quintessence, as if the whole world could recast its existence quite platonically by tacking on the appropriate prefix. The community of lonely men lived there also, the great men simultaneously united and kept apart as in Hölderlin's famous poem about vanished friends and fallen heroes: Schiller, Napoleon, and the other members of that immortal society. But beings sustained by the creator's concern also inhabit this nimbus, as archetypes. It is there, not in the first

"original," that the Ur-Faust, the Ur-Tasso and the Ur-Meister are to be found. Goethe must constantly have heard that beloved voice asking, "Do you know the country . . . ?"

Goethe's greatness was that he lived on both planes simultaneously and in perfect harmony, without there having ever been a credible sign of dissonance or disruption. If there had been even one, we could look at his public, social, ritualized image as both author and courtesan as if it were completely false and he nothing but a soulless marionette. He would simply be a mask, and we could read hypocrisy and cynicism into his gestures. Some small anecdotal details might support this hypothesis, but on the whole the mundane aspect of Goethe's ordered life, in conversation or while writing, does not give the onlooker this impression. Certainly one must abandon one's suspicions in the end.

At the same time Goethe's relationship with temporality was not totally free of internal conflicts and dangerous leanings. When he was shaken by the call of his vocation of solitary man in communion with other, absent, solitary men, he presented the public with a ritualized image, a stiff, expressionless, grotesquely dour, almost paralytic mask. On those occasions he seemed pedantic or even foolish. When interior and exterior failed to come together he took refuge in ritual. Is not ritual the transaction that links subject and object? Without it, does the body not dissolve in gestures and the rictus of speech, erecting the private ritual of hysteria or neurosis?

Too painful the cynical commentary on historical events, too many prophetic second thoughts wasted for the accusation to swing ninety degrees back against the accusor, the beautiful soul.

Too many proddings, too many inducements. Everything echoes off everything else, each thing internally linked to all others. All things exist in a continuum, and the world seems an open book filled with arcane glyphs, like magic formulae. Each and every detail conceals a revelation. Benjamin saw this with exceptional clarity. He interpreted the collector's obsession, the need to record everything, to take note of everything, to prevent a single word from being lost when it leaves one's mouth—a single sheet of paper that has passed through one's hands—in precisely these terms.

Goethe gradually converts himself into a sacred cow, and we then see him as such. His appearance, his step, his walk, his expressions, most of all his look—all give off a halo. And his writings seem to overlap in the end, blotting and obscuring each other, becoming what Benjamin calls "the chaos of the symbolic." Everything finally becomes clear, the many-hued mixture of colors gives way to the dreaded but anticipated purity of absolute darkness and absolute light. As a young man Goethe frequented the somber, nocturnal region. As an old man he groped toward the Space of Light, that place where the butterfly experienced the appropriate metamorphosis and floated free of its species. In the flawless unity of the Space of Light all signs and inscriptions run together into pure energy, the one and only symbol. The souls of all his friends, the quintessential cast of his puppet theater, all the archetypes and symbols enter this crucible, this elemental, annihilating Platonic One where all is all and nothing is nothing. Time is conquered and the realm of perishable things, the domination of frightful mothers and the Feminine are all suppressed. The virile acts of doing, making, and taking charge are all annulled. Life and writing canceled out.

In his solitude, aware of the temptation he does not quite accept, Goethe anticipates in a balanced, harmonious way the modern artist's adventure in instability.

V

First nuance of Ortega's ambiguous interpretation of Goethe's statuelike stiffness in his old age: that he was suffering the anxiety of being forced to descend into his own body and social milieu, the anxiety of being caught in the twilight world between sleep and wakefulness when one has already flown through one's own Space of light and the vocational imperative has made itself seen and heard in an excess of light. He was caught between the extreme options of ascent or descent, flying or staying seated, aerial or earthly presence, writing in the air and on the crests of waves or lasting in-

scriptions on stone and paper. . . . Phaeton's vocation was the pre-
requisite for a successful vocation in architecture or civics. But we
must add a second nuance, the somber, evil-boding counterpoint
to the other. Or is it the case that shadows do not necessarily
trespass against the light nor black against white, the nocturnal side
of nature against the aerial and hyperborean, the earthly subter-
ranean side against the Olympian and stellar? Goethe's statuary
stiffness may once again suggest an answer.

In the text cited above Thomas Mann speaks of indolence and
ennui. Schiller also complained of these ailments. There is yet an-
other unnoticed effect of the conflagration of inducements and pro-
jects stimulated by the "chaos of the symbolic." Too many en-
deavors getting in each other's way, and too many writings. At
bottom, too many instigations, too many inducements giving rise
to perennial indecision, *ewiges Zwanken,* and the endless peril of
indeterminacy. At this point doubt, obsessive doubt, arrives on the
scene. Each and every attack on the senses, each and every blink
of the eye, each contact with the skin becomes as inducement,
because they have already proven their symbolism and meaning.
One must act, one must bring each seed or hint to fruition. All
possibilities must be seen through their metamorphoses, ushered
to their entelechy.

When the prods are too hard, however, they puncture the skin
as if it were volcanic lava and the body then experiences the Pom-
peyan effect of irreversible mummification. The individual turns
to stone, sinking into a state of mute hypertension that repels all
attempts at redirection. Only the Deity can overcome this anes-
thesia brought on by overexcitement: only the Deity can realize the
humanly impossible desideratum of being everything all at once
and suppressing the *quodammodo* (in a certain way) of the saying,
"Anima est quodammodo omnia (in a certain way the soul is all
things)" or giving form to the formless All, once and for all, *tota
simul,* justly suppressing the tyranny of time. Because when each
thing is everything, when all is rightly joined in wholeness and
union—where does one begin to act, where give shape by estab-
lishing the first limit? At this point possessiveness, betrayed by the

quivering rigidity of that other face, sets in. This is not the pos-
session of a helpful *daimon* like Faust's Mephistophelian spirit of
negation, doubt, and contrariness that makes all actions possible
by nursing them to maturity, smoothing their harsh formlessness,
breeding light and shadow together in them and inscribing them
in concrete reality by yanking them from the clutches of the sub-
jectivism of possibility. There is a demon older than Mephistoph-
eles, dating from the age of Saturn, when Logos became Action.
This Mephistopheles is more earthly, impish, and uniquely ap-
pealing to the feminine side of nature, that is, the lunar, nocturnal
side. Goethe writes:

> He thought he could detect in nature—both animate and inanimate,
> with soul or without soul—something which manifests itself only in con-
> tradictions, and which, therefore, could not be comprehended under any
> idea, still less under one word. It was not godlike, for it seemed unrea-
> sonable; not human, for it had no understanding; nor devilish, for it was
> beneficent; nor angelic, for it often betrayed a malicious pleasure. It re-
> sembled chance, for it evolved no consequences: it was like Providence,
> for it hinted at connection. All that limits us it seemed to penetrate; it
> seemed to sport at will with the necessary elements of our existence; it
> contracted time and expanded space. In the impossible alone did it appear
> to find pleasure, while it rejected the possible with contempt.
> To this principle, which seemed to come in between all other principles
> to separate them, and yet to link them together, I gave the name of
> Demoniac, after the example of the ancients, and of those who, at any
> rate, had perceptions of the same kind. I tried to screen myself from this
> fearful principle, by taking refuge, according to my usual habits, in an
> imaginary creation.[9]

In his magnificent study of *Elective Affinities* Benjamin singles
out the final, revealing statement: "I tried to screen myself from
this fearful principle." He quotes Goethe's horoscope as the poet
presents it at the beginning of the *Autobiography*: "My horoscope
was propitious: the sun stood in the sign of the Virgin, and had

9. *The Autobiography of Johann Wolfgang von Goethe,* trans. John Oxenford
(Boston: The Aldine Publishing Company, 1910), p. 423.

culminated for the day; Jupiter and Venus looked on him with a friendly eye, and Mercury was not adverse; while Saturn and Mars kept themselves indifferent."[10] He also cites the more disquieting horoscope from Boll's *Sternglaube und Sterndeutung*: "The fact that Saturn in the ascendant is so near to the evil Scorpio, lying in its realm, casts some shadows onto Goethe's life. A certain tightness at least can be ascribed to the dubious astrological sign in conjunction with the secret essence of Saturn in its old age. But it also bespeaks—and this has to do with what follows—a living being who drags himself across the earth, governed by the "earthly" planet Saturn, and has a strong attraction to matter, clinging to the earth with a base sensual love and hungry organs."[11]

A second face of Evil appears before Mephistopheles, the helpful prod who gives Faust the urge to transcend. This other face of Mephistos takes possession of its victim and plunges him into those "Saturnine" moods familiar since ancient times but especially common during the decay of Renaissance classicism.

The "spirit of denial and contradiction" thus splits in two. This two-faced being, incrusted in the very heart of Nature and Being, undergoes a change all too infrequently identified with precision. It may be an understatement to call the feeling produced by this second possession the *tedium vitae*, that sterile, fruitless suffering or encarceration in the prison of subjectivity. Where the first Mephistopheles encourages one to take flight, the second plunges the individual into the depths of the earth: it is the "spirit of gravity" that Nietzsche speaks about, and the place it carries one to is Hell, strictly speaking—the icy place, in Baader or Thomas Mann's

10. Ibid., p. 3. Benjamin's is the most interesting and important interpretation of Goethe that I have read. It more than lives up to the promise, made in the opening pages of the text, to provide criticism instead of commentary, as criticism deals with the substance of truth while commentary is concerned with objective content alone. It is fruitful to compare Benjamin's piece with E. R. Curtius' "Goethe as Critic," "Goethe as Administrator," and "Fundamental Features of Goethe's World," in *Essays on European Literature* (Princeton: Princeton University Press, 1973). Curtius studies certain biographical data in detail while relating Goethe's thinking about symbols to his theory of colors and his theory of metamorphosis.

11. In Walter Benjamin, p. 150.

words, where a man turns into a statue carved on the side of an iceberg. In this polar landscape of Siberian tundra no incitement or inducement crystallizes in inscription or endeavor. Nothing flowers or germinates there. In my book *Drama e identidad* I called hell "the place of good and evil intentions that never transpire in action." Hell is the Saturnine realm where thought gets lost among mute daydreams, where the individual is totally cut off from the objective world, where unproductive doubt, sterile contradictions, brooding denial, and hopeless indecision hold sway. The quietism that Goethe complained of as an old man, the evil-boding Nirvana in which not a single action, invention, or creation ever blossoms results from this conjunction.

Jupiter and Venus looked on each other with a friendly eye by the light of the sun: whence the need to fly, the necessity of light, the Apollonian passion for the concrete. Goethe ends his horoscope:

the moon alone, just full, exerted the power of her reflection all the more, as she had then reached her planetary hour. She opposed herself, therefore, to my birth, which could not be accomplished until this hour was passed.[12]

The set of oppositions takes this form: black and white are the basic poles, while blue and yellow are their chromatic limits, as are the light and shadow held in firm moderation by the scattering fog of dawn and clear nights full of stars. Earth and sky are limits, and the worm's urge to fly free of the chrysalis, transformed into a butterfly, and the lure of the abyss personified by Lord Byron and Euphorion.

Goethe lived his life in such a way that the double excess of shadow and light never defeated him. It was an extremely well-administered life in which cautious intensity counterpointed a vocation for amplitude. The quantum and the quale of Goethe's biography blended into a seamless harmony. He put off the eventual meeting as long as he could, and when it happened in the emotional crisis of adolescence it wore the somber earthen face of Sturm und Drang, a veritable explosion of the Saturnine element until then

12. Goethe, *Autobiography*, p. 3.

restrained by an upbringing that glorified the Jovian imperative of Action and Resolve. In his final years the same appointment took the form of an excess of light.

This set of oppositions is the visible aspect of the archeological work that Goethe carried out on his own past experience. It is a given, the fruit of his own reading of himself. Because it is his version it is of course masterful and especially telling, but not for this reason necessarily truthful. His presentation is too motionless, too posed. We would rather see it in motion, as if it were a living thing. To capture this vision we must look at the cast of the puppet theater and get to know some of the characters. The same contrast is at work in the proverbial match of Faust and Mephistopheles, but Goethe's contrary, ironic genius is too kind to Faust: it hides the "other face of Satan," which is close to "the evil side of Nature" and therefore more deformed. We must look instead to *Young Man Werther,* written in the Sturm und Drang period. This work is an embryo, the true homunculus of what we are looking for, product of the malaise of a century that had witnessed the rampant growth of the evil side and its diabolical forms. There are glimmerings there nevertheless—the states of mind in which Werther, lost in the prison of subjectivity (all unchecked passions are subjectivist at bottom), allows an emotion to encroach and get lost in indecision, dragging the unhappy young man down into this very loss; or when he goes against his own motives and inducements, giving the lie in the end to the same act of repudiation and managing, by virtue of his denial, to come close to his indecision and that aspect of him that resembles Ossian.

These overly Hamletlike moods, clearly brought on by an ascendant Saturn, can be seen in all their harsh authenticity in *Torquato Tasso.* This first crumbling of the ideal of classical harmony forever smashed the *concordia discors* of the Renaissance, seeing its most spectacular flowering in Mannerism. The polished synthesis of book and sword, thought and action, Jupiter and Saturn no longer holds at the court of Ferrara. The prince alone keeps the tradition of the *uomo singulare* alive. But he must mediate *in extremis*

between irreconcilable extremes, as his hands are tied—the hand of the soldier, the Minister and Diplomat, and the hand of the poet plunged like bitter and implacable enemies into strife that appears to have no solution. Antonio's poetic style does not curb his Machiavellianism, nor does Tasso's compromise with the realities of court life curb his Saturnine temper. He plunges into taciturn moods, touching off a battle within himself, a battle in which no quarter is given and from which not a single harmonious note can issue. In naked connivance with the objective world, the individual self gets lost in the maze of ghostly desires that branch out and become hopelessly entwined. The individual is the loser, but he nevertheless feels the desire to destroy himself so that he can want and caress his self-wrought misfortune. Every cure becomes an affliction, and nothing can save him. The individual has gone mad, confusing pursuer and pursued. The end result is withdrawal, agoraphobia, inertia. Only Princess Leonor's benevolent ascendancy, which is sympathetic to taciturn natures, helps him to externalize his experience as Poetry.

Werther succeeds in objectivizing a minimal portion of his disease by inscribing it in the letters he keeps sending to his friend. In *Tasso* the homunculus is completely formed, but the disease has also grown. It is more serious to be possessed, but at the same time the act of inscribing through correspondence has risen to the level of Poetry with universal appeal, in which the story of men of action in an epic world is told instead of the misfortunes of the Self. Now, to the extent that creative activity expresses or redresses mute quietism and possession paves the way for writing—that is, the realm of the tangible sign—we can say that the fictional character finds himself on the way to acquiring form, to being cured. Wilhelm Meister finds his own life of Bohemian adventure inscribed in the Temple of Knowledge: at that moment he understands that his adventure was an apprenticeship. Pure sterility only characterizes the individual lost in contemplation of himself, possessed by the second Mephistopheles. This demon is therefore the opposite of the vocational imperative. It whispers temptingly in the individual's

ear: "Free yourself of guilt." It plunges him into the dreamworld of feelings, letting him go astray in the labyrinth of emotion. At bottom, Emotion and Creativity are radically opposed. Ottilie and the Captain, in *Elective Affinities,* are two poles of a very serious problem. Goethe works it out and dramatizes it in these fully realized characters, who are truly superior beings, but it affects all men and women. Werther and Tasso are mere preliminary sketches by comparison. Ottilie is a creature of nature: from nature she derives not only her magnetic energy, her disquieting mimetism, and her powers as a medium but also her dark, "amoral," self-destructive side. The Captain personifies the union of subject and object. His love for Charlotte is no less passionate than Ottilie's love for Eduard, but he tempers this subjective force with the constructive activity of his vocation, which creates works of engineering and architecture. In the last analysis the work of art or poetry consummates the synthesis of creativity and emotion by deriving its life blood from the subjective realm while taking material form in stone or on paper. In Goethe the work of art is precisely this polished and harmonious synthesis. In later art and its philosophical consciousness or esthetics, however, this synthesis is replaced by a dangerously close association of beauty and disease, of art and the lure of the abyss. Romanticism is the harbinger of this disorder. Goethe was the last to succeed in concretely joining the conflicting experiences of guilt, vocation, and sign in a harmonious whole.

VI

Guilt is assuaged by inscription, and vocation is fulfilled by the creation of signs. At first there are fleeting shadows that jostle the kaleidoscope of fantasy at the first hint of sensual stimulus: the young man's nervous excitement, vacillating between life and death, does not falter. What is worse, inspiration comes at the wrong time. It crosses one's path too many times in the course of the day, so that one must do the odd pirouettes that go with the profession,

writing occasional verse on shirt cuffs or scraps of paper. Little by little the soul quiets down. Out of the puppet theater a homunculus raises its head—later it will frighten its creator, as the monster frightened Doctor Frankenstein when it first rose up before him. The young man lays his suicidal frenzy to rest by creating this foul Sosias, which immediately takes on a life of its own. In the meantime the young man backs off and flees or, if you wish, deserts. Because he deserts he will be able to give another twirl to the alembic and make more complete characters like Tasso, Orestes, Meister, Faust, Germain, and Dorothea.

The young man dreams of his future as he negotiates his first serious emotional hurdle, but it turns out to be a ghost that he has conjured as a prophetic hunch. He is riding horseback in the country when suddenly he sees himself returning along the same route, only several years later. The anecdote appears in his *Autobiography*, the consummate work of Goethe's creative life in which he finishes building his own Sosias. Man arrives at his final form by passing a series of apprenticeships, not by studying his prefiguration in the homunculus. In his physical being, as perceived by himself and by others, in his presence as mask, Man is the first inscription, the equality sign, the original scripture. The text of Goethe's *Autobiography* is the rubric of this inscription. First his own monster is created, then the poet exalts his memory. On the heels of the first doubling comes a second, and with this identity—his first incursion into fiction—he can create an ambiguous character to join his fictional world. From the narrow viewpoint of narrative fiction the character is real—as real or more real than any drawn from a chronicle or other objectively historical account. Sign and narrative have moved forward and come closer to truth: the real doubling is the successful creation of a new protagonist, brewed like his siblings in the alchemical retort. His right to possess a personal pronoun does not, however, give him greater ontological scope.

He must have thought out the future course of his life as a boy and as an adult, in dreamlike states, laid it out in paragraphs and chapters. As an old man he can finally allow himself the luxury of writing an ambiguous autobiography, spelling out the day-by-day

script. It is the first truly imaginative work Goethe wrote, and it came after his identity was complete, like the rubric of his recollections. As objective, public inscription it achieves musical harmony, vitality, and symbol. We are talking, of course, about a pact in which for once both parties come out ahead: the excess of life-giving force does not lead to its extinction in death or mental derangement. Its defect never quite strips the sign of its fiery essence. Some price had to be paid for such an advantageous pact: the Olympian stiffness of the flesh-and-blood man, a dour personality, a certain suspicious ritualization of working, collecting, and saving. What is gained is wisdom and poetry in harmonic unity with power. The works of Goethe's old age—the second part of *Faust*, *Elective Affinities*, *West-östliche Divan*, the *Autobiography*—are pulsing with it. Vocation is fulfilled and debt repaid in tangible signs and sacraments. We can learn an ethical and political lesson from this: life passes and the spirit flies up to its proper sphere, but statues, buildings, and monuments stand firm, provided they have been erected with care and in leisure from the first stone to the last. As for Goethe the old man, the product of an entire life, he is, strictly speaking, a statue or monument, a concrete symbol and declaration of the truth.

Nature's rhythm wears away the firmest constructions of law and morality. Even marriage gives way before the law of elective affinities, which gives unto nature what is hers, or what is too much like her. This law allows gas to sublimate so that other elements may combine. Ottilie's sacrifice is not in vain. In Benjamin's view she was a scapegoat: she returns to her home because Nature is her element. But the law does not come out ahead when applied to the elements of nature. The physical law of affinities corrupts the logical, social, and spiritual law of legal and institutional order. Nature mauls matrimony and morals to death. This is why Charlotte loses this cruel game, even though, with the Captain, her tact and discretion make her the heroine. In the end her quiet presence precipitates a subtle and valid moral lesson: *Nomos* shows astounding heroism when beset by *Physis*.

Only the Captain manages to come closer to truth, devoting

himself to emotional and sacramental inscription, which is on a higher plane than the creative objectivization of Self in nature that leads to marriage. It even transcends fatherhood. His achievement is also more genuine than Ottilie's inward-directed objectivization of her dreams in the form of her Diary. By channeling his activity into architecture and engineering, by building for the common interest, the Captain succeeds in creating a super-natural, social, and sacramental objectivity. His creativity is *civic*. In this respect he foreshadows Faust, the builder-impresario. The Masonic ritual that illuminates the novel—revealed by the bricklayer's speech— takes concrete form in the Captain and gives meaning to Faust's famous "Tat." He does not initiate the action: he brings it to a close. He is the finished product rather than the design, not the last stone lain but the first. Sign and act are mediated in entelechy.

VII

Ortega y Gasset is therefore mistaken when he interprets "Tat" as the raw outset of the action, the decision to act or simply the first step. In the case of Goethe the man, action unfolds and evolves in many directions. Writing is not its prevailing form. Goethe's activity took part *aliquo modo* in all of these directions: despite Ortega's interpretation, the concentration of vocation in the realm of literature did not definitively guarantee a greater yield of quality or fame. In his life he sought to embody the *uomo singulare*, the soul that is to some degree all things, to the extent that he could—that is, to the extent that he understood it and the history of his time allowed. There are many accounts of his boundless curiosity. This and his ability to be active in many areas are sufficient proof that he pursued an ideal that had little to do with Ortega's notion of the vocational imperative to be a self-made man. On the contrary, the humanist ideal demands that man make himself into the All. Faust is the definitive posthumous expression of this ideal. The desire to be all things means that one must to some extent make himself into all possible activities. This kind of determination runs

the risk of falling victim to the Saturnine fiasco, to its dialectical countersign: if the man born under the sign of Saturn cannot be all things, he dreams or imagines them. At which point all things mean his damnation, as for Nietzsche, and the All becomes naked indecision. Goethe endured the evil influence of his star without ever overcoming it.

This is why he could be writer, statesman, philosopher, and naturalist. But this prodigious outpouring of work was transcended in the end by a final, ambiguous synthesis of poetry and wisdom. They are moments very close to truth, when action and its effect in the marketable form of tangible inscriptions rise toward whatever transcends them. Because in the final analysis truth is beyond the reality of both act and symbol, even though they are its material form. This is why truth is metahuman. Only poetry and wisdom, embedded like a mute admonition in tangible acts and poetry, indicate this limit situation which in fact exceeds and surpasses all things. It is negative unity, paradoxical synthesis. It does not belong to the world of categories, it transcends it. It is transcendence *de iure*. On this second and final plane doing, creativity, objective history, and the subject-object synthesis are canceled out. Adjectives, which belong to the categorical world, do not apply to the Truth because it is not natural, scientific-positivist, social, or historical. Categories must not be related to transcendence. The confusion of the two is solely responsible for the vision of Goethe as wrongheaded proponent of jeopardized scientific doctrines or cynical commentator on social processes. Marxist exegesis becomes reductive on this point. It is also hampered by its proverbial ignorance of psychology. When posed solely in scientific or sociohistorical terms, the relationship of the individual to Truth—that is, the problem of veracity—lacks the fine tools required to pinpoint psychological loopholes. Lacan remarks that the Marxists would do well to leave some free space for Truth, which they are too quick to label social. The same could be said of Lacan and psychoanalysis when they bounce back and forth from intersubjective to ontological truth. It is nevertheless certain that Marxism too

often confuses the ontic with the ontological. Such an approach cannot make sense even in historical terms—for which we lack insight into psychological motivation—of Goethe's deepseated repugnance for everything that smacked of revolution. Nor can we understand the identical role played by natural and social disasters, which turn up again and again in "Hermann and Dorothea" and "Honorio und der Löwe," not to mention Goethe's reference to the Lisbon earthquake, in the *Autobiography*.

We can too easily forget that Goethe was an eighteenth-century man who was very sensitive to the future and judge him on the basis of his sensitivity, rather than the reality in which he lived. Like any eighteenth-century man Goethe viewed men and society with the eyes of "natural history" and plotted the course of events by reference to the extremes of conservation and calamity. We overlook the subtle links of affinity, if not identity, that join the weak heart aflame with passion (a popular icon that sheds its emblematic nature in Goethe's hand and is made to yield truth) with the natural disasters, the earthquakes, floods, and fires, that shatter the smooth flow of urban, bourgeois life, trapped inside its walls and defensive towers, courtyards, and bolted doors. And we ignore the connection between these two types of disaster with the third kind that rounds out the triptych: the collapse of nations, classes, and estates that culminated in the French Revolution. It is a triptych of terror: the mind deranged by the experience of love, the mad face of Nature in upheaval, society in revolt. It is the triptych of Sturm und Drang, of the *mal de siècle* that Goethe tried to cure in himself in the best way God had taught him. In the final analysis, however, he was his own physician and therapist. He lay down on the couch, and from the ensuing operation—similar to what Hegel performed on naive consciousness in *The Phenomenology of Mind*—issued Werther, Tasso, Meister, Orestes, Faust, and Goethe himself as protagonist of the *Autobiography*, all of them spirits in the making. These apparent deserters, these apparently cynical stances, douse the blaze. But appearances can be changeful and deceiving.

Goethe's consciousness moves from naivety to maturity. The

creation of life and writings is the rubric of the passage. In the end, it all comes together on the couch. The same thing happens to young Meister when he enters the Temple of Knowledge. At that point Goethe is writing from the depths of his own experience. He is relating his own epistemology and building his own historical monument, contributing to the concrete, tangible creation of a self. He succeeds in objectivizing his identity and carrying it over into the objective realm of inscription. Goethe trains his own Medusan eye on himself, converting his identity into object. He is intrigued by his own case. In this way he consummates the art and the refined *ethos* of a genuine *gay science*. Not a single objective specter intrudes on the narration, no half-paid debt, suspicious guilt, or self-reproach breaks the flow. Reason fixes us in its spiritual gaze and, icy and warm at the same time, it takes us by surprise. We are caught off guard by its "nonconfessional" quality, which is so alien to morality and the Christian spirit.

In the beginning the beloved woman suffers the Medusan gaze. The poet's hands mistake the embrace and the pose, clasping the Roman woman's body between hexameters. In the *Roman Elegies* the erotic object is still clearly doubled: the god descends to the tavern. The Olympian poet makes the Roman woman into a Greek goddess while she finger-paints with spilled wine on the convent table. The verdict of the poet's obsessive neurosis then tells the first half of the adventure. It tells us much about the itinerary and the baggage that the naive consciousness carries in its years of wandering and apprenticeship. It tells us little, on the other hand, about the treatment he submits himself to, when this is much more important than the plain account of his first erotic proclivities. The psychologist's bad faith and abuse of power consist in leaving the patient in a state of negative objectivity, seeing himself the sum of traits forcibly dictated by his infancy. To the Other (the therapist) falls the task of educating the patient and working his cure. So, it would seem, it usually happens, though it need not. In any event, it is clear that the diagnosis of proclivities lets the process of self-cure, which is what really matters, get lost between the lines.

Lacan's method does very well with the writer's early works and early *memoires*, but it misses the mark with his mature work. The distance from *Elective Affinities* to *West-östliche Divan* is the distance from neurosis to health. In the latter, poetry and truth lay down on the Couch of wisdom. The entire poem consists of poetry about poetry, the truth about the truth. The unbridled power of nature— fires, hurricanes, sandstorms—is tamed by the poet's inscription and his song, in the knowledge that he is raising himself with his symbol toward the truth, that in the long run this defense cannot be anything but the opposite of a breastplate or a shield. His treatment of truth, closer to the very guts or marrow of natural being, distills a more secret and hidden truth. The symbols are neither clear nor direct because in the end, as Benjamin points out, everything becomes symbolic, order reverts to disorder and the chaos of symbols. At that point everything echoes in everything else, as in books of magic. Everything becomes meaningful, exuding pleasure and clarity. Fleeing from the nocturnal side we fall into the clutches of another more worrisome terror. This is why, in the middle of the *Divan*, the dangerous butterfly of light erupts into flight, throwing the tranquil progress of the mediating inscription into disarray.[13] Benjamin suggests that this is the fear of life or anguish, but not in regard to *Madame Lamort*. Existentialism and

13. Sagt es niemand, nur den Weisen
 Weil die Menge gleich verhöhnet:
 Das Lebend'ge will ich preisen,
 Das nach Flammentod sich sehnet. . . .

 Nicht Mehr bleibest du umfangen
 In der Finsternis Beschattung,
 Und dich reisset neu Verlangen
 Auf zu höherer Begattung.

 Keine Ferne macht dich schwierig,
 Kommst geflogen und gebannt,
 Und zuletzt, des Lichts begierig,
 Bist du Schmetterling verbrannt.
 Selige Sehnsucht

Heideggerian psychoanalysis must here submit to being interpreted by the object of their interpretation. The excess of clarity and pleasure, the unbearable pleasure that Goethe constantly refers to in his poetry, brings on this anxiety. For this reason the grandest, the most fortunate, and the least "maudit" of all writers can confess: "Reassure yourselves, I was not a happy man."[14]

14. We might find that the *Roman Elegies* and certain passages of the *Autobiography* are "interpretable" in the usual sense of the term. This is not the case with the *West-östliche Divan* which, like the second part of *Faust*, the *Autobiography* considered as biographical fiction, and *Elective Affinities*, requires criticism rather than commentary or interpretation. If it must be interpreted, the interpretation must be in the musical sense, that is, interpretation of symbols instead of allegories. These texts attempt to speak the truth, and they succeed as far as it is humanly possible. This requires that one experience the truth: that is why they are difficult. Truth is incendiary by nature. It inflames the poet's breast, and the poet, in the middle of his desert, would suffer the most frightful isolation if his cleverness and intelligence did not forearm him with the saving grace of talismans, like the magic flute in Mozart's opera. With their aid, the poet can walk through fire, which then issues from his mouth as a song of praise, from his hands as inscription on stone, tablets, or papyrus. No finger-painting in the wind. One avoids the rapidity of inscription and decay. The minstrel or the poet takes his ease, and the community benefits. Goethe is nevertheless tempted to inscribe words or signs on the shifting waves, just as, pleasantly nostalgic, he longs to leap toward the Space of Light like the butterfly of fire, writing its own sign on the sky as it flies toward the region beyond. His last, secret word to the few wise men in the world hangs in the air: I want to praise this suicidal butterfly.

5

Hegel: Clarity and Melancholy

How can the individual soul, ruled by contingency and limitation, ever be all things, participate in the All or the Absolute? How can the goal be reached in such a way that the soul participates in the total, concrete, and specific knowledge of the All and not just a dim reflection of it where consciousness and knowledge are lost forever?[1]

These questions appear to be implicit in Hegel's *Phenomenology of Mind.*[2] The originality of this work consists in its leaving the

1. This is one of the leitmotifs of the present text. It is derived from the Aristotelian notion that "the soul is *in some way* all things" (anima est quodammodo omnia). The entire problem stems from the definition of *quodammodo*. I suggest the following interpretation: the notion of "idea" has steadily deteriorated since the Renaissance, with Aristotle's *quodammodo* growing steadily fainter with each successive stage of modern cultural and intellectual history. While Pico della Mirandola saw man as the being that is all things, interpreting the *quodammodo* as a function of *creativity* (becoming or creating things), Hegel defines the term in the sense of understanding and knowing. As an Idealist, he justifies this interpretation by equating knowledge with being and thought with reality. The process of decay can be summarized as follows:

1) Pico della Mirandola: the (human) soul becomes all things.
2) Goethe: the soul is all things *to a certain extent.*
3) Hegel: the soul *knows* all things.
4) Wagner: the soul *imitates* all things.
5) Nietzsche: the soul *imagines* all things.

2. G. W. F. Hegel, *The Phenomenology of Mind,* trans. J. B. Baillie (London: Swan Sonnenschein, 1910). The passages cited at the end of this essay are from the chapter titled "Revealed Religion," in vol. 2.

separate soul to its own devices instead of wrenching it from its natural habitat and subjecting it to external coercion or force in the hopes of elevating it to another, higher space. The soul gets a vote of confidence for its own ability to apprentice itself and get ahead: if it eventually does violence to itself and its surroundings, it is solely responsible. The soul guides and instructs itself, providing its own educational standards while the philosopher looks in from outside without in the least influencing the course of development, somewhat like the mysterious schoolmaster who crosses and re-crosses Wilhelm Meister's path in the course of the experiment without ever revealing his identity. Only at the end of the journey, when Goethe's protagonist has entered the Masonic temple, when Hegel's naive consciousness has attained absolute knowledge, can the mystagogue reveal his name. Both then unite in an intimate brotherhood of identically educated men.[3]

We are pointed down the road toward the meaning of the soul's experiment as early as the prologue to the *Phenomenology of Mind.* We are told that the soul is *in itself* all things, that everything is deposited in its depths like a profane endowment left by the spirit of the world. This substance is the painstakingly crafted fabric of the world's raw exposure to history. The soul is spared this dark task: it need only probate the will. Its experiment does not have the nature of an operation or a trial, let alone a pronouncement: it is rather an acknowledgment of the work that has been done for it and deposited within it, for the soul holds *within it* all things. Its task is to probe its own depths and clarify to its own consciousness what is already there for it to find. It must bring out *for itself* what it holds *within itself.*

At the beginning of the *Phenomenology,* then, the soul is all things. But it is not aware of its riches. The first step toward consciousness is taken with the first phenomenological insight: the feeling consciousness knows something about this plethora, but its certainty is too shapeless and proximate. Only at the end of the experiment

3. Regarding the ritualistic nature of apprenticeship and coming of age, as well as a general view of various key works of the Western philosophical tradition, see my article "La filosofía como drama," *Revista Literal* 2 (Buenos Aires, 1975).

will the soul become conscious of the total capital at its disposal. This capital is not increased, however, at either the beginning or the end of the process. No interest accrues during all those years of apprenticeship and wandering. The capital remains always the same, like a piece of real estate. Always the same Thing, always the same God. Its dark task has been completed, one trusts, in and for all time.

With respect to the arrival of the world soul, which in the form of some individual will give a truly renovating twist to History and to Mind, the philosopher is a latecomer. He is left with the opportunity, even the right, to raise his exultant heart in a genuinely enthusiastic toast to the crass general passing by on horseback on the street below.

Is Europe's epic endeavor really over now, after the Enlightenment, revolution, and empire? Is there no more place for the spectacles of comedy and tragedy? Can this Europe, feeling her years now, have really exclaimed, "Comoedia finita est," echoing Augustus? If so, she will be left with the consciousness of her past and the final honor accorded to those who step down from important posts, the sempiternal right to dictate her memoirs. In other words, there will be a place for Historical Consciousness and, in a broad sense, philosophy.

Whether it appears on the well-lit stage of world culture or in the political arena of the Bastille and international war, this consciousness will scarcely be heard above the din of battle. In the old days, when pen and sword seemed constantly to exchange their higher functions, the living, reportable present was the object of both. Reporting was essential to that lovely age, when everyday acts were transcendent, when history was *made*. No one had time or space to think about it. One thought while one was acting: consciousness was not split into subject and object of *reflection*. For Hegel and his generation this being, necessity, or transcendence was in the past. Some register the fact emotionally, as if embarked on a nostalgic mental journey to a distant, medieval origin. Hegel is more cautious and level-headed: he tries to conceptualize this amorphous feeling. And yet the same melancholy lingers in his

conceptual constructs. Hegel's melancholy is more authentic and substantial, and less soothing, than the romantic variety, which is more nostalgia than melancholy. To the degree that clarity and melancholy are, if not virtually synonymous terms, at least closely related, Hegel's is more lucid. It grows out of a twilight awareness that life, the real life of the good old days, is gone for good and that our *memory* is all that is left of it.[4]

Beauty, the aesthetic spirit and the religion of art are likewise aspects of the past. The beautiful days of classical Greece are gone, and as a contemporary spirit reminds us in an equally melancholy poem, the marriage of Faust and Helen ended in divorce. The new Faust is a highway engineer, a builder of bridges and canals. His creative activity rests on the destruction of the realm of beauty personified by Philemon and Baucis, the last survivors to perish beneath Mephistopheles' stampeding hordes. The new power that rises up in its place is hopelessly estranged from beauty. Its foundation is utility, and it conceives of a world subject to rules so compulsive and severe that Beauty and Art can only occupy that space left over at the fringes of its operation. Its own art and literature are imbued with consciousness and knowledge: they are less art than art criticism. The work of art and reflection on the work of art are the same thing, or perhaps it is a work of art only to the extent that it reflects on the work of art. It is in any event less art than aesthetic consciousness.[5]

4. After Hegel and Schopenhauer, philosophy is a *post festum* meditation which implies the twilight of life. During the Enlightenment the philosopher was still a man of action, a polite courtier, a political and journalistic man of the world. On the rise of philosophy as an awareness of the decline of epic endeavors, see my essay on Mann [chapter 8 of this book]. On the antinomy of action and awareness, see Fernando Savater's *Ensayo sobre Cioran* (Madrid, 1975) and my *Drama e identidad,* especially the last two chapters.

5. It is interesting in this respect to compare the introduction to Hegel's *Aesthetics,* where he presents the perceptive notion that art is dead—a notion that was to have such enormous consequences—with the final section of Goethe's *Faust,* second part. Both Hegel and Goethe, like the Romantics, knew that the modern age (the fall of the Ancien Régime and the rise of industrialism) necessarily entailed a questioning of *what was aesthetic* (the harmony of spirit and nature). Unlike the Romantics,

The statues set up are now corpses in stone whence the animating soul has flown, while the hymns of praise are words from which all belief has gone. The tables of the gods are bereft of spiritual food and drink, and from his games and festivals man no more receives the joyful sense of his unity with the divine Being. The works of the muse lack the force and energy of the spirit which derived the certainty and assurance of itself just from the crushing ruin of gods and men. They are themselves now just what they are for us—beautiful fruit broken off the tree; a kindly fate has passed on those works to us, as a maiden might offer such fruit off a tree. It is not their actual life as they exist, that is given us, not the tree that bore them, not the earth, and the elements, which constituted their substance, nor the climate that determined their constitutive character, nor the change of seasons which controlled the process of their growth. So too it is not their living world that Fate preserves and gives us with those works of ancient art, not the spring and summer of that ethical life in which they bloomed and ripened, but the veiled remembrance alone of all this reality. Our action, therefore, when we enjoy them is not that of worship, through which our conscious life might attain its complete truth and be satisfied to the full: our action is external; it consists in wiping off some drop of rain or speck of dust from these fruits, and in place of the inner elements composing the reality of the ethical life, a reality that environed, created, and inspired these works, we erect in prolix detail the scaffolding of the dead elements of their outward existence—language, historical circumstances, etc.

Hegel manages to overcome this melancholy observation by making an audacious, even daring apology for self-consciousness:

But just as the maiden who hands us the plucked fruits is more than the nature which presented them in the first instance—the nature which provided all their detailed conditions and elements, tree, air, light and so on— since in a higher way she gathers all this together into the light of her self-conscious eye, and her gesture in offering the gifts; so too the spirit of the

however, they avoid setting aside a separate area, like a national park, where one could still cultivate a "feeling for nature" while simultaneously evoking the historical past. Fully aware of the tragic nature of this option, they rejected this tendency, betting instead on building a world based on purely abstract premises—scientific, technological, and industrial premises which by definition are not aesthetic.

fate, which presents us with those works of art, is more than the ethical life realized in that nation. For it is the *inwardizing* in *us*, in the form of conscious memory (*Er-innerung*), of the spirit which in them was manifested in an outward *external* way; it is the spirit of the tragic fate which collects all those individual gods and attributes of the substance into the one Pantheon, into the spirit which is itself conscious of itself as spirit.[6]

Myth and ritual, the theater with all its masks, epic, and tragedy, sun worship and the religion of the flowers, linear and organic architecture, anthropomorphic sculpture—this entire world of beauty has been lost forever. The comic consciousness of Attic comedy is the end product of the enlightened spirit born in the very heart of tragedy, in Euripides: it is where that spirit steps down from the pedestal and shrinks to a lesser, human stature that can be turned into fiction. No sooner had critical consciousness raised its head than the masks came off, mortally wounded by the comic's laughter. Is not laughter a genuine outgrowth of truth, the true *verification* of the gap between the mask's tragic, heroic stature and its human reality? The artistic realm of imitation made way for the sober world of revealed truth.[7]

6. G. W. F. Hegel, *The Phenomenology of Mind*, pp. 762–64.

7. This same "falling off of the masks" provoked by the comic consciousness must take place for there to be room for the phenomenon of the *novel*. The masks have become ridiculous, pretentious: they threaten to become grotesque. The only remaining object worthy of attention is the "subject" who holds them up, that is, man, whose very dignity depends on the unmasking.

Since the middle of the nineteenth century, though, we have suspected that man himself may be a mask. Fichte and Feuerbach could still propound Pico della Mirandola's "humanism," although in a conflicting and problematic form. But since Marx, Nietzsche, and Freud it seems that this most dignified being, who had come to the fore after the twilight of the gods and heroes (masks), has begun to suffer terrible humiliations: man, too, was then found to be a mask behind which forces of a different sort—economic, biological, libidinal—were at work. Consequently the novel no longer has heroes. Stendhal's do, but Balzac's protagonist is Money and Zola's is Heredity. Once again, comic consciousness is best suited to this shift of scale: it allows Flaubert to write the encyclopedia of human folly. *Bouvard et Pécouchet* can be read as a parody of *Phenomenology of Mind* or of Faust's restless, ever-inquisitive spirit. The sum total of the period's Knowledge and Culture passes through these characters and through naive consciousness. These characters are the

A new world arose in the place of the world where spirit made itself felt in the stone it sculpted, in the craftsman's work or the hymn he sang, in music and poetry. This was the transparent world of spirit, a world itself transformed into spirit, subjectivized, humanized, made historical. A world without tangible physical underpinnings, a world born of concepts and science. In such a world God does not require temples or statues: the spirit incarnate in men is its own temple and its own statue.

The blossoming of self-consciousness that finally bears fruit in the Enlightenment and the Revolution and Empire that followed, found its first expression in Greek rationalism and Attic comedy. It is cheerful and confident, pleased and self-satisfied in its original manifestation. It takes on myth and ritual, letting the masks of a still religious theater fall away, in a way that is still spontaneous and natural. The advent of revealed religion intensifies the evolution of the process that reaches its full stature in the Enlightenment, when art becomes *truth* by being marched under guard into the Pantheon called Salon, Museum, Aesthetics, Archeology, Historical Consciousness.

Hegel is the melancholy culmination of this process.

counterimages of the true heroes of the age, however—of Wilhelm Meister, Faust, and Goethe himself. They want to discover everything, but there is no perceptible progress or advance in the endless pages of these novels. Like Frederic in the *Sentimental Education* they tread endlessly around the same point. The very concept of the Bildungsroman, along with rites of passage and apprenticeship, can be said to go bankrupt in Flaubert. The way is open for the aimless, unidentifiable creatures of modern fiction, the creatures who populate Joyce's and, especially, Beckett's novels.

6

Wagner: Incipit Comoedia

I

Ordinarily it would be foolish to add to the extraordinary bulk of critical comment that has been heaped on the once polemical wizard of Bayreuth. The fact that the author of the present text, far from being a professional music critic, is a mere amateur would only emphasize the audacity of such an act. This, however, is a special case. Wagner of course was more than a composer, or less, depending on one's point of view. The would-be critic can handily point out that Wagner's critical opus, in addition to his musical-dramatic works, affects areas of culture and experience that are not strictly musical and are therefore of interest to the writer, the philosopher, and the critic. But one must not forget what Manuel de Falla said in this regard as long ago as 1933: "Everything that can be said about Wagner's esthetics, his irksome Romanticism, his philosophical motives, etc., has already been said, along with a great deal that need not have been said."[1] The audacity of affirming a well-known portion of the critical literature in one's own name

This essay is based on an article titled "Wagner: Proteo y Dionisio," published in the *Cuadernos de la Gaya Ciencia 2*.
1. Manuel de Falla, "Notas sobre Ricardo Wagner en el cincuentenario de su muerte," *Cruz y Raya* (Madrid, September 1933).

can only be attributed to impardonable ignorance of the whole literature. What sense is there in giving the pen free rein? This is all the more true today, when no one seems inclined to receive enthusiastically new comments on Wagner: although not long ago he aroused passionate debate, today he lives on in the hearts of a minority of followers who play anything but a leading role in present-day culture.

For this very reason, however, we may be able to reflect calmly and with common sense on the meaning of Wagner's work, and in this way we may be able to extract some meaning and substance from a figure who is otherwise a relic of the past. The proper approach may also shed some light on both the period to which he belonged and our own, if only indirectly. Granted that Wagner linked his destiny to that of a spirited, privileged class whose apotheosis (and the seed of its ruin) coincided with the crucial date of 1848, when he gave birth to his most important works, he can be seen to gather together, like a crossroad or a net, several loose threads of European history that are essential to our comprehension of the period in question.[2]

Wagner ascribed to Feuerbach's belief in an all-encompassing humanism designed to replace the ancient commandments of god-fearing ages. He sympathized with Bakunin and with him took

2. Some believe, like A. Coeuroy in *Wagner et l'esprit romantique* (Paris, 1965), that the Romantic spirit culminates in Wagner, the ideological, aesthetic, and musical motifs present in the works of Hoffmann, Novalis, and Weber taking concrete form in his operas. Others maintain that he is "le dépassement du romanticisme." René Liebowitz, for instance, argues this thesis from the point of view of ideology and music, in *Les fantômes de l'opéra* (Paris, 1972). In *Aspects of Wagnerianism* (London, 1968), B. Maggee presents a strictly ideological interpretation of Wagner as precursor of psychoanalytical theory.

Whatever the interpretation, it is clear that Wagner straddles the gap that both separates the "romantic spirit" from, and unites it with, fin de siècle sensibility. This is why his music profoundly moved men like Baudelaire, the poet and critic who gives a coherent symbolist reading of Wagner in his magnificent essay on *Tannhäuser*, "Richard Wagner et Tannhäuser à Paris," April 8, 1861, in his *L'art romantique* (Paris, 1968).

part in the 1848 revolution.[3] Disenchanted with these beliefs, he eventually embraced Schopenhauer's philosophy of pessimism. He was also a fervent nationalist, throwing his support behind the pan-Germanic, racist, Francophobic and anti-Semitic ideology that began to take shape with the birth of the Second Empire. At the end of his life he turned to the kind of religious mysticism evidenced by his opera *Parsifal*. In other words, Wagner experienced a number of conversions, embraced a variety of credos in his life. He was something of a barometer of the changeful ideological climate of his time. Only a Protean nature could have held so many beliefs.

I will take this singular aspect of his personality as a point of departure in my attempt to penetrate the tangled universe in which he chanced to live.

II

The publication of Wagner's Francophobic tract, *Capitulation*, provoked a sinister game of lies thinly disguised by suspicious second thoughts.[4] This may provide a biased means of unveiling the psychological makeup of this artist who forces us too often to echo Manuel de Falla's words:

When I listen to Wagner's music I try to forget the man who wrote it. I have never been able to stand his haughty vanity or his childishly egotistical insistence on portraying himself through his dramatic characters. He believed he was Siegfried, Tristan, and Walther, even Lohengrin and Parsifal.

3. In his autobiography, Wagner left an excellent account of his experiences with Bakunin in the 1848 revolution in Dresden, including a remarkable portrait of his comrade. Regarding Wagner's relationship to leftist Hegelian philosophy, especially that of Feuerbach, see both his own statements in his autobiography, which are corroborated by his writings from the period before his conversion to Schopenhauer's aesthetic pessimism (in particular his *The Art-Work of the Future*), and Karl Löwith's timely references in *From Hegel to Nietzsche*, trans. David E. Green (New York: Holt, Rinehart and Winston, 1964).

4. The anecdote is related in detail in A. Coeuroy, in the chapter titled "Teutonisme," pp. 143 et seq.

Of course he was merely symptomatic of his age: like so many others in his category he was a great protagonist in that great carnival that was the nineteenth century and that only came to an end with the Great War, the root and foundation of the great madhouse that our country has become.[5]

We cannot blame a Frenchman like André Coeuroy for raising the suspicion of Wagner's duplicity in the affair that followed publication of his Francophobic piece. The thesis is also supported by passages of his biography that allude to the strange combination of fanaticism and opportunism at work in each of his many conversions to this or that creed.[6] Wagner switched from one belief to the next with great fanfare: each time he embraced his fellow believers with blind faith and joined in persecuting the foe. As Hadow says, "He was constitutionally incapable of seeing any standpoint but that immediately before him; he was remorseless in burning what he had adored, he was of those to whom persecution is the necessary complement and climax of conversion."[7]

How can we explain this personality trait? Can we sum Wagner up as a two-faced opportunist, a blind follower who was as fanatic as he was shallow, or must we look more closely at the *vocational* motive for his behavior? Wagner obviously had a gift for theater. His passion for the stage is apparent even in his childhood. The histrionic part of his personality, which Nietzsche insists on again and again, may then be considered an outgrowth of this vocational zeal. He may have loved the stage because he felt at home there, at his most spontaneous and *real*, while he often unconsciously sensed that he was playing a role when it came to everyday life. If indeed he believed that he was Siegfried and Parsifal it was because his real life and the theater frequently overlapped, and his very identity became involved in the eternal theatrical game of changing

5. Manuel de Falla, "Notas."

6. I believe that anyone who reads Wagner's autobiography will agree with this statement. Wagner tested his convictions in heated discussions, where the *pathos* created by his fervor undoubtedly proved the sincerity of his budding faith. It would even appear that this *pathos* is the true foundation of his faith.

7. W. H. Hadow, *Richard Wagner* (London: Thornton Butterworth, 1934), p. 54.

roles and masks.[8] The same confusion characterized his love life. Going against the traditional interpretation of *Tristan*, Marcel Doisy doubts that Mathilde Wesendonck's appearance on the scene predisposed Wagner to write the opera. He bases his argument on Wagner's statement that art begins where vitality and happiness leave off.[9] Doisy writes,

We must rather ask ourselves to what extent Wagner's mental state, while he was immersed in writing this work, drove him to develop this infa-

8. Wagner played this game consciously while at the same time sublimating it on a metaphysical level, during his relationship with Mathilde Wesendonck. The proof is in his letters to her, *Richard Wagner to Mathilde Wesendonck*, trans. William Ashton Ellis (New York: Vienna House, 1972). Wagner read Schopenhauer's metaphysics and Calderón's drama in this period: his reading provided the doctrinal basis for an experience that took personal form in his love for Mathilde, and artistic form in *Tristan und Isolde*. It is typical of Wagner to shift constantly back and forth from life to art and art to metaphysics without reaching any lasting resolution. In the end, the reader of the letters does not really know where experience and genuine emotion leave off, and where play-acting and reflection on emotional experience begin. The letters are like footnotes or rough drafts of *Tristan und Isolde*, which was written at the same time, or reflections on it in the immediacy of its creation.

9. Wagner withdraws from the reality of his love life and the conflicts it created in order to find the uneasy peace, rest, and freedom that he craved in both his life and his work. He was like Tannhäuser, Wotan, Siegfried, Parsifal, Lohengrin, and the flying Dutchman, except that he chose Venice for his backdrop. In his autobiography he describes the anxiety he felt when he first saw the gondolas, whose shape and color reminded him of Charon's ferry. Venice means peace and freedom but also death, that is, the end of desire, the total extinction of emotion. Wagner wrote Mathilde several letters from there on this topic. He speaks of sublimating unrequited desire in a redeeming tranquillity that implies self-sacrifice, separation, and absence. This terrible event becomes transcendent in artistic creation, which is the next to last step toward sainthood. Art therefore implies the waning of both the desire to live and desire or emotion, which are completely transformed into a new kind of creative will that is beyond emotion and death. In these epistolary musings art is seen to be the antithesis of Nature, a phenomenon in which Nature's blind, untrammeled powers of creation and reproduction are overcome. Art is antinatural and so is the true love attained through self-sacrifice and absence, the love that proudly counters the fertile reproductive power of Nature. Of course this love is sterile, and in Wagner's interpretation its sterility gives it a special relationship to

tuation. We can assume by the same token that the eventual failure and frustration of the love affair must have spurred the dénouement of the drama, which was written after the break-up. This could be the subject of a disturbing psychological study.[10]

This would not be the first case of an artist organizing his life around his creative work, of course, in such a way that the empirical individual found himself subject to the creative individual's laws. When this happens the creator becomes the transcendent individual who determines the course of the experiment, and the real individual becomes nothing more than a character in a play, a Loh-

beauty:

He says that Nature pursues its ends blindly: its only concern is the species, that is to say, it only cares to live over and over again, in new forms, forever. The individual man, saddled with all the tribulations of life, is nothing more than a grain of sand in the immensity of the species, a grain that can be replaced by Nature a thousand times over, or a million. . . .

He says that Nature is not "sacred" except when it rises to tranquillity. . . .

He says that everything about him is antinatural, that he has no notion of family, of parenthood, of children, that his marriage was nothing more than an experiment in patience and correct behavior. . . .

He says that life or reality is every day more like a dream: the senses are dulled, sight clouds over, the ears cannot hear the voice of the present even though they want to, that we cannot see each other where we are but only where we are not. The present, therefore, does not exist, and the future is oblivion. . . .

Thomas Mann always maintained an intelligent and ironic distance from his mentors. Anyone familiar with the works of this great follower of Wagner and Schopenhauer will nevertheless notice the similarity between the settings and subject matter of the operas and "Death in Venice," "Tristan," the last part of *Buddenbrooks*, and Mann's essays on marriage, Schopenhauer, and Wagner—especially "Sufferings and Greatness of Richard Wagner" and "Richard Wagner and the Ring" (in *Essays of Three Decades*, trans. H. T. Lowe-Porter (New York: Alfred A. Knopf, 1947). One sees the focal point of Mann's inspiration in Wagner's Venice, in his relationship with Mathilde Wesendonck as sublimated in *Tristan und Isolde*, and in themes of the relationships between art and life, beauty and fertility, and art and creativity.

10. Marcel Doisy, preface to the bilingual edition of *Siegfried* (Paris, 1971), p. 26.

engrin, Tristan, or Parsifal, depending on what the creative process requires. In this way the creator assures the successful achievement of his vocational goal and continued self-fulfillment in his works. The metamorphoses of the individual parallel or follow from the metamorphoses of the creative work. Wagner, then, in good Feuerbachian style, identified with both Wotan, the hero of the present, and Siegfried, the hero of the future.[11] Likewise, he followed Schopenhauer to the extent that he saw through his hero and his "natural being," identifying instead with Brunhilda, the goddess made merely human who eventually despaired of humanity, from which she had expected her redemption. At the end of *Götterdämmerung*, transformed into a flaming pyre, she ascends to Valhalla, her father's house.[12]

It is also true, however, that Wagner's conversion to mystical religion at the time he was composing *Parsifal* must have combated the pessimistic point of view. In other words, he must have followed, in his life, the autonomous laws laid down by the work of art: his belief—and the conversion, apostasy, and adherence to the terms of good and evil, piety and impiety, that followed upon it— must have been dictated by the work's strange tyranny over its "author." Carrying this hypothesis to its extremes (although I am aware of its general limitations), it would appear that the normal relationship of the creator to his work was somehow inverted in Wagner's case. Wagner has often been called the perfect seducer. In *The Beloved Returns*, Thomas Mann reminds us that the artist, a born seducer, is also by definition continually seduced by Beauty,

11. Wagner himself used these terms in a letter to his friend and fellow follower of Bakunin, Roekel: "Look well at him [Wotan], for in every point he resembles us. He represents the actual sum of the Intelligence of the Present, whereas Siegfried is the man greatly desired and longed for by us of the Future. But we who long for him cannot fashion him; he must fashion himself and by means of our annihilation." *Letters to August Roeckel*, trans. Eleanor C. Sellar (Bristol: J. W. Arrowsmith, 1897?), pp. 100–1.

12. Wagner's identification with Tristan is amply, even boringly, indicated by his correspondence with Mathilde Wesendonck.

the visible face of Death.[13] Wagner was the consummate seduced seducer. His work, his creation, was the tangible presence of the Beauty that seduced him. He was seduced by his works and by the characters he personified and with whom he identified. At times he could seduce and bewitch them in return with his music and his drama. Like the witchdoctor described by Lévi–Strauss, he had to bewitch and hypnotize himself in some authentic way before he could do the same to his "patients." Wagner was living proof that one person can infect many others with his conviction, creed, or fanatical belief: a man must convince himself of the validity of his belief before he can convince others of it.[14] No wonder that Nietzsche, in the writings that follow the private split with Wagner

13. The notion turns up repeatedly in Goethe's monologue (chapter seven) in *The Beloved Returns*. On the relationship of Beauty to Death see the lines from Von Platen cited by Mann in his essay on marriage.

14. See the chapter on shamanism in Lévi-Strauss's *Structural Anthropology* (New York: Basic Books, 1963), where there is a detailed description of the witch-doctor's strange mise-en-scène, designed to allow him to "incorporate" the victim's disease (the evil spirit). He mimes the patient's characteristic movements and gestures. His *identification* with the patient, to use the term common to psychoanalysis, can be said to constitute a lesser form of *possession*. This in turn is a minor variation on the general theme of *mimesis*, which is so basic to our understanding of the disturbing mechanisms that rule our psychic activities and the realities of *stage-acting*.

Wagner's life gives numerous indications of the connection between mimetic talent and the way in which invention stimulates the body, causing constant rashes, swellings, and inflammations. These are truly "imaginary diseases," in the narrow sense, as their immediate cause is undoubtedly the Imagination. Thomas Mann found material for his characteristically subtle observations in these phenomena. We need think only of Christian, in *Buddenbrooks*, or Felix Krull, with his terrible contractions of the pupils and "make-believe fevers." This experimentation with the body on the part of the imagination is part and parcel of Mann's conception of the artist. Measured against Freud's inquiries into hysteria this could be a fruitful area of study, if given a careful, detailed, and broad-minded treatment, free of doctrinaire preconceptions.

On the relationship between the activities of the witchdoctor described by Lévi-Strauss and the problem of belief, see Dominique Octava Mannoni's superb remarks in *Clefs pour l'imaginaire, ou, L'autre scène* (Paris: Éditions du Seuil, 1969), the chapter titled "Je sais bien, mais quand même. . . ."

that antedated the public split, used every means he could think of to examine the mechanics of the creation and transmission of beliefs.[15]

III

We have drawn close to the mythical figure of Proteus, the creature without being or substance who exists in a state of permanent metamorphosis. We are also in the presence of the witch Circe, the true goddess of stagecraft, whose magic powers work constant changes in men and things.[16] Nietzsche's condemnation of Wagner breaks down into precisely these charges: magic, witchcraft, drugging or numbing the will—his own and others'—play-acting, hysteria.[17] These labels can only be insulting to those who are distant from the world of the stage and immersed in the world of *fiction*, to those philosophical spirits who from Plato to Nietzsche have found it highly attractive and at the same time unbearable to be around artists. Is it surprising that Plato expels the artist from his republic on the grounds that he deals in lies and the creation of images, when a clear distinction has already been made between the true deity that is the object of philosophical contemplation and the false pretender to that title? The former is by nature One and homogeneous, most simple and pure and free from change, while the latter is in a perpetual state of becoming: lacking substance, always changeful and impure, it is synonymous with the image, the *eidola*, always metamorphosing. This is why Plato compares

15. This begins with Nietzsche's private or "esoteric" writings from before the public feud, especially those pieces from the so-called (for better or worse) "positivist" period, in which he extended his friend Paul Ree's study of the genesis of moral belief.

16. On the meaning of Proteus and Circe see Rousset's excellent study of baroque culture, *Circe y el pavo real* (Barcelona, 1973).

17. These terms appear over and over again in "The Case of Wagner" and "Nietzsche contra Wagner." They characterize the works of the final period in general.

the false pretender to Proteus.[18] The artist is sympathetic to Proteus: he naturally embodies the mythical figure of the trickster. Like the sophist, he is the true mime of knowledge. He is not all things, he only makes copies of them. He does not know all things, he simply reflects them in a mirror that faces in all directions.[19]

The entire drama of Platonic philosophy centers on the problem of the One's mediation with the many, *to hen kai to pan*. All of the incongruities associated with the problem can be found in their rough, unpolished form, in the *Parmenides*. At one moment the One must be disproven so that the many can be affirmed, at another moment the many is suppressed in the interests of preserving the One. In the first instance the totality of being loses substance and foundation, becoming almost a simulacrum, and the boundary between true knowledge and deceit, philosopher and artist, understanding and illusion threatens to disappear. In the second instance Unity becomes an unthinkable, mystical ideal, and the philosopher flounders in desperate pursuit of this needed and desired object, which never gives its imprint to the world of multiplicity.[20]

It is no surprise that Nietzsche takes up a number of characteristically Platonic *topoi* with the express aim of overturning Platonism. One of these *topoi* is the notion of art's alliance with falsehood, illusion, appearance, and the world of the *eidola*. The artist creates lies. He is a trickster and a seducer. Dionysus, god of appearances,

18. "Do you think of a god as a sort of magician who might, for his own purposes, appear in various shapes, now actually passing into a number of forms, now deluding us to believe he has done so; or is his nature simple and of all things the least likely to depart from its proper form?" Plato, *Republic* 380d (p. 72). Later in the dialogue Plato refers to Proteus, chastising those mothers who have been influenced by the poets and who "scare young children with mischievous stories of spirits that go about by night in all sorts of outlandish shapes" *Republic* 381d (p. 73).

19. To begin with, the poet hides his identity: he lets his characters, who are "other" than "himself," do all the talking. The only exception is the lyric or epic poet who at times speaks in his own name. When tragedy or comedy is properly staged the author disappears from the work. The camouflage succeeds completely and perfect mimesis is achieved.

20. On this subject see Víctor Gómez Pin's outstanding books, *De usía a manía* (Barcelona, 1973) and *El drama de la ciudad ideal* (Madrid, 1974).

is the true artist: like Proteus, his face, his mask, his entire outward appearance undergo a never-ending series of metamorphoses. For Nietzsche, Dionysus is the real demon, because for Nietzsche the real demon is nothing but "skin" or surface.[21]

The ambiguous or suspicious aspects of Wagner's proteiform character put him in dangerously close contact with Dionysus, the god of masks. They also set him apart in a way that is difficult to grasp but which clearly brands him the "false pretender" to the Dionysian title. Wagner therefore seems to be both the confirmation of these hypotheses and their experimentum crucis.

We might even conclude that Proteus is a spurious version of Dionysus. This requires an explanation.

IV

The desire that flows through Nietzsche's work is shaped by the often-evoked triangle of Perseus, Ariadne, and Dionysus. Dionysus is the artist who defeats the hero and claims Ariadne as his spoils. Wagner's relationship to Cosima, who left her husband and her father, can be understood in these terms. The intrusive philosopher tries to find a place at the heart of the triangle, but it is always occupied. There is room only at the end of his life, in the insane hallucinations that follow his tragic declaration of love (I love you, Cosima), when his mind is completely clouded. Only then can he say, "I am Cosima Wagner's husband."[22] Nietzsche signs his last letters with the name that corresponds to his real identity, Dionysus. But by then he is Dionysus crucified.

The syntagm of the crucified Dionysus helps us to differentiate between the god of masks and Proteus, the dangerous pretender.

21. "When the Devil casts his skin does his name not also fall away? For that too is a skin. The Devil is perhaps—a skin." Friedrich Nietzsche, *Thus Spoke Zarathustra*, trans. R. J. Hollingdale (Baltimore: Penguin Books, 1968), p. 285.

22. On March 27, 1889, already hospitalized, he says: "My wife Cosima Wagner brought me here." "Historia clínica de Jena," in *Revista de Occidente* (August-September 1973), p. 282.

Like Proteus, Dionysus obeys the law of perpetual metamorphosis by changing masks. Unlike Proteus, however, each of Dionysus' actions, each stage through which he passes profoundly affects the character's very body and soul. Each time he changes skin, so to speak, he sheds it.[23] Each change is a torture, each step a Gethsemani with all the attendant suffering, flagellation, shame, crucifixion, and *consummatum est*. The pain itself is the prerequisite for subsequent rebirths.[24] Through extreme suffering alone does the law of return become reality.

Nietzsche's questions about the proteiform nature of the dramatic artist are based on this point: does the actor truly suffer during his metamorphosis or does he merely act like he is suffering?[25] Good philosopher and investigator that he is, Nietzsche lays his own sufferings on the table as a carefully chosen trial case, object of the Salomonic decision as to who is the true and who the false pretender to Truth. And Truth, for Nietzsche, is synonymous with anguish. If Truth and pain are the same, then the philosopher's ability to bear the truth indicates his threshold of pain. Nietzsche is suspicious of the change or metamorphosis that takes place painlessly, and he is equally suspicious of purely *simulated* pain. Unlike the voluptuously *moral* and quite unesthetic pleasure that the philosopher derives from his self-laceration, simulated pain is voluptuous in a

23. Nietzsche repeatedly uses the image of the snake to represent knowledge. The snake must shed its skin if it is to survive.

24. On the suffering that comes from changing one's doctrines or beliefs, a genuine change of skin for the understanding, see Lou Andréas-Salomé's perceptive psychological analysis in her *Friedrich Nietzsche in seinen Werken* (Vienna, 1894), especially the chapter symptomatically titled "His Metamorphoses."

25. I do not mean to imply, of course, that the artist—in this case, Wagner—did not suffer spiritual anguish as great as the philosopher's, in this case Nietzsche. Wagner's biography dispels any illusion about his having led a "happy and self-satisfied life." I am simply trying to call attention to the process that leads a man from one belief to another, that is, the spiritual trajectory that ends in a change of belief or doctrine. Whereas the philosopher suffers his greatest anguish *at the moment*, in his very flesh, the artist (Wagner) much more openly externalizes the transformation. The artist's anguish is of a different sort, but it has no *express* relationship to the problem of the change of belief.

false, decadent sense.[26] The dramatic artist's *aesthetic* pleasure, the morbid delight in simulating pain that comes when reality and the stage become confused, is opposed to the moral imperative of the philosopher, who becomes his own tormentor.[27] From the philosopher's heroic stance, then, we pass to the presence of the actor on stage.

Nietzsche tried to be all things, all the time aware that laceration and a painful death on the cross accompanied the transition from each state of being to the next. He also tried to know all things: he changed his creeds and visions of the world a number of times. In good scholastic fashion he could separate his Romantic phase from his positivistic phase and both from maturity. And yet each change of skin grew out of nothing less than the torture he inflicted on himself, body and soul. Wagner, by contrast, found a theatrical

26. Lou Andréas-Salomé, in the work cited above, presents a truly perceptive analysis of this phenomenon. Nietzsche's one-time admirer concludes that the composer's soul "is split into a god that requires sacrifices and a sacrificial victim." Nietzsche himself made an impressive analysis of the cruelty inherent to the relationship between torturer and victim and the pleasure both parties derive from it. See *The Genealogy of Morals*, chapter 2.

27. There are many semiconscious—and therefore quite "romantic"—references in Wagner's life and works to the alliance of pain and lust. Consider, for instance, the profound enjoyment that Tannhäuser experiences when, satiated by the pleasures of Venusberg, he "wants to suffer." In his work on Tannhäuser, Baudelaire examines this phenomenon in great detail and with the great lucidity—that is, in a "late" or "post-Romantic" manner—characteristic of the "setting of the Romantic sun." This further supports my contention that Wagner's aesthetic sensibility undergoes rites of passage.

To reduce the point in question, *ad usum delphini*, to a barbarous term like "masochism" would be an affront to historical common sense. Sacher-Masoch occupies a previous stage in the evolution of consciousness. He is something of a premonitory spirit in whom the complex intertwining of reality and drama, felt and feigned emotion, spontaneity and play-acting, and every aspect of the problematic relationship of torturer and tortured and the pleasure derived by both parties, have already been clarified and resolved in favor of self-consciousness, lucidity, and a kind of play-acting that is perverse by virtue of its very straightforwardness. Wagner, on the other hand, and even Baudelaire must still make references to the "romantic sun," even though it shines in the elegiac tones of nightfall and twilight.

way to fulfill the humanistic, Faustian ideal with which he so thoroughly identified. At the root of Wagner's many identifications, Faust himself seemed to be a character who could be incarnated and played on stage.[28] Wagner fulfilled the Faustian or humanistic ideal through play-acting. He never became all things, he simply acted them out and in the process testified to the bankruptcy of humanism. In this sense his experience was diametrically opposed but also complementary to Nietzsche's, which fulfilled the same ideal, perfectly complemented Wagner's, in the realm of hallucination.

The ideal could in fact only be fulfilled through an ongoing dialectic between truth and art, between the role of the philosopher and the role of the artist. In this way the transition to play-acting and the stage could be accomplished without blocking reason's access to perfect clarity and understanding. Wagner lacked the clarity and self-awareness that made the Emperor Augustus, as Nietzsche reminds us, sense the *truth* that the theater came to represent in the course of its development.[29] We never hear Wagner say *Comoedia finita est* either explicitly or implicitly, unless we give *Parsifal* a shrewdly favorable interpretation as a work of cynicism and parody. This opera proves, on the contrary, that at the end of his life Wagner found yet another way to dodge the truth, this time through mysticism.[30]

28. His beautiful overture *Faust* is proof of this.

29. To the extent that he interprets "Qualis artifex pereo" in the same sense as "Plaudite amici: comoedia finita est" in his argument against the Socratic method, Nietzsche actually assimilates the last words of Augustus and Nero. Each of these great figures had a different personal notion of theatrical self-consciousness, Augustus being more in favor of consciousness and Nero more in favor of sheer histrionics. This will become clearer in context, below. The relevant text by Nietzsche is aphorism 36 of *The Gay Science*.

30. Nietzsche maliciously interprets *Parsifal* to be Wagner's swan song to tragedy. The masks fall, making way for the transition to comic or burlesque lucidity. (In both Nietzsche and Hegel comedy is closer to the truth than tragedy because it is the moment of enlightenment in which, as *Thus Spoke Zarathustra* puts it, even tragedy seems comic.) Nietzsche asks, "was Wagner earnest with Parsifal? . . . We should like to believe that *Parsifal* was meant as a piece of idle gaiety, as the closing act of a satyric drama, with which Wagner the tragedian wished to take leave of us, of himself, and above all *of tragedy.* . . ." (in "Nietzsche contra Wagner," *The Case*

This is why, despite his genius and his faithful representation of his period's culture and society, which were the fertile soil of our own, Wagner fails to reach genuine greatness or to develop the "grand style" that Nietzsche searched for in vain among his contemporaries. Shakespeare is the custodian of this style. In a famous section of *Hamlet* he describes, with unparalleled clarity, the artist's innate ability to give shape to his soul's anxieties, hopes, and fears in the form of dramatic characters. In *The Tempest*, Shakespeare consciously and faithfully fictionalizes his own experience, identifying himself with Prospero, who, like the artist, uses witchcraft and magic to govern the natural elements of his island. Prospero manages the on-stage action from behind the scenes, directing and molding it to the specifications of his master plan. At the end of the play, before retiring from his office, he gives an extraordinary speech in which he reveals his true identity. In fact he relinquishes his magic powers and takes leave of the stage with more or less the same words uttered by Augustus: *Comoedia finita est*. Despite his genius, Wagner apparently comes from the same stock as those who, like Nero, make quite a different pronouncement as their end approaches: *Qualis artifex pereo!* These last words may point to a definition of what could be called the "Grand Style," a form of *classicism*. They also mediate between the realm of beauty—which takes concrete shape in images—and the realm of truth—which

of Wagner, trans. Anthony M. Ludovici [New York: Russell and Russell, 1964], p. 71). Comparing this paragraph with the previously mentioned section of *The Gay Science* and those sections of *Zarathustra* that discuss the relationship of tragedy and comedy, one finds a number of patterns that are helpful for understanding Nietzsche's aesthetic in depth, specifically his fundamental notion of the *Grand Style*. A thorough investigation along these lines would prove that Nietzsche's aesthetic was "rational(ist)," I believe, somewhat in the sense proposed by Galvano della Volpe in his work on Nietzsche's aesthetic (in the chapter of his *Crisis de la estética romántica*, dedicated to Nietzsche), even though this author wastes an opportunity to expand the scope of his analysis. Della Volpe reconciles Nietzsche's aesthetic with Croce's intuitionism, when it is clear that Nietzsche's attempt to transcend the romantic aesthetic would have failed had he been an intuitionist. In any case this question goes far beyond the epistemological scope of the Italian philosopher's theory.

constantly strives to unmask imagery. They join the world of art (fiction, drama, and art) to the world of philosophy.

Nietzsche tried to find the magic formula that would unite art and truth by ridding art of its purely theatrical, mimetic nature while at the same time preventing philosophy, as typified by Socrates and Plato, from stubbornly denying the inherent truth of art. His search for the Grand Style is symptomatic of his attempt. He sought a new classicism that would keep art from being decadent (from becoming purely Protean) and keep philosophy from being so narrowly focused (and denying the artistic urge). Nietzsche's commitment to life led him to fight in favor of stimulating, vitalizing forms of art and against Schopenhauer's narrow obsession with truth, while his commitment to truth made him combat those spurious kinds of art that capitalized on theater and imagination. Nietzsche's weapons were empathy and his personal experience of suffering and crucifixion, the prerequisites of artistic as well as philosophical activity. In other words, Nietzsche sought truth in art and art in truth. His goal was always beyond his reach, however. Neither he nor his contemporaries were able to give it concrete form.[31]

V

Wagner's art therefore lacks the *critical* aspect of art as it appears in the grand styles of Shakespeare, Goethe, and Schiller, among others. The *last words* are never said. Because it lacks this critical aspect Wagner's art constantly confuses felt emotion and acted emotion. Nietzsche accurately accused it of being effectivist and hypnotic and only rarely rising to great heights (in the magnificent

31. This important theme can only be hinted at here, as it obviously demands a detailed treatment based on a broad but painstaking exegesis and criticism of Nietzsche's work. In fact I believe that Nietzsche's aesthetic is one of the least explored areas of his thinking. It is also one of the most useful for our understanding of his philosophy and the modern sensibility as well.

opera *Tristan und Isolde*). But its very success is based on its inability to exercise critical judgment regarding the excesses of enraptured inspiration. In this sense it is the art form most representative of the "great carnival that was the nineteenth century," in Manuel de Falla's words, a carnival that lacked the rational, moderating influence that would have come from recognizing that it was a carnival. Instead, it took itself for the norm, for reality, and the truth about it could be known only by critical effort of the most destructive, corrosive sort, by criticism bordering on nihilism. This was the voice of those who ripped away the veil of Maya, behind which genuine feeling and acted feeling, real action and theatrical declamation, coexisted in true Romantic confusion. This intense criticism was more radical than anything dreamt of by Kant. It revealed a desperate, unseemly creature stirring behind the façade of what passed for reality, a creature that was dubbed Will, the Will to Power, class struggle, natural selection, or the survival of the fittest. In the form of Marxism, psychoanalysis, and neopositivist or analytical philosophy, our century's philosophical experience grows directly out of that act of unveiling. In *Der Zerstörung der Vernunft*, Lukács for once shows a fine sense of humor, remarking that carnival is over and Ash Wednesday, the first day of Lent, is upon us—a Lent that ends in the unholy Friday of two World Wars. Carnival and the criticism that came in its wake are transformed into "the great madhouse that our century has become," to quote Manuel de Falla again.

The same tragedy has occurred in the theater as in philosophy and, generally, in the day-to-day social reality of modern times. Theater vacillates between fulfilling its rigid, unromantic duty of providing carnival, fostering an art form from which reason is banished once and for all and giving free rein to the raw gestures of primitive instinct—and, on the other hand, its obligation to present a solid critical view that protects reason from the mesmerizing incursions of a bewitched and enchanted world, even at the cost of divorcing fiction from the stage. At one extreme is carnival, untempered by reason; at the other, Reason untempered by carnival.

VI

Seen from a certain height, Nietzsche-Zarathustra reminds us, the greatest tragedies seem comic. In the *Phenomenology*, Hegel suggests that comedy, as an instance of self-consciousness, represents a more advanced stage of the mind's self-constitution than either epic or tragedy. Comedy always comes after epic and tragedy as their moment of truth and act of enlightenment. By contrast to them comedy is *lucid*: it shows the masks for what they are, simply masks, by measuring the distance between the mask and what it masks. This measurement thereby becomes a verification or exposé of the truth, and if it takes the form of laughter it is because laughter is the subjective response to the entire process, a concrete sign that designates the void that separates the mask, perceived as simply mask, from what it actually masks. For there to be laughter, someone or something—a specific character or situation—must verify the truthfulness of the context. This is what the maid does in *The Imaginary Invalid*.

In the Ring Cycle the role of unmasker is played by Loki, the spirit of fire, and—more ambiguously—by Wotan, the most complete of Wagner's characters. By comparison to these ethereal prophetic figures the ancient gods look like stiff-jointed marionettes whose puny stature does not correspond to their circumstance, the period of decline in which they are living and suffering. Man's exposure of the gods is not, in this respect, a meaningful act of verification: Siegfried immediately proves himself to be a "paper tiger." This is clear from his pitiful, necessarily unconscious behavior in his protector's presence and also, more importantly, from the silly stories—the true epic of the *miles gloriosus*—with which this final opera of the series ends. Man is also Mask: this is the serious and truthful lesson of Wagner's enormous opus. The same spirit of enlightenment and comedy that shrinks the stature of the gods here goes to work against Man, the creature who seemed to emerge victorious from the unmasking. The anthropology which Feuerbach lovingly substituted for theology shows its critical weakness on this point, becoming a victim of its own insufficiency, and

Wagner was Feuerbach's sometime pupil. In other words, although men, transformed into gods, follow in the footsteps of the gods, the spirit of enlightenment and comedy ridicules man's latest metamorphosis, showing that behind the façade lurk the un-human depths to which man reverts in an inevitable process of decline and fall. This revelation brings down the house, only this time Man is one of the stick-figures on stage.

The unveiling of Maya identifies the substance of those depths to be the will to power, wealth, and heredity. The plot and the protagonists of the future drama reside there, and this drama surpasses the tragedy and comedy that bring it to light. It is the novel, a genre without gods or heroes. It presupposes the completion of the process of enlightenment, criticism, verification, and laughter. What we understand by the novel in the *modern meaning* cannot be reduced to what it may have been considered before this process was complete. The modern novel is born when Money (Balzac) and Heredity (Zola) become the true protagonists. Flaubert gave it genuine dimension by showing the hero and heroine's supreme stupidity and inability to progress or mature. Once this revelation has been made and the very mold of the Bildungsroman (the novel's archaic form) has been shattered, and with it the rites of apprenticeship and passage, a space is opened for deviation and unattachment, a space in which men and objects float aimlessly. The modern novel gives revealing names to this aimlessness: Kafka's Castle, golem, Godot. Characters wander about cities whose streets lead nowhere at all, be they in Dublin or Mexico City. Because he lived so close to the heart of contemporary life, Wagner communicates this irreversible process in the Ring Cycle. He does so despite himself, all the while revealing his personal distaste for clarity and comedy. This is his lasting truth and his legacy and what makes him our genuine contemporary. Indirectly, perhaps even unconsciously, he clears a space about which we can think and write, in which we can live and act, believe or not believe in an age when there are no more gods, heroes, demigods or demiheroes—in *our* culture, where there are no protagonists. In this space the streets never lead anywhere, as in that mysterious, prophetic, and quasi-

cabalistic city called Prague. Each twist of the labyrinth leads to another labyrinth, and over them all reigns the feverish countenance, in the form of grotesque mask or cackle, of the always elusive Golem.

And yet the imposing outline of the Castle can be seen from any vantage point in the city. It is a secular Valhalla transformed into an object of fruitless pursuit, paralysis, and nightmare.

7

Nietzsche: Mind Divorced from the City

I

On January 6, 1888, whatever meaning the life and works of the hermit of Sils-Maria may have had for his contemporaries until then underwent an important change. It would be more accurate to say that from that moment forward Nietzsche's life and works acquired meaning for modern culture. Until then he had been virtually ignored and so little read that he had had to edit the fourth part of *Zarathustra* by himself and print it at his own expense, as he could not find a publisher. On the day he went mad Nietzsche began to abandon the extreme isolation that had characterized his life as a philosopher and became a major cultural figure. His insanity would appear to be the price he paid for this transformation, as if the living man's retreat from public life, his radical introspection and surrender to the most extreme and haunted privacy, were the indispensable condition of his promotion to the rank of well-known public personality. The critic is seized with doubts about the link between both series of events: the connection seems paradoxical unless there is a hidden hypothesis or suspicion of some underlying law applicable to the "Nietzsche affair," where it is most purely exemplified, and to other analogous cases. Must the authentic philosopher or artist retreat from public life and personal contacts in order to achieve notoriety in present-day culture? Must he efface

his qualitative worth in order to appear legitimately in the unin-
carnated guise of a Double, as if this were a public, communicable,
and interchangeable sign? If this is so, then Nietzsche's existence
as a legend begins when his personal history ends, and 1888—a
year to which he explicitly refers in one of his letters—is his Rub-
icon.[1] His history divides neatly into a first, specifically historical
half, and a second half which is legendary.[2] In the second half
Nietzsche becomes part of the Collective Unconscious: he is sud-
denly an indispensable cliché, a battle cry for some, for others an
intellectual catalyst, but for all an obligatory point of reference.
What happened to Nietzsche on January 6, 1888, awakens his con-
temporaries' attention. They are fascinated by and drawn to this
unknown thinker. Ten years later begins his dizzying and ironically
triumphant, we might say, conquest of all Europe.

Nietzsche, then, really crossed two Rubicons: the first time as
an historical individual and the second as a cultural Sosias who
comes into being with and at the cost of the other Nietzsche's
madness. The second phase is a genuine *vita nuova*. It presents the
double face of the institutionalized madman who is every name in
history ("I am the husband of Cosima Wagner," "I am the Kaiser")
and who is also a cultural Sign endowed with the secure and solidly
based identity of a household name, an Immortal.[3] This paradoxical
double Return assures his immortality: Nietzsche the flesh-and-
blood man becomes all things by riding the circuit of Being until
he returns to his own self, while Nietzsche the cultural entity
achieves a selfhood of the monolithic variety through the words,
the writing and the reading of others. In the first instance the
individual accomplishes the return by breaking entirely with cul-

1. Letter to Peter Gast, Turin, December 31, 1888.
2. "I am strong enough to cleave the history of mankind in two." Letter to August
Strindberg, Turin, December 7, 1888. In *Selected Letters of Friedrich Nietzsche*,
trans. Anthony M. Ludovici (London: William Heinemann, 1921), p. 308. On
Nietzsche's reinterpretation of history and myth, see Ernst Bertram, *Nietzsche, Ver-
such einer Mythologie* (Berlin, 1921).
3. "Fundamentally, I am every name in history." Letter to Jacob Burckhardt,
January 6, 1889. Cited by Ronald Hayman, *Nietzsche, a Critical Life* (New York:
Oxford University Press, 1980), p. 336.

ture; in the second, the accomplishment is predicated on breaking all ties to nature and history. The legendary or mythical man is then opposed to the historical individual.

Nietzsche criticism should try to reach the middle ground between nature and culture, privacy and public life, history and myth, madness and normality by examining the forced connection between the first and second transitions. The middle may well be the ground that properly belongs to criticism, the area in which criticism can confirm its priestly, mediating function.[4]

II

First of all, we must use common sense to belittle our suspicions. It is only natural that the news of Nietzsche's insanity should have deeply shaken public opinion, and that the general attention should have turned at once to the life and works of the hermit of Sils-Maria. The impact was especially great on the young, as there are observations of incalculable value in Nietzsche's work on the phenomenon of decadence, which was so deeply experienced by the generation that came of age at the height of the fin-de-siècle mood. Nietzsche's work is rich in schemes to rejuvenate the ailing body and spirit of Europe.[5]

And yet none of these facts invalidates our suspicions. Other kinds of explanation are required. Let us propose a very experimental, perhaps even far-fetched hypothesis: its exaggeration may itself shed some light on the issue. This hypothesis might be called the "paradox of present-day culture." It makes the rather apocalyptic claim that the recognized public character of the creative artist or thinker is inversely proportional to the quality and authenticity that the created work is supposed to have. A corollary of this law might be proposed to cover the case that concerns us

4. I examine this theme in my *Filosofía y Carnaval* (Barcelona, 1970).
5. Similarly in Spain during the crisis of 1898. In the eyes of the new generation Nietzsche was the prophet of spiritual rebirth. See Gonzalo Sobejano's well-documented book, *Nietzsche en España* (Madrid, 1967).

here. It would state, in very apocalyptic fashion: "The transaction
between the shared social character of the creative individual and
the quality and authenticity of the created object can only be com-
pleted if the creative individual withdraws from society by going
mad, dying, becoming silent or, like Rimbaud, turning his back
on or deserting society." I am perfectly aware that this conceit
dressed up to look like theory is on the casual, off-hand side, if not
downright lunatic. But it may conceal a grain of truth that will
help us make our way through the dense jungle of present-day
culture, with all its endless imperfections and schisms between the
private and public sectors, between the privileged elite and the
masses it manipulates. And this culture grows out of the fin de
siècle milieu in which Nietzsche, the object of our study, lived,
fought and went insane.

These same imperfections and schisms are openly and explicitly
described early on, in works from Nietzsche's youth, as in the
section of *Thoughts out of Season* titled "Richard Wagner in Bay-
reuth." In all of his later works it appears as an obligatory, recur-
rent, and even repetitious leitmotif.[6] As a wonderfully naive, genial,
and idealistic young man Nietzsche was deeply disgusted by the
ugliness of the daily life it was his lot to live and by the philistine,
childish, uneducated, crass, and vulgar nature of the public that
every artist and original thinker—the artist's ally and confidant—
must potentially do battle with. This becomes especially clear if we
take into account the impracticality of the standards by which
Nietzsche was judging his times, that is, the ideal of a resuscitated
Greek classical learning that required a loving marriage between
young philologists and the cream of the Wagnerians. This strong,
idealistic young man had passionate faith and hope: in the best
tradition of German classicism, he combined the qualities of the
preacher, the depth of the pre-Socratic philosopher, and the initi-
ative of an educator. Surprisingly, when it came to founding a new
classical age, a new Greece in which Wagner would represent the

6. Regarding Nietzsche's shock at encountering the Philistine, *demimondain*
world of the Reich and the Second Empire at Bayreuth, see Charles Andler's inter-
esting *Nietzsche, sa vie et son oeuvre,* especially the second book.

spiritual return of Aeschylus, Nietzsche at first resisted undergoing
the difficult test of a reality principle that was infinitely more hostile
than that against which Winckelmann, Goethe, Schiller, and
Hölderlin had had to measure themselves.[7] But little by little he
awoke from his magnificent dogmatic slumber (*Et in Arcadia ego*).
His growing melancholy confirmed the lucidity he acquired after
renouncing the educational and reformist ideals of his early youth.

His pact did not, however, dictate his renouncing the role of
authentic philosopher of the pre-Socratic mold. He would never-
theless pay an extraordinarily high price for the truthfulness and
honesty he inherited from Schopenhauer by comparison to those
who had led the philosophical life in earlier periods, when culture
was more harmonious, less estranged from social reality. He would
also as a consequence find himself to be "out of season" (yesterday
as well as the day after tomorrow) and begin his career as wandering
Jew, moving from one spa to the next. Readers of the section of
Thoughts out of Season dedicated to Wagner, in which Nietzsche
sketches Wagner's profile through references to *The Flying Dutch-
man*, *Tannhäuser*, and *Lohengrin*, will suspect its autobiographical
nature, later confirmed by *Ecce Homo*.

When Nietzsche in lucid desperation undertakes to live in soli-
tude, substituting the fleeting presence of ghosts for the company

7. "In the long run I have become aware of the importance of Schopenhauer's
teaching about the wisdom of the universities. A thoroughly radically truthful ex-
istence is impossible there. . . . So it comes to this, we shall sooner or later cast off
this yoke—upon this I am firmly resolved. And then we shall form a new Greek
Academy—Romundt will certainly join us in that. Thanks to your visits to Triebschen
you must also know Wagner's Bayreuth plan. . . . Even supposing we get but few
adherents, I believe, nevertheless, that we shall be able to extricate ourselves pretty
well—not without some injuries, it is true—from this current, and that we shall
reach some islet upon which we shall no longer require to stop up our ears with
wax. We shall then be our own mutual teachers and our books will only be so much
bait wherewith to lure others to our monastic and artistic association. Our lives, our
work, and our enjoyment will then be for one another; possibly this is the only way
in which we can *work* for the world as a whole. . . . Ought we not to be able to
introduce a new form of the Academy life into the world. . . ?" Letter to Erwin
Rohde, Basle, December 15, 1870. Signed Frater Fridericus. In *Selected Letters of
Friedrich Nietzsche*, pp. 73–75.

of friends (he later aggrandizes his ghosts, making them strictly mythical companions), he is making an important change of scenery from his youth, when he did battle against real institutions (the University, Bayreuth), real enemies (Wilamowitz), and public enemies known to others.[8] As soon as he abandons the world of institutions, the arena of confrontation and conflict changes for him. No longer will he meet and tangle with real or potential enemies in the agora, which in the meantime has become a marketplace dominated by spurious interests, if not by a monolithic state. From the external space of the city he moves to the internal space of the soul, which acquires the shape of a fortress or citadel: inside, conflicting powers do battle, and to the extent that each one of them defends an antagonistic interest or urge, no truce is ever made. There is instead a somewhat chaotic succession of dynasties, each one of which exercises a precarious hegemony by dominating the others. Classes, estates, and spheres of influence in all their dynamic relationships of dominance, hegemony, and detente make up the metaphorical arsenal of the psychologist's subtle explanations and determine his approach to the sea of urges, emotions, virtues, and mental faculties.[9]

The new soul will nevertheless lack any authentic connection to the city in its concrete identity "outside" the individual. The Platonic correlation of soul, with its repertory of powers and corre-

8. The first devastating blow comes from his colleague Wilamowitz in connection with the publication of *The Birth of Tragedy*. See Nietzsche, Rohde, Wilamowitz, and Wagner, *La polemica sull' arte tragica* (Florence, 1972). Included are Rohde's two critiques of Nietzsche's book, the text of the Wilamowitz-Möllendorff polemic, Richard Wagner's open letter to Nietzsche defending his book, and the Rohde-Wilamowitz debate over it.

9. This kind of metaphor is abundantly present in all of Nietzsche's works. He speaks of conflicts among the virtues and of the hegemony of the strongest virtue over the rest in language best adapted to describing the external world. Applied to the objective world, this ambiguously "spiritual" terminology "subjectivizes" it a posteriori. We might say that this description of the subjective world is metaphorical in the first degree, while the description of the external world is so only in the second degree. The dialectical relationship of subject and object, which maintains difference within unity, has been smashed. As a result of this schism, dialectic can only be reestablished by the use of metaphor.

sponding virtues, and city, with its many estates, is thereby broken. It is true that for Plato the correlation took place through the Forms, not in the material world. But the fact that it had been at least established enabled Aristotle to formulate the second necessary connection, that is, the concrete synthesis of world and idea. Nietzsche's work sanctions the schism between the psychological realm of the individual and the socio-political reality of the objective world. The city has been internalized, in a manner of speaking, transformed into the individual's exclusive fiefdom, which absorbs the attributes of the external world in a purely metaphorical way. The *Dinge an sich* or *ens realissimum*, the objective residue of the transition to metaphor that comprises the concrete, empirical city—the realm of facts, reality, or the "thing in itself" that Nietzsche's criticism shows to be the domain of intersubjectivity and compromise—can be said to lose its rich complexity in the eyes of the recluse. It becomes an obscure, colorless, confused Mass without features or nuance. One is aware of it only insofar as it affects the individual.[10] And what one does know is certainly unpleasant and disheartening.

The true conflict is played out on the internal stage, and it deserves to be given attention, importance, outpourings of energy and devotion. The recluse fights his decisive battles there, and each battle is a milestone marking the individual's painful encounter with his own internal contradictions. On this stage one part of the self alternately tyrannizes the other through the systematic exercise of voluptuous cruelty or celebrates its victory in acts of solidarity and exaltation in a true orgy of triumph.[11] The danger does not therefore come from external beings but rather from the chambers of the internal citadel. The Adversary—the hostile spirit of negation

10. The external world acquires the identity of a naked abstraction—the Masses, the Marketplace, the State.

11. Lou Andréas-Salomé presents a perceptive analysis of Nietzsche's double identity of self-torturer and victim, in *Friedrich Nietzsche in seinen Werken*. Madame Lou seems to follow Lévi-Strauss's "scientific" ideal to the letter, treating men "as if they were ants." Although the result of the experiment is scientifically irreproachable, it is debatable from an ethical point of view and is of doubtful aesthetic value.

that drags down everything before it—launches its most harmful attacks in the underground corridors and fathomless depths of the self, changing first into a dwarf, then into a mole, a wizard, the wanderer or his shadow.

It appears, then, that there is one conflict and one conflict alone that is genuine and decisive. It is Zarathustra's argument with the Demon who drops heavy globs of lead on the prophet's head in order to prove the hopelessness of all perfectionism and sever the bonds that tie him to the planet earth. This Demon is the spirit of Gravity or Gravitation itself: it ties the prophet's legs together so that he can neither dance nor fly nor speak of the "Lightness" of the earth. It is the opposite of what Gaston Bachelard has so majestically dubbed "the spirit of ascent." The substance of the earth is the true antipode of the ether, of the Azure, the eternally snow-covered peak and the dancing star.[12]

III

The Demon first appears in Nietzsche's youth, in a disturbing vision:

What I am afraid of is not the frightful shape behind the chair, but its voice; also not the words, but the terrifyingly unarticulated, inhuman tone of that shape. Yes, if only it would speak as human beings do.[13]

This may be one instance in which Evil sheds its misleading disguises in order to reveal itself in the "horribly inarticulate and inhuman" tone of voice that may find its written form in an in-

12. Gaston Bachelard, *L'Air et les songes* (Paris, 1943). In chapter 5, "Nietzsche et le psychisme ascensionnel," he analyzes with great precision the mythical and philosophical meaning of the natural elements in Nietzsche's work, where air figures more prominently than earth or water.

13. In Ronald Hayman, author and translator, *Nietzsche* (New York: Oxford University Press, 1980), p. 103.

comprehensible cabalistic sign:

> Alpa! I cried, who is bearing his ashes to the mountain?
> Alpa! Alpa! Who is bearing his ashes to the mountain? [14]

Sánchez Pascual, the Spanish translator of *Thus Spoke Zarathustra*, makes the following comment about this strange passage from a strange dream:

There is no satisfactory explanation of the ambiguous word "Alpa." It is often related to the equally enigmatic first line of Canto VII of Dante's *Inferno*. In Italian, it reads:

> Papè Satàn, papè Satàn, aleppe!

These words, which belong to no known language, are intended to give an idea of the language spoken by the devils. [15]

To whom does the voice behind the chair belong? Whose horribly inarticulate, inhuman tone is expressed in the untranslatable words? Some of these words, so extraordinary and "out of season," assault whoever reads *Zarathustra*. The wanderer and his shadow, that representative of "damp, melancholy old Europe," suddenly remembers an "old memory," which he relates in a song. He recalls visiting, once upon a time, a small oasis "among the daughters of the desert." Suddenly there appears a word quite "out of season": Selah. The first two stanzas of the poem end with this word, and the remaining stanzas end with a word that may strike us as both surprising and revealing, even though it appears frequently in Nietzsche's vocabulary. The word is Amen. It denotes the resigned, melancholy, jubilant yet determined acceptance of a specific destiny, which may also be a certain dark Pact:

> I cannot do otherwise, so help me God!
> Amen!

"I cannot do otherwise, so help me God": "Ich kann nicht anders, Gott hilfe mir." These are the words that Luther pronounced before

14. Nietzsche, *Thus Spoke Zarathustra*, p. 157.

15. Nietzsche, *Así habló Zarathustra*, trans. A. Sánchez Pascual (Madrid, 1972), note 201.

the Diet of Worms on April 18, 1521. "With them," Sánchez Pascual remarks, "Luther appears to have ended his response to the proposal that he retract his beliefs."[16]

But what do we say about Dudu and Suleika, the daughters of the desert, or the "oasis-belly," the "flying insects," and the "girl-kittens" also mentioned in the song?[17] What strange event is he alluding to as he shakes the dust off this "old memory"? What relationship is there, if any, among the allusions I have just cited so the reader can solve the riddle, if he should so desire? In any event Nietzsche knew full well who his Foe was. It never lived outside his internal citadel: always dressed in a new disguise it appeared again and again in those underground caves and passageways.

When the Devil casts his skin does his name not also fall away? For that too is a skin. The Devil himself is perhaps—a skin.[18]

The skin of the brain, we might say, bitten by strange flying insects, by the "sweetest smelling of all little mouths" and "ice-cold, snow-white, cutting teeth."[19] A cerebral skin wounded with dark stigmata, caressed and perhaps pierced by the intoxicatingly seductive "daughters of the desert."

In the end Nietzsche's Foe won the battle, which was given the clinical name of "cerebral paralysis." From this moment on the drops of lead are no longer an inducement to transcend: the individual man must make the final, definitive effort to succeed at the cost of his conscious existence. The "grand mal" encourages great and terrible solutions: it is as much a one-way flight as it is hope for the eternal Return.[20]

16. Ibid., note 425.
17. *Thus Spoke Zarathustra*, pp. 315–19.
18. Ibid., Part Four, "The Shadow," p. 285.
19. Ibid., p. 316.
20. Ibid., Part Four, "Among the Daughters of the Desert." The title may allude to an event of Nietzsche's youth, such as a visit to a brothel, which made a permanent impression on his sensitive mind and probably his body as well. Thomas Mann, who refers to this "well-known secret" in some of his studies of Nietzsche, incorporates

IV

In Nietzsche, then, the city is internalized. The struggle is internalized as well: even the Foe takes on the form of an hallucination and each time he appears gives proof of his Protean ability to change shape. Deep within the walls of his self-absorption the individual is so consumed by the enormity of the struggle that he must keep a daily inventory of his dealings with the outside, to prevent them from blocking, interfering, or in any way affecting the necessarily monadic activities of the internal space. The surroundings must be rendered immune: the setting, the weather, environment, and food must be chosen with the greatest precision and care—if neglected they could undermine the citadel, even cause it to suffer incomprehensible changes or disruptions. The individual knows from experience that his hypersensitive nature registers the slightest vacillations in the weather or in his food with lightning speed, vacillations that scratch at the "skin of the brain" until they have scored it with signs charged with affective electricity. His bodily and spiritual organism is a genuinely sensitive surface that records even the slightest variations from Outside, like the nanny with traces of Platonism. Inevitably, however, the contours that distinguish Inside from Outside become gradually blurred, diffuse, and flexible, and a dangerous fusion of subject and object insidiously sets in, unchecked by any moderating mediation.

The greater the actual distance that separates the subject from the object, the sharper one's awareness becomes. The object loses its balance and shape and in the eyes of the subject seems totally deformed, at one moment swollen to hideous proportions, the next shrunk to absurd insignificance. The individual vacillates between unusual susceptibility in the face of events which, from a hypo-

an identical event into the extraordinary career of his Doctor Faustus. Under demonic influence the prostitute Esmeralda transmits a spiritual and carnal "meta-virus" that directly affects the brain. The Devil always wears different clothes when he makes his appearances in this novel.

thetically balanced and sane point of view, lack the importance given to them by the circumstances, and the vertiginous leap over the barrier of objectivity in a climate simultaneously manic and euphoric that augurs the transformation of weakness into the utter strength personified by illusory Will. The boundaries that separate desire from its object, the bow from the arrow, the arrow from the star, can be seen at that instant to disintegrate. The actual, concrete transvaluation of all millennial values can take place by virtue of this heroic act: the cosmic scheme, the all-embracing policy goes into effect, and the "inverted Platonic city" dreamt in the ordinary idealism of adolescence—the city where those most deeply in love will live together "on the most distant peaks"—is built. This reality will successfully penetrate the mirror image of the double and the shadow and arrive at a new space, a new element beyond the mirror and beyond all morality and all will to truth that ushers in a new society, a new culture, and a new history.

For this to take place the subjective consciousness must be shattered: only then can the individual become all names of history. The individual will break out of the hellish circle of his immanence, renouncing his role as theoretician. He will reject the vocational imperative that dictates, as an agent of duty, the patient, day-by-day construction of that vast rhetorical edifice called the Will to Power. Then he will know the joy of liberation and the lightening of his burden. He may also experience the weightlessness that comes from smashing the dialectic of vocation and guilt. He will feel a vague innocence—and perhaps a vague sense of abdication?—in the great euphoria of its first flush. He will have the impression of seeing the world for the first time, and everything that up to then had been perhaps merely a means or a tool will acquire primary importance—trattorias, tailors, passers-by. Everything passing over his cerebral skin acquires a unique and independent being with no cause and effect relationship to the other beings around him. This liberation breaks open the space outside for a brief instant, after which it is "filled up" by subjectivity. The individual becomes gradually aware that he is a "grand seigneur," seeing himself at last

as an aristocrat and a man of the world. Like Goethe he begins to understand that he is someone more serious and important than a mere poet or philosopher. As a result he changes his vocation.[21]

But the world became wounded and scarred between Goethe's age and Nietzsche's. The peaceful integration of aristocrat and writer, of politician and poet, man of the world and recluse had been buried in the grave of impossibilities. Nietzsche alone makes real his adolescent dream of a new culture, classical and serene, that will redeem Germany and the rest of Europe from the cultural philistines, from stupidity and baseness, by submersion in the subjective experience of the imagination. Unlike the *uomo universale* of the Renaissance, unlike even Goethe, Nietzsche is not all things. He does not even think all things, in Hegel's sense of the identity of being and thought: he simply imagines all things.

In that instant a single means presents itself as the sine qua non of the individual's opening away from himself toward being-other: repression of the subjective Self and the debasing of subjectivity in madness. This is the way in which Nietzsche presents the unsettling dead end of subjectivism that strives to attain transcendence in living flesh. Being, the world, all that is Outside exacts madness as payment for the journey. This is the true name of that "Kehre" so often debated in total ignorance of the experience on which it is founded. . . .

21. I am suggesting an interpretation of this development, which leads to the spiritual insights revealed in Nietzsche's last letters, in terms of Vocation and Debt. My point of view is the same as in my essay on Goethe [see chapter 4], where these terms were examined in the light of existentialism and existential psychoanalysis.

This "revelation from the Outside" can be seen in Nietzsche's letter to Peter Gast of December 16, 1888, where he exclaims enthusiastically about the superiority of Italian cuisine. In the same letter he refers to himself as a "grand seigneur," and in a letter to Gast dated December 31, 1888, from Turin, he mentions that he will probably take lodgings near the Palazzo del Quirinale.

In other words, Nietzsche stops thinking about the "Grand Style" and begins to live it. His last letters give the general view of a desperate, tragic attempt to "live out" everything that until then had only been *written*. Nietzsche identifies with his dream-vision of the Superman as presaged by the *uomo singulare* in the dress of a courtier under Louis XIV, Goethe, Napoleon, etc.

Nietzsche's experience established the horizons of life and reflection that close us (the men of the twentieth century) in, whether we like it or not. On this horizon appears a culture that exacts, as tribute to the transition, the death, madness, silence, or denial of the individual and his simultaneous transformation into a shared and familiar sign. Artaud and Van Gogh sealed the deal with madness, Rimbaud with abdication, Mallarmé—like the current avantgarde in music and painting—with silence and the blank page, Joyce with a nonsensical, schizophrenic discourse in which the words, "terribly inhuman," become the text itself instead of providing clues through their very esotericism. Joining the league of literature and culture with Evil, philosophy tends to specialize in the "perverse notions" to be found on Plato's list of categories: nonbeing and difference, visibly represented by Death and Madness. In consonance with this theoretical bent philosophy emulates Nietzsche's style, foreswearing the systematic approach in favor of aphorisms and fragments. This is as noticeable in Wittgenstein as it is in Heidegger's later works. . . .

But Nietzsche reveals something else: an ontological configuration that we can hardly do without, unless we lose hold of either the form or the content of our contemporary thought.

Let us try to deal more closely with this very difficult problem.

V

In the ontology evident in Nietzsche's last works and correspondence, where it is most fully expressed, reality seems to be identified with imagination. To call this experience Idealism would mean too little, however, as the "ideas" have been strangled and transformed into an amoebic substance like the constantly shifting patterns of a kaleidoscope. It is of course not an absolute idealism in the Hegelian sense, in which the scheme to transcend the objective world through *Aufhebung* has not yet broken its ties to that world, nor is it a kind of subjective idealism based on a thorough interpretation of the tenet *esse est percipi*. It would also be inappro-

priate to speak of a Hallucinatory Idealism when referring to a process that specifies in all of its nuances the use that the term "hallucination" has had until now. The word is imprecise because it suggests images, three-dimensional representation, daydreams. It appears rather that in Nietzsche's final days the visionary world gradually drew back into its Authentic Identity as urge or *pure* affect without "Apollonian" mediation of any kind. The individual seems to move toward a total experience of this Authenticity until he becomes something more (or less) than the sign that takes the place of the urge. The return trip from Metaphor to Truth is signaled by the critical retreat that takes place in a work of Nietzsche's youth, *On Truth and Falsehood in the Extra-moral Sense*, in which he regresses from the thing to its conceptual image, from this image to linguistic sign, from the word to the Apollonian image, from this to the elements of music (the semiology of emotional affect), from music to the primordial Chaos of affect and urge. It is a procedure that seems to lower Ariadne's veil. The approach is no longer theoretical or discursive: it is at last action, experience, praxis. The *terminus ad quem* of this regression—a true regression in the psychological sense—is not the individual, who is de-edified by it, but that substance beyond subjectivity that we can call matter, natural being, or—most correctly—*Physis*. It must be understood that this being is not an otherworldly entity like Spirit, the Matter of metaphysical materialism or Schopenhauer's Will, but rather the vacillating plurality of independent, individual lives. By virtue of the law of Return, which supplants the rule that matter must be subject to *accidentia*, this entity acquires a secure Platonic existence within the circle circumscribed by eternity. Without a doubt this is inverted Platonism, but it is Platonism all the same.

This ontological experience transcends idealism, becoming something like a sui generis materialism in which the law of Return impedes the totally haphazard scattering of individual, finite units. With each twist of the kaleidoscope it establishes new causes and effects.

Nietzsche would seem, at first, to affirm the hell of metempsychosis—at least in principle—against all ascetic ideals which at-

tempt to break out of the wheel of necessity: the Buddhist Nirvana, Plato's Ideas, the Jewish and Christian Deity. On reconsideration, however, Nietzsche discovers the transaction between the hunger for eternity as represented by the ascetic ideal and the "rage to live" that demands metempsychosis. His original affirmation acquires true ontological vitality as a function of this reconsideration. The law of eternal return fulfills the conditions of the pact between the principle of immanence and the principle of transcendence.

VI

This is Nietzsche's notion of ontology as it appears in his last works and letters. It reveals the nature of the transition from immanence to transcendence: alone and lost in his internal struggles, relating to the world through his writing alone, Nietzsche abandons the theoretical project that was to take ten years to complete— *The Will to Power*—and switches to a new vocation. This may be an act of equivocal abdication, but it may also be the perfecting of his true vocation, in which the "thinker" becomes a man of action and the man of theory becomes a great lord and strategist. The outside world is soon transfigured, acquiring clarity and substance for the first time, it seems, in many years. Everything Nietzsche comes across has meaning: trattorias, tailors, etc. The inner man gradually intrudes on this freshly revealed outside, however, repopulating it with a series of identifications. Soon Nietzsche is signing his letters "The Kaiser," "The Crucified," "Dionysus on the Cross". . . . In the end he realizes that he is "every name in history," a genuine substitute for the dead God, Creator of all things.

The issue of subjectivity has clarified the Outside, but the Outside then takes the form of a hallucinatory society, culture, and history—of a society, culture, and history reverted to the "natural state." There is an immediate, direct, unmediated transition from individual to ontological experience, a leap across the Rubicon that splits history down the middle. On one bank of the river is a world inundated by subjectivity in which subjectivity, when it questions

its identity, flows kaleidoscopically from being to being, from thing to thing and from name to name, identifying with and encompassing each in succession. On the other bank the subjectivity that rises like a Phoenix from its own ashes—the body, in the Nietzschean sense—loses the unifying bond that holds it together in oneness and identity, breaking apart into fragmented impulses and urges.

The two experiences overlap: the glory of the absolute subjectivity that justifies an allusion to Hallucinatory Idealism, and the dissolution of subjectivity, with the consequent transition to an immediate, direct, sudden contact with matter. The Idealism of the visionary individual meets the Materialism of the vacillating object. But this object is natural, wild. It is impulse, affect, urge. The following situation therefore comes about: an intrusive subjectivity makes the transition to objectivity stripped of all civic attributes, purged of the fertilizing subsoil of culture. The individual comes face to face with the natural object, and the confrontation is not mediated or softened by passing first through the city and the society "of mankind." The natural object, moreover, is a weakened, soul-less physis: like raw hyle, wasteland and desert, it is nature having lost all its vital, fertilizing power. It no longer has the power to give form. Hence Nietzsche's pathetic leitmotif: *Deserts grow*.

VII

We must take a slight detour through ontology in order to clarify this statement although our clarifications of the notion of Truth will be necessarily sketchy and inadequate.

If for no other reason than to avoid a confusion of terms, we can say that there is in effect a Truth with a capital T. It is the Enigma indicated by Plato with the famous expression: *epekeina tes ousias*. All subjectivity and objectivity alike can be said to be annihilated in this Truth. We can also say, however, that the duality of soul and substance (in Plato, the Idea) is effectively based on this de-

struction. This Truth must be transcendental. But it can neverthe-
less shed the mystical vagueness fostered by negative theology if
it is thought of dialectically as a Truth that is forced to make its
presence known. Through what signs or what realms of being does
it do this? For the time being we can identify two basic areas in
which Truth manifests itself. They are internally linked, but they
also yield to separate analyses. They are the realm of the subject
and the realm of the object or, if one should prefer, the psycho-
logical realm and the social or civic realm. In Platonic terms, we
are speaking once again of the Soul and the City. The subject–object
relationship takes concrete form in the third realm, which can be
called Culture.

This detour allows us to define the scope and the limitations of
the ontology founded by Nietzsche and of which we are all heirs,
whether we like it or not. In Hegelian language, Nietzsche can be
said to have leapt like a shot from subjective, psychological truth,
which he subjects to a microscopic critical analysis, to transcen-
dental truth, without ever "settling the score" with social and po-
litical reality—a settlement that would entail work, praxis, devel-
opment. As pointed out at the beginning of this essay, this
decisively conditions the individual's rare transition from the self
to the cultural world.

Without corroboration this statement might seem dogmatic. Its
confirmation comes in the last phase of Nietzsche's conscious life,
precisely when he crosses his Rubicon—when he goes from the
psychic citadel to the citadel of reality, from the inside to the out-
side, when he denounces the universal plot and schemes for political
takeover. The critic, therefore, is confronted with an exaggerated
subjectivity, on the one hand, and a kind of raw objectivity on the
other. Lacking any concrete object, this objectivity alternately
dreams itself and destroys itself: its pure urges and unabated affect
also make and unmake the subjectivity that keeps it company. This
triumph of hyle points toward a hollow transcendence. Nietzsche
is not all things: either he dreams them from within his interior
self or he returns them to their original nature by stripping them
of their social, political, civic, and educational trappings.

For perhaps the last time in Western history Nietzsche attempts to embody the Renaissance humanist ideal of the *uomo singulare* and *universale*: to be all things and live in total harmony. He relived the epic of Faust, himself providing the required companion in the form of the Demon Gravity. But where Renaissance men and even Goethe could actually embody this classical ideal in their lives and their work, Nietzsche personifies the break with this ideal. He no longer is all things: he simply imagines them.[22] Nietzsche's case clearly shows that the humanist ideal can be realized only by recourse to madness.[23]

22. Deleuze-Guattari's philosophy, in *Anti-Oedipus: Capitalism and Schizophrenia*, trans. Robert Hurley, Mark Seem, and Helen R. Lane (New York: Viking Press, 1977), derives from the same confusion of reality and vision. Because of it, drug-induced visions and the "production désirante" of an industrial complex appear to have the same ontological status. The machine gun in one's head is as real as the machine gun in one's hands. In that nightmare where everything becomes a "machine désirante" and the distinctions between nature and industry, subject and object, individual and society, Desire and Object are effaced, thinking also becomes confused with being and the thought object (as well as the perceived or imagined object) is confused with the object *itself*. Mental creation becomes identical to material production. This absolute idealism can therefore only survive in the form of extreme materialism. Matter, however, along with industry and machines, has become a figment of the imagination. Lacanian idealism seems much more honest in this sense, as it clearly states that the desirous Subject's creations are quite imaginary and it has no illusions about the subjectivist approach.

Substituting the realm of image through "free differentiation" (Deleuze's philosophy prior to *Anti-Oedipus*), that is, through the verbal and apparently more "real," "physical," and "materialistic" realm of the mechanisms at work in schizophrenic thought processes, is not a true advance. Beneath it always lies the same fundamentally "Heideggerian" option: inauthentic Being (be it called free differentiation, Folie, or Schizophrenia) reveals the space in which things (masks, machines; theater, factory) are dispersed. The same problem is always at issue—the opening of Dasein to Being, the problem of transcendence. The *real* realm of objectivity is always cheated because, whether we like it or not, it is conceived of by the Individual (questioned) when it is open to Transcendence.

23. In Nietzsche's last works, the individual that he incarnated and upon whom he reflected makes the humanistic notion of "being all things" a reality, in psychosis and hallucinations. The individualistic, idealistic interpretation of *Anima est quodammodo omnia* is fully consummated in Nietzsche's life and philosophy. Beyond the beyond there is nothing. The individual jumps *out* by opening the window of

This is not the proper place to point out in detail and with analytical finesse all of the reasons for this cultural schism, be they subjective, objective, psychological, social, cultural, or historical. The attention that Nietzsche has commanded throughout the twentieth century is nevertheless proof that the signs and symptoms of this schism, if not its final explanation, are to be found in his life and works. Nietzsche does not open up new frontiers of thought and experience: he establishes the borders within which we twentieth-century Europeans live, in which the ultimate consequences of his misfortune are played out. Our special mal de siècle is such that several philosophical schools in vain attempt to "transvalue" our values by making the negative experience that Nietzsche personified into something positive. A lucid analysis prevents us from making a virtue of necessity, however, by proclaiming the birth of a new culture where in reality there is only the slow erosion and gradual decay of a millennial culture.

VIII

Nietzsche's existence as a man of flesh and blood and as an ontological being was proof that there were obstacles blocking the connection between the transcendent realm of Truth and the immanent realm of the subject-object relationship, a connection that was simultaneously conflicting and harmonious. One of the poles of the continuum is either obscured or totally erased, taking the shapeless, amorphous form of the Masses. Objectivity, then, has been stripped of its formal manifestation and made subject to the raw determination of indeterminacy, somewhat like Aristotle's

the monad and throwing himself into transcendence. What he sees is not open air or arctic spaces but rather the wall, "smooth and cold as marble," to quote Hölderlin's famous poem. Suddenly the outside takes the form of an inside, only more closed, and the desired "first motion" reveals its immobile essence. The individual who tried to be pure process, pure creativity conjugated to infinity, free differentiation and naive becoming, consummates his vexed existence in mental paralysis, uncontrollable trembling, and catatonia.

hyle. This debasement is neither arbitrary nor accidental. It is the direct reflection in the area of emotion, affects, words and writing, of a debasement that had taken place previously in history, making inscription and self-consciousness possible.

This historical debasement of the objective pole simultaneously drags down the opposite pole, of course. We need only invert the structure of the drama, as Nietzsche ended it, to see the inevitable consequence: an evil objectivity that assumes the role of carrying on the humanistic ideal of being and knowing all things. The to-talitarian State becomes the preferred object of free-floating matter: the State will be all things by exercising unbridled control over individuals and estates, erasing the distinction between the public and private sectors, between individuals and society. The State will know all things because the all-knowing police keep tabs on all manifestations of individuality, making it impossible for the soli-tary man even to dream in private. Consequently, either the soul fulfills the humanist ideal at the cost of stripping objectivity of its civic content or the city fulfills the ideal by violating everyone's right to solitude and privacy. In the first instance the synthesis of soul and city takes place on the level of the imagination; in the second, on the police "blotter."

When mediation between the psychic and the social realms breaks down, culture swings back and forth between the polarized ex-tremes. Sometimes it is an object that the State machinery can manipulate: then it loses its creative, critical dimension and degen-erates into a subculture. At other times it becomes a shelter for the critical, creative intimacy that the State threatens to do away with forever. In this capacity, precariously quarantined, it delivers a critical discourse on the strange situation that prevails, and its speech has a purely intransitive, verbal value and effect, as it only reaches a minority that already shares the same sense of invasion and isolation.

When the tie between subject and object is severed, ritual and myth—the most ancient manifestations of all soundly established cultures—swing back and forth between two debased forms of their millennial substance, becoming either objects manipulated by

the State or the ideolectic reserve of subjectivity. Because they lack contact with social reality they feed off psychosomatism, and the way is clear for the rich conceptual repertoire whose basic characteristics were described by Freud.

We can end this essay with the following diagram, based on terminology developed in my book *La filosofía y su sombra*. Those elements indicated by the positive sign (+) refer to Nietzsche's ontological experience. The negative sign (−) designates the *shadows* or "options" that correspond to the positive signs: they are implicit in Nietzsche's philosophy and in a certain sense complete it. Together they make the *space* within which both categories make sense as specific formulations of the same set of problems, assuming of course that these problems have been raised by *history*, without which they would not be able to take shape in consciousness and writing.

Mind Divorced from the City

(+)	(−)
—The soul incorporates the city.	—The city incorporates the soul.
—"In itself" the city is formless, the Masses confronting the individual.	—The individual exists as a function of the State apparatus.
—The soul is all things in the realm of madness.	—The State is and knows all things through the police "blotter."
—The individual takes refuge in privacy (total solitude).	—The objective world, molded by the totalitarian State, invades the private sector and effaces it.
—Insanity (euphoria, hallucination) destroys the frontier between subject and object.	—The objective insanity of the totalitarian State debases all distinctions between the individual and society, between the public and the private sectors.

—Subject and object are rec-
onciled in Madness, the only
path to the Truth.

—Subject and object are rec-
onciled in the State (an ex-
ample of "evil objectivity"),
which is the only path to the
Truth (of the Führer or the
totalitarian Party).

The rites of passage from the private to the public sector,
which alone assure cultural interplay, are blocked: the
individual must be debased so that his Work can become
a public, acknowledged, and shared value.

8

Thomas Mann: Diseases of the Will

zum Raum wird hier die Zeit.

Richard Wagner, *Parsifal*, Act 1

I

There are several reasons why Thomas Mann's work has receded into the background of the current cultural scene in Europe. It may be a spontaneous defensive retreat from the silly trendiness of a culture dominated by a supermarket mentality that presents books for sale as if they were just another consumer product. There is little room in such a context for finely wrought works demanding the reader's time, patience, and persistence. It may also reflect the unsuspecting reader's reaction to Mann's perversely discursive style, so "European," "German," or "antiquated" (which is of course not synonymous with decrepit), and so apparently out of tune with the schizophrenic writings of the European and American avant-garde. On a second, ambiguous level, the phenomenon may be due to Mann's excessive lucidity, which overwhelms and suffocates even the friendliest reader to the point where he cries out for fresh air!

The following text was the basis of several lectures presented at the German Institutes of Barcelona, Bilbao, and Madrid on the occasion of the centenary of Thomas Mann's birth.

The same cry must have been on Mann's lips when in his old age he began reading Joseph Conrad. In *The Story of a Novel* he confesses that while reading the great teller of tales—especially adventures on the high seas—he felt "entertained, impressed, and as a German somehow shamed by his manly, adventure-loving, linguistically superior, and psychologically and morally profound narrative art. To say that this art is rare with us is false—we simply do not have it."[1] I suspect that a good friend of mine, an assiduous admirer and critic of Mann, uttered the same complaint that fine day when he packed up all our author's books that cluttered his desk and placed an order for Conrad's complete works. My friend had never read *The Story of a Novel*, so he could not have gotten the idea from Mann.

Not only Mann's readers but Mann himself, as we have seen, suffered the same sense of suffocation that Mann's characters suffer. At some point in their lives they, too, as a rule feel the need for fresh air and elbow room. In a word, they feel the need to *travel*. Is it not true that all of Mann's works in this category seductively stimulate the desire to travel? His highly detailed analyses—are they not extremely successful in predisposing or tempting the reader to take to the road? The Wagnerian motif of *Wanderlust* seems to permeate Mann's works, turning up with cyclical regularity.

This very desire on the part of Mann's characters often runs into obstacles, however, from which strange transactions result. Mann's entire work, or perhaps his role as creator, may well be nothing more or less than one of these transactions between *Wanderlust* and this kind of obstacle, between what Mann called the "youthful thirst for space" and the "vital discipline" that moderates this thirst.

Thomas Mann speaks of the double aspect of his character and his fate, both maternal and paternal, which reveals itself in a subtle, artistic fashion in the ambiguous realm of his *Autobiographisches*, where poetry and truth mix. The same character can be seen in his works generally: a character and fate that transcend his person,

1. Thomas Mann, *The Story of a Novel* (*The Genesis of Doctor Faustus*), trans. Richard and Clara Winston (New York: Alfred A. Knopf, 1961), p. 191.

perhaps the character and fate of the Europe that he so profoundly personifies. Its urges and obstacles and dualities are also his own.

II

Another constant leitmotif in Mann's works is the Sea. It is closely related to the *Wanderlust* motif: both are siren songs full of promise and danger. Both present the greatest possible danger to the individual and also the ultimate test of the will, from which he emerges either strengthened or utterly broken. These motifs are clearly linked to that other siren song called music, which is a profoundly ambiguous cultural artifact secretly in league with Satan, according to Mann. A muffled echo of this insinuating feminine voice reaches the child reclining in a chaise longue during his summer vacation at Travemünde, by the sea. It is the musical caress of the ocean breeze, vaguely reminiscent of his mother's fingers. Swift and ethereal, they flee toward the horizon, the direction of their flight clearly pointing to some place beyond the Atlantic, another continent, perhaps, in the tropics. They conjure up a daydream image of a new world, new territories, and a whole series of adventures and wanderings in overgrown jungles, swamps, and muddy rivers. . . . As a boy he finds himself in a state that will never leave him in adulthood. As an old man he would define it with the wonderfully apt expression, "dreamy laziness." He would never again recapture the joy that he generously passed on to Tony Buddenbrook, Aschenbach, Thomas, and the narrator of "Mario and the Magician." In his characters he analyzes both the benefits and the evils that come from the dreamlike state one enters in the presence of the Sea.

An important leitmotif of *Buddenbrooks*, which appears in some later works as well, undoubtedly comes from this seaside experience. Although it is of a naturalistic, descriptive nature, it has a constructive symbolic function in the narration as a characteristic that differentiates characters and generations. It can therefore be called a leitmotif in the strict Wagnerian sense of the word. We

may call it the leitmotif of the "Blue-Shadowy Eyes." There was nothing dreamy about old Johann Buddenbrook's eyes, as his nights were sufficient or more than sufficient opportunity to surrender himself to sleep. He had no reason to compensate for his insomnia by indulging, during his waking hours, in a substitute surrender such as sentimentalism, religious piety, or daydreams. His imagination was well fitted and adjusted to his actions, and his desire to its concrete manifestations. His working discipline was therefore spontaneous: it never got in the way of his full enjoyment of the good things in life. The leitmotif is already stamped on the face of his son Johann, the Consul, although in a purely embryonic state. It is born of the conflict between its spontaneous, lively nature and the discipline required of bourgeois businessmen. For Consul Buddenbrook work is a moral imperative: it does not partake in the spontaneous flow of life. Unlike his father, who married his first wife for love, Johann and his sons are required to make a "romantic" sacrifice of love to the noble cause of family and business. In compensation for this outlay he experiences the first "dreamy" slackening of his will, the systematic cultivation of sentiment typical of a romantic generation that liked to confuse genuine emotion with play-acting. The second time he slackens his will his wife catches the disease, finding release in piety, the "confused ringing of bells" that characterizes the cult of feeling.

The next generation experiences the conflict between a degenerate, cliché-ridden romanticism fit only for those Madame Bovarys of a waning bourgeoisie who have not managed to rise above their "sentimental education," and the lucid postromanticism that rips the veil of Maya, revealing behind the façade of bourgeois will the hidden depths of Class Struggle, Boredom and Pain, and the Will to Power. Tony Buddenbrook belongs to this annoying, trivial, disheartening, unconscious, and charming generation. In the fine spirit of romantic irony, he is forever incapable of mediating between his everlasting tendency to mistake fantasy for experience, intention for act, feigned emotion for genuine feeling. Because he gets unsuspected pleasure from the blindness and confusion that lead him continually to hit the wrong note on the keyboard of

Dignity, he can never examine or really know himself. Like Frederic in *Sentimental Education,* Tony is condemned forever to turn on the same point, even though in the course of his dull and common journey he always extracts a surplus of value of Dignity from his dearly-loved though hostile fate. The leitmotif of the Blue-Shadowy Eyes, which clearly describes his face, appears therefore in a profoundly pathetic but never tragic light.

As parody, the leitmotif is embodied by Tony's brother Christian, a perfect specimen of the ne'er-do-well Bohemian spendthrift, the prototypical black sheep. His eyes are clearly lost in the woods of fiction. In the end his body itself falls victim to this fiction. This experience and many of his personal traits presage the race of artists that richly populate Mann's later works, the most interesting of them perhaps Felix Krull. The dramatic mimicry that Christian practices in his conversations, like the make-believe paralysis brought on by hypochondria, certifies his membership in this family of artists.

Only in Thomas does the leitmotif acquire a tragic dimension, because Thomas is not a homunculus but a fully matured man. Even though they are perfectly integrated into his social personality, his considerable dramatic talents reveal from the very beginning a conflict between living and stage acting. Of course the conflict never eludes his skillful self-awareness, which controls it and gives it direction. We might even say that this self-awareness enters the scene as a corrective principle or virtue only at that moment when he becomes aware of the conflict between living and acting. More than a virtue, it is a defense mechanism, the same self-awareness that comes fully into being on the cultural level with the twilight of romanticism, when the *epic* struggle of Europe is clearly in decline. It is not surprising that in both Thomas's life and the general cultural context the rise of lucidity entailed a genuine decline in religious belief and the cult of deities, which flowered for the last time in the romantic generation's anything-but-spontaneous cult of emotion.

Thomas's father strikes a dramatic pose in regard to his son-in-law the swindler and his son, as he had in regard to the rebels of

1848. His theatricality was unconscious, however, and conse-
quently there was no need for lucidity to come to his aid: his
pragmatic sense was not seriously threatened by a confusion be-
tween reality and the stage. He was therefore less "intelligent" in
the usual, that is "modern," sense of the word, than his son
Thomas, who knew the nooks and crannies of the human heart far
better than his father and was consequently a better "psychologist."
Nevertheless, because his "practical sense" was greater than his
son's, the father was more sure of his actions and decisions in the
long run. On the whole, that is: as a young man Thomas had a
brilliant career, but it was not long before he showed himself to
be a very bad broker. He burned out young, partly because he saw
too clearly the future course of his family and its business interests.
At first this lucidity was quite a boon, but it soon became a major
obstacle. Lichtenberg's comment came true: he was a man who,
"despite his intelligence, was good for nothing." He also lacked
the spontaneous faith in life and commerce that his grandfather had
had as well as the religious and moral faith that his father had
substituted for it. In him faith, hope, religious values, and even-
tually the belief in life itself passed through the prism of self-aware-
ness. As a symbol of European history Thomas represents the
transition from Religion to Philosophy and its sequel, that is,
knowledge that has no illusions about *action.* As the years go by
and fatigue sets in, the disharmony between living and thinking
takes concrete shape before the thinker's eyes, and the entire dra-
matic content of his public life anxiously unfolds before him.
Thomas spends long hours in the solitude of his office, sunk in
lucid daydreams; at night he engages in endless monologues. All
the while he lives his daily life in the firm, in the senate, and with
his family in the full awareness that he is playing a part in a play.
Self-awareness and dramatic consciousness are symbolized by
Night and Day, and there is nothing to mediate between the ex-
tremes. A length of red thread ties this glimmering of self-aware-
ness and philosophical mediation together, this clear insight into
the importance of drama and masks, this uncensored view of man-
kind, the loss of faith, hope, and vital incentive, and the need to

attain freedom through death which takes on new life with his brief encounter with Schopenhauer's book. The leitmotif of the Blue-Shadowy Eyes therefore finds its most adequate space in a hyper-critical Philosophy which is highly lucid but at the same time mercilessly denies the value of life. It is a decadent philosophy which, like Hegelianism, takes wing when life is already over and the Race is in decline.

Art, the ineluctable companion of the owl of Minerva in its flight, also explodes in Thomas's house, in the form of the music played by his wife and son. Hanno, Thomas and Gerda's little son, is the microcosm in which all these elements come together. He will epitomize declining vitality, total disenchantment, lucidity at all cost, and overflowing musical talent. This vivid portrait brings *Buddenbrooks* to a close. His death in the novel signals the beginning of a new story, Thomas Mann's own. In *Buddenbrooks* he describes his own archæology.

The leitmotif of the Blue-Shadowy Eyes reaches its high point in the figure of Hanno. His successor, the one who survives him, is Thomas Mann himself, who identifies in himself the twin leitmotif of "dreamy laziness" which he mentions in *Autobiographisches*. Within the context of a family like the Buddenbrooks the Blue-Shadowy Eyes motif can be interpreted as an element that is antagonistic to the vitality of business, civic, and human life in general, the first sign of laxity and decay, the first seed or virus to undermine the Will, leaving it seriously diseased. The end result of this illness is Sloth, the enervation that Hans Castorp feels when he arrives at the sanatorium and begins to adjust to the magical backdrop of his extended vacation. The same leitmotif is freshly stamped on Hans Castorp's face, but he belongs to a new stock: he is a contemporary of Mann's. For this strange, paradoxical new group, which rises from the ruin of the authentic European stock, sloth and the daydream state are not purely evil. Rather, they are critical instances of testing, upbringing, and education which furnish the student with that special, necessary, and essential set of life experiences without which one embarks on the struggle for survival improperly armed. The laziness and daydream that dom-

inate the hellish stage of the sanatorium enable him to establish contact with the irrational, demonic element that disarms the unforewarned individual with its irresistible charm and power.

The ambiguous, double-edged nature of the diseases of the will are thus prefigured. They are diseases in the negative, life-threatening sense of the word, of course, that is, they are potencies allied to death, enemies of the will to live. But they can also be learning experiences by which the individual tests his courage and strength. The diseases of the will are therefore *ritual trials* by which the individual—Hans Castorp, for instance—in the course of his education, during his "years of apprenticeship," goes through a process that can lead him to a mature, fully human existence. *The Magic Mountain* should be read this way, as a Bildungsroman in which an individual undergoes the necessary rites of passage through the hell of the sanatorium, where he encounters all of the temptations that can possibly test his willpower. Castorp's experience there is a genuine descent into hell. Like Mozart's *The Magic Flute*, Goethe's *Wilhelm Meister*, and Hegel's *Phenomenology of Mind*, *The Magic Mountain* is a modern version of secular initiation rites that subject the individual to various tests designed to prove his "Manhood," tests that prove whether, as Tamino in *The Magic Flute* attempts to ascertain, he can "be a Man" (ein Mensch zu sein).

Daydream and laziness, the anesthesia of the will that makes the individual shirk the daily responsibilities of work and other activities, is then a double-edged sword that tests his courage and vitality. One either emerges from the trials strengthened, or one perishes in the struggle.

What brings on this laziness and this dreamlike state? What drug or potion plunges the individual into a state where his powers of volition fall to pieces? What temptation or prospect takes over at that point? We have mentioned the Sea and Music and music's maternal or feminine nature. We might also speak of love potions, eroticism, poisons, and disease. We have likewise referred to real or imagined Ocean voyages to South America, to Brazil, and we spoke of swamps and dense jungles. . . .

III

When Gustav Aschenbach, that "hero of our times" so aptly described by Mann in "Death in Venice," feels stirring within him "the most surprising consciousness of a widening of inward barriers, a kind of vaulting unrest, a youthfully ardent thirst for distant scenes," his desire first projects itself visually in an imaginary but unmistakable vision:

He beheld a landscape, a tropical marshland, beneath a reeking sky, steaming, monstruous, rank—a kind of primeval wilderness-world of islands, morasses, and alluvial channels.[2]

In a brilliant stroke of psychology Mann leads his character not so much to that swampy, tropical place that his imagination painted for him as to a discreet setting by the sea, where the still waters gather into something like a pond. This place matches the nature of the adventure and the character at his particular age, with his special set of personal and artistic problems, at that precise moment of his career when decline obscurely fades into apotheosis. He finds, one day, that he wants to travel, and at first his desire is vague, like all desires that are not regulated by reason and conscious control. On some level, however, his decision eludes his conscious control, like the dark transactions that his will makes with the first images revealed by his dreaming fantasy.

By using the Sea—concrete, tangible sign of flux—to symbolize the favorite, natural object of desire, Mann reveals his understanding of the true nature of desire. The Sea is indeterminacy itself: its deceiving surface alone gives the illusion of fixed form. Rhythm and time are at work in its waves, but the sea itself is not subject to time. It is perhaps the only timeless space. In Mann's mythology, the Sea is associated with music, which also gives the unprepared, naive listener the illusion of movement through time when it is in

2. Thomas Mann, *Stories of Three Decades*, trans. H. T. Lowe-Porter (New York: Alfred A. Knopf, 1966), p. 380.

reality spatial. This is why music, like the sea, affects the soul so deeply, and why it stirs the innermost regions of desire, revealing the nature and ambitions of desire to desire itself. The nature of desire because desire is essentially timeless: beneath the surface of sudden fears and raptures, it is basically the same in all of its manifestations. Mann's thinking on this point has its source in Schopenhauer and in Freud, who was also a devoted reader of Schopenhauer. The ambitions of desire, because desire strives to revert to the state of total rest symbolized by eternity, the timeless space where music is freed from its physical form and, as pure will, at last finds self-fulfillment. Desire is confronted, then, by the hostile power of the virile, Apollonian impulse to fix limits in time, the disciplinary urge concretely symbolized by the hourglass, another recurring icon in Mann's mythology (see "Death in Venice" and *Doctor Faustus*).

To transform time into space: this is Adrian Leverkühn's alchemical intention when he invents the twelve-tone system. In the final analysis, this is the hubris of the modern artist. Just as the time-bound flow of rivers finds its harmonic basis and irrevocable cadence in the sea, so there exists a second level of unity beneath the texture of music's harmonic discourse *in praesentia*. On this level harmonic relationships are established between exclusively spatial intervals. The timeless, spatial nature of the sea as *mens momentanea* corresponds therefore to the true essence of music. Leverkühn wants to lift the veil of Maya that, piecemeal, with the passionate, sensual illusion of music, like shreds of cloud at dawn, hides the truth that is its exclusively spiritual and chemically pure beauty. To do so he must strip music of its emotional, sensual element, the "heat of the stable." In a daring, almost impossible tour de force he must rip the unyielding yoke of time from music, which is what really binds it to Maya. He invents the twelve-tone system in order to compose purely spatial music, the only kind that is properly read from top to bottom. The single definitive piece would be a single, definitive chord in which all possible relationships between the intervals could be heard. As part of the

composer's pact with the Devil, it would reveal to mankind the mysteries of the heavenly spheres.

The sea, essential music and timeless space, appears to be the strict unity of the genuine object of all desire. It is all the same, in this respect, whether desire uses the body, the spirit, or the soul as a means of extending itself. But when desire erupts in all its strength, which man is powerless to tame even if he wants to, it invariably carries out an operation that can only be called, in all correctness, possession—possession of one or another part or component of the human being at the expense of the rest. Possession of the spirit at the expense of body and soul, possession of the soul at the expense of spirit and body, possession of the body at the expense of soul and spirit—this is what passion should really be called. This exclusivist, unbridled passion takes possession of the victim's spirit, as in the case of Doctor Faustus, disconnecting it from the pleasures of sex. In cases like Hans Castorp and Aschenbach—that is, whenever the victim falls head over heels in love—it takes over the individual's soul and his autonomous, intransitive world of dreams and imaginings at the expense of his critical intelligence and carnal appetites. Finally, like disease, desire takes exclusive possession of the body, disconnecting it from the spirit and the life of the soul, predisposing it for every kind of carnal transaction. This completes the triptych of the diseases that assail the will whenever it gets too close to the sea, music, or timeless space—the entire feminine universe that can appropriately be associated with the terrible primeval Mothers who tempt Faust in a famous passage of Goethe's poem.

A moderating power confronts this feminine, maternal component, which is older than the Olympian laws regulating the Dionysian frenzy (in its primeval formlessness every desire is Dionysian). It is the principle of temporality and reason, Goethe's synthesis of time and eternity in the actual present moment, in creative work, in *Poiesis*.

In the pages that follow, Mann's own words will clarify the nature of this possession that we have called unbridled passion, one

of whose best-known manifestations is the combination of love
and passion in the phenomenon of falling in love.

IV

In "Death in Venice," Mann writes:

A solitary, unused to speaking of what he sees and feels, has mental
experiences which are at once more intense and less articulate than those
of a gregarious man. They are sluggish, yet more wayward, and never
without a melancholy tinge. Sights and impressions which others brush
aside with a glance, a light comment, a smile, occupy him more than their
due; they sink silently in, they take on meaning, they become experience,
emotion, adventure. Solitude gives birth to the original in us, to beauty
unfamiliar and perilous—to poetry. But also, it gives birth to the opposite:
to the perverse, the illicit, the absurd.[3]

There is no need to comment on this beautiful statement: any
attempt to do so would merely translate an inspired passage into
pedestrian prose. It can, however, be compared to another of
Mann's works, *The Story of a Novel*. Adrian Leverkühn's shadowy
affection for his friend Rudi Schwerdfeger is here described in terms
that can be applied, without doing them any violence, to Aschen-
bach's dark affection for Tadzio. Mann speaks of the "seductions
of solitude," in which one craves intimacy with oneself and in
which homosexuality plays the role of a familiar spirit. I believe
that Mann's thinking on this point is extremely important. More
than anything else, shedding some light on the nature of seduction
can help clarify it. Mann answers our question in the mouth of
Goethe, in the famous monologue in *The Beloved Returns* (chapter
7), a passage opportunely cited by Francisco Ayala in his intro-
duction to *The Transposed Heads*. Mann's Goethe says,

In the whole moral and sensual world the thing whereon my whole life
I have most dwelt with horror and desire is seduction—inflicted or born,

3. Ibid., p. 395.

active or passive, sweet and terrible, *like a command laid on us by a god*; the sin we sinlessly commit, guilty as tool and victim both; for to withstand it does not mean we cease to be seduced. It is the test no one withstands, it is so sweet, even to endure it spells defeat. *It pleases the gods to send us sweet temptation*, to make us suffer it, as its instruments, as patterns of all temptation and guilt, for the one is already the other. (my italics)[4]

A little later in the same monologue Goethe calls the poet "much seduced, the tempting-greatly-tempted."[5]

It is no accident that Aschenbach, a writer and creator and therefore naturally a seducer much seduced, recalls those passages of Plato's *Phaedrus* that examine the phenomenon of seduction in great detail. Both Plato and Goethe understand seduction to come "from above." The empirical subject is not the seducer—not Tadzio, Lotte, or Rudi. They are the medium used by the deity that can only properly be called Beauty. It is a two-faced god: behind the face of Beauty hides the equally terrible but more circumspect face of Death. Mann cites the following lines from Von Platen in his beautiful essay on marriage:

> Wer die Schönheit angeschaut mit Augen,
> Ist dem Tode schon anheimgegeben.
>
> He who sees beauty with his eyes
> Is already bespoken by death.[6]

In this same essay Mann distinguishes love as passion, whose hidden essence is homosexuality, and love as reason, which is institutionalized in marriage.

Mann defines homosexuality as the true experience of passion, as genuine "erotic aestheticism." Homosexuality sides with Beauty to the extent that, for Mann, Beauty and Death are the same thing. The individual who is seduced by Beauty therefore runs the risk of dying, of losing his identity. Homosexuality as the paradigm

4. Thomas Mann, *The Beloved Returns: Lotte in Weimar*, trans. H. T. Lowe-Porter (New York: Alfred A. Knopf, 1940), pp. 357–58.

5. Ibid., p. 359.

6. Thomas Mann, in Count Hermann Keyserling, *The Book of Marriage*, p. 250.

of all erotic and aesthetic experience is consequently an enemy of life. The final proof is that it is sterile. The same can be said in general about all passionate love that does not channel desire in such a way as to render it fertile, as it is channeled in marriage. Like Beauty and Death, however, love as passion is constructive as well as destructive: it therefore sets up tests that the growing individual must pass if he is to lead a fully human existence. Although Death and Passion do not come from the same sphere of life they are nevertheless, as Mann says, examples of "criticism and correction." The double-edged nature of the diseases of the will, of which love as passion is one prominent example, is again apparent: they are both destructive and educational. Mann's entire thinking on the subject is summarized in the following passage from his essay on marriage:

Where the idea of beauty reigns, there the law of life forfeits its precedence. The principle of beauty and form does not spring from the sphere of life itself; its relation to life is that of a stern critic and corrector. It is indeed proudly melancholic, and it is closely and deeply allied with the idea of sterility and death.[7]

Mann's separation of Beauty and life is symptomatic. We might say that in Mann's aesthetic the path of *Eros*, which leads in Plato's *Symposium* to marriage with Beauty, does not culminate in the creation of beautiful works. Contact with Beauty does not, then, engender or propitiate new forms of life, as it does in Plato. Consequently, *Eros* and Beauty have no heirs. On the contrary, the result of that contact that takes place at the end of the road that leads from *Eros* to Beauty is sterility. With this perception Mann gives a profound and subtle turn to the anti-Platonic bias of contemporary art and aesthetics. And yet it seems that this same art and aesthetics carry on another Platonic notion in apparent contradiction to the one just mentioned, namely, the idea that Beauty and the Good (for Plato they are identical) are transcendent, unattainable entities, accessible only to the individual possessed by

7. Ibid.

Eros if he allows his identity to perish. As Plato tells us, this same Beauty, the same Good exist "beyond being," *epekeina tes ousias.* The individual can accede to this being, which by its very definition transcends him, through death, madness, estrangement from himself. There is only one way, then, for the modern artist to become fertile: by making a pact with the powers of the netherworld, a pact with the devil. The art that results from this is paradoxical in its innermost being. To the extent that it acquires concrete form in actual works it appears to affirm life, but in reality it is opposed to life, as it can overcome the curse of sterility only by striking a deal with the devil.

Doctor Faustus confirms this hypothesis, which inevitably carries us beyond the scope of the issue at hand, into the vast territory of contemporary aesthetics and its opposition to classical aesthetics. Because it is beyond the scope of this book the hypothesis can only be hinted at in the following summary:

Plato's *Symposium* dramatizes a rite in which the individual, still in the process of maturing, makes contact with the Good and the Beautiful by being possessed by love. As in all rites of this kind the individual undergoes many trials, and these trials in turn are the steps that lead him to his goal. It is an extremely ambiguous goal. If we limit ourselves to the *Symposium* the individual appears to arrive in the end at complete harmony between *Eros* and Beauty, from which issue beautiful works. Contact with beauty is fecund. If on the other hand we take into account the passage of the *Republic* where Plato states that the Good exists "beyond being," our previous observation seems to be cordoned off, in quarantine. In the latter case contact with beauty turns out to be destructive to the individual, who, unable to maintain his essential stability, is annihilated in mystical union. No works can issue from this union: it must end in derangement or death.

Modern art can be said to specialize in the second of these Platonic notions, sanctioning the divorce of beauty from life, of eroticism from fertility. At best man can attain an ambiguous, somehow spurious fertility by conjuring up the Devil and his negative powers. In a way Mann develops and dramatizes this notion. The only

difference is that, not content with the device of pacting with the Devil, he figures out a way to connect the immediate, factual problems of modern art (following the second Platonic notion) with the classical ideal of reconciling life and art. The ultimate expression of his success is *The Beloved Returns*.

In order to achieve this difficult coupling Mann turns the "via negativa" into a way by trial and ritual. Beauty divorced from life is not an end, then, but a means—not a goal but an approach, the pilgrim's destination instead of a resting place.

This interpretation provides a general explanation of Mann's view of the diseases of the will, of which passionate love is one example. For the modern artist these diseases are objectives that tempt and in the end hypnotize and seduce him. In the end he gives in to the "lure of the abyss," to genuine *Todeslust*. Mann, however, tries to avoid this spiritual and artistic fate while at the same time making use of its instructive power. What for the modern artist is an objective thus becomes a trial by which the individual will is either strengthened or destroyed.

Epilogue

Many of the ideas I have put forth in this book have been merely outlined or hinted at. Without exhaustive treatment there are always a few loose ends. Unfortunately, because I chose the essay form, it can be no other way. The essay is the genre of trial and error, somewhat like what in music is called a "tiento." An essay puts forth a number of hypotheses, none of which need be rigorously proven. The proof need only be suggested. The essay's power to suggest excites and stimulates the reader without ever intending to win him over with definitive arguments. In any case, there is the complementary genre of the treatise, which unlike the essay proposes very few hypotheses with the intention of fully proving each one. Both are legitimate and irreplaceable in philosophical writing.

Nevertheless, the reader will probably have noticed an internal tension in the preceding pages, a deliberate wavering between both of these genres, a constant intrusion of the spirit of geometry and the desire to systematize. As if each sketchy essay threatened to adopt an organized philosophical structure.

Principally, this book points to the possibility of a more systematic kind of construction, tighter and more cohesive, in which all of the ideas here propounded are fully developed.

This future work might well be an aesthetic based on a specific epistemology and ontology. This aesthetic would tie together the notions suggested here (*Eros* and *Poiesis*, Soul and City, Art and

Society). It would also describe in detail the *dynamic* of this conceptual structure and its historical manifestations. And of course it would explain the logic of the dialectical relationship between the opposing conceptual poles and identify the point at which they make dialectical contact or break apart into schism.

Epistemologically it would work on the relationship between the terms Subject and Object, always avoiding detours into idealism and casuistry, laying the basis for an ontology which upholds the primacy of being over thinking.

At the moment this work is still on the drawing board. My next goal is to lay a sound foundation for the project by widening the experimental scope of the experiment with new essays, new approximations. If new concepts are to come into being they will probably require a broad but rich empirical base. Without a firm foothold in experience they will be empty and superficial, lacking both background and immediate support. But it is an internal law of development that these concepts must be *real,* they must be true principles inextricably bound to experience. It is difficult to arrive at such concepts. The process requires years of wandering and apprenticeship. It takes Time.

Index of Names